MW01070970

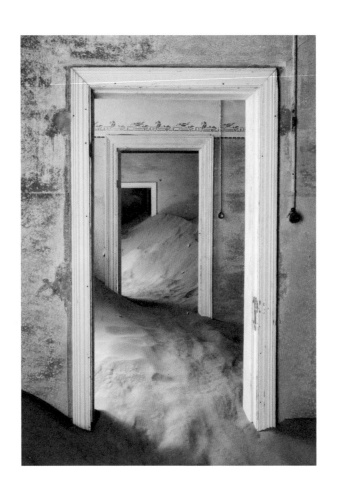

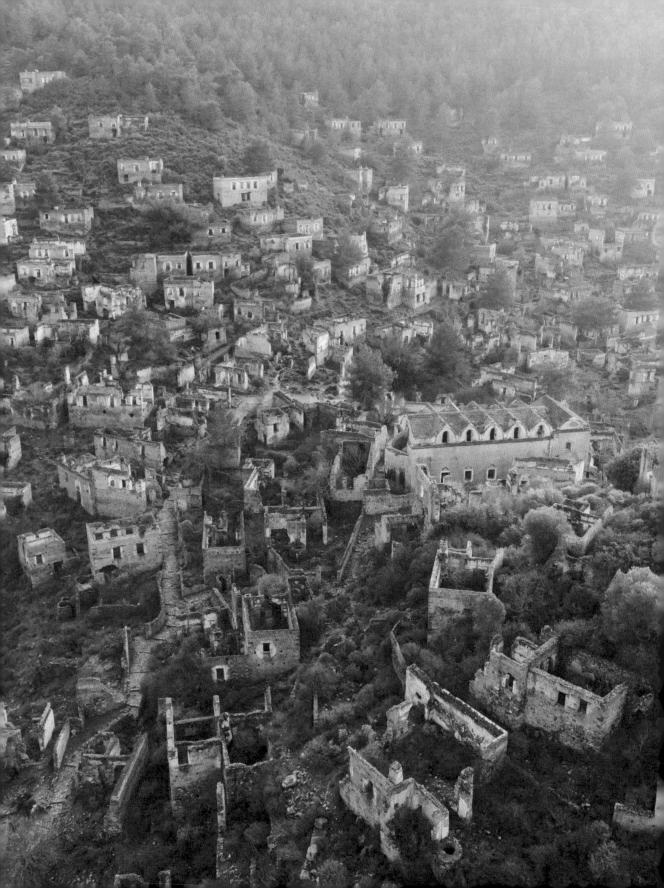

ATLAS *of* ABANDONED PLACES

A journey through the world's forgotten wonders

OLIVER SMITH

MITCHELL BEAZLEY

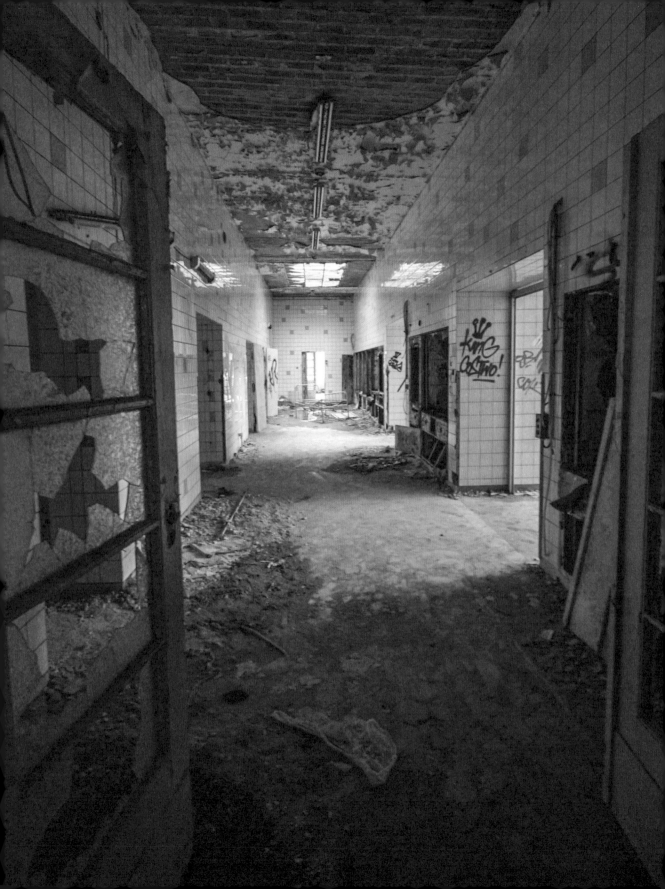

Contents

Introduction

To step into an abandoned place is to cross a kind of threshold into the past – to time travel from the present day to the instant that people departed.

That journey we embark on might be as short as a few years or it might be as long as some centuries. In Pyramiden, in the Norwegian archipelago of Svalbard, it was 1998 when the inhabitants left the cold frontier, and the Arctic draught gusted along the corridors. In Kolmanskop, Namibia, it was 1956 when the last families departed, long after the diamond mines had shut and the first grains of sand began to slip through cracks in the walls. We emerge from our temporal journey with questions: who lived here, worked here? What were their dreams? And, selfishly, what would our own world look like decades from now, if it too suddenly became frozen in this instant? What would survive of us? What would wither and decay?

Throughout this book you will find stories of palaces, mines, trains, planes, hotels, theme parks, theatres, stations and military installations. Some are half-built, some half-destroyed, some only half-abandoned, but they all are in some way enclaves of a past, readied for futures that never came. They are scattered across the corners of the globe, from the polar regions and immense deserts to the centre of world cities such as New York, London and Paris.

Some are fallen monuments to impossible dreams. Others are ordinary houses and apartments in which we might easily imagine ourselves, such as the Fukushima Red Zone or the Chernobyl Exclusion Zone. More intimately than any photograph or video, personal possessions record the habits and hopes of these past lives: broken beds or little crucifixes, coffee cups or children's toys. Some only glanced through a window pane, going decades without a human touch.

In the 21st century, these abandoned places seem to have a growing relevance. They strike us as anachronisms in a crowded planet of almost eight billion people. Today, every speck of Earth has been mapped: there are no great mountains to conquer or wildernesses left to cross. But there is a sense that the terra incognita is now in our midst, in places that have been left behind, that have lapsed as we have progressed.

Recent decades have seen the growth of 'urban' exploration – an anonymous online community as enthusiastic about entering off-limits sites as the history of the places they explore – but their accounts are often extraordinary. Some urbexers (urban explorers) have sailed to the Second World War sea forts in the Thames Estuary. Others have travelled to the remote mountains of Bulgaria to stand among the frayed mosaics of Buzludzha. For those who trespass beyond barbed wire and CCTV surveillance, the past can be a frontier awaiting discovery.

Abandoned places are full of lessons about our present, too. In the absence of humans, nature has shown itself capable of rapid resurgence. Lynx, boar, wolves, bear and bison are among the species now stomping the landscapes around Chernobyl. Mangroves have sprouted from shipwrecks in Sydney Harbour. Around the world, grey

ruins have turned to green ecosystems. The healing powers of our planet seen during Covid-19 lockdowns have proved themselves over and again in these forgotten corners.

Though perhaps they are not wholly forgotten. We may like to think that the clock hands have stopped and people have gone, but onion layers of graffiti, campfires, looting and litter attest to the passage of people and seasons in most abandoned places. Nor are any abandoned places immune from present-day politics and economics. Spreepark in Berlin – a much-photographed abandoned theme park – is currently in the process of being restored and gentrified, while Canfranc Station – a Beaux-Arts marvel lost in the Spanish Pyrenees – is soon to be trodden again by awestruck passengers.

Abandoned places have also found unconventional uses in the present day. Beginning life as a series of quarries, the Paris Catacombs have evolved into a subterranean free zone – a venue for raves and artists' installations. The abandoned hotels at Tskaltubo, Georgia, have become a home to refugees from Abkhazia. Aldwych underground station in London is often a film set.

Abandonment is an elusive, shapeshifting term. It might be a shy, invisible dust we imagine settling for a while after people depart, which disperses when disturbed by too many incomers. Most places in this book have become abandoned in modern times. 'Abandoned' is a word we use less often of the ruins of Pompeii or the Pyramids. It is not a word we associate with Stonehenge or caves inhabited in the Palaeolithic – or, indeed, any place whose dwellers we strain to imagine. Abandonment might be part of the lifecycle of a place on a journey into disintegration. Abandonment seems to have its own point of expiry.

For all their stories of the past and surprises of the present, it is the prophecies of the future we unconsciously solicit from these places. In a future of climate refugees, we might learn from the Aral Sea, where ships rust on a dry seabed as a consequence of a Soviet plan to divert rivers. On a planet of finite resources, we might find forewarnings in the rusted saltpetre mining towns of the Atacama Desert. Where countries like Italy and Japan are depopulating rapidly, we might dwell on Craco, or Hashima. There are positive learnings too. When evil tyrants seem omnipotent, we might turn to the ruined legacies of Saddam, Mobutu and Hitler for assurance that their time too shall pass.

The places profiled in this book have been abandoned for a wide variety of reasons: some are hard and illegal to access, while for others all you need to do is buy a ticket. But in a time of anxiety about climate change, pandemics and nuclear war they collectively offer a glimpse of what a greater, global ruin might look like. They serve as a postscript to cemeteries: a vision of our deaths not as individuals, but as communities, as a species. As tectonic plates push together, the bricks and mortar we once built are pulled apart. As timbers rot, young trees soar. For places that seem lifeless, their lesson is that – in some form or other – life goes on.

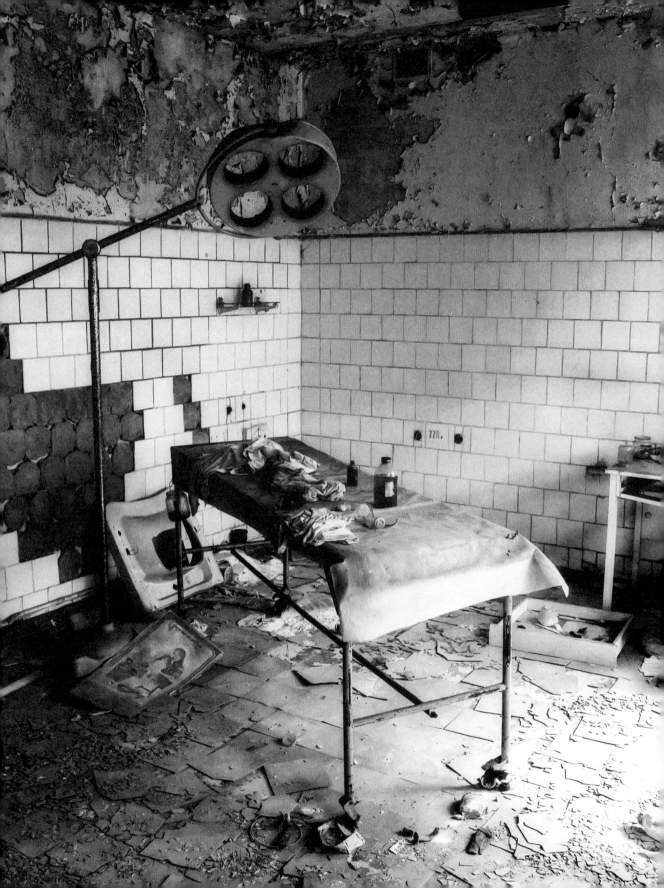

Europe

Maunsell Forts

51° 28' 31.836'' N, 1° 0' 6.408'' E

THAMES ESTUARY, ENGLAND

Second World War fortifications, guarding the skies over the Thames Estuary

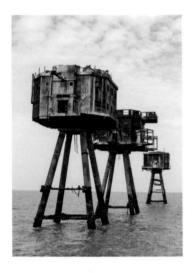

British history has ebbed and flowed with the tides of the Thames. Invading Saxons and Vikings followed the river upstream; the ships of Empire sailed downstream to plunder the world. In the Second World War, German bombers used the estuary to navigate, flying from where its mouth yawns open to the North Sea to where the river winds darkly among the lights of the capital.

To intercept these aircraft, the British began the construction of seven 'Maunsell Forts' out in the estuary: distinctive platforms mounted with anti-aircraft guns. They count among the last major fortifications built to defend London and the Thames, a closing chapter in a tradition that began with the city's Roman Walls and includes the Tower of London. But, being marooned up to nine nautical miles out at sea, they receive relatively little attention today. On a clear day, you can squint and see them from the promenades of the Kent and Essex coasts. More often they are cloaked in mists, rusting into obscurity on the edge of UK waters.

Built between 1942 and 1943 to designs by Guy Maunsell, the forts divide into two categories, Army and Navy, with three Army forts off the Kent coast and four Navy forts further out in the North Sea, collectively forming a rusty archipelago.

Left: Shivering Sands – an Army fortress about eight nautical miles from the coast of the Isle of Sheppey in Kent.

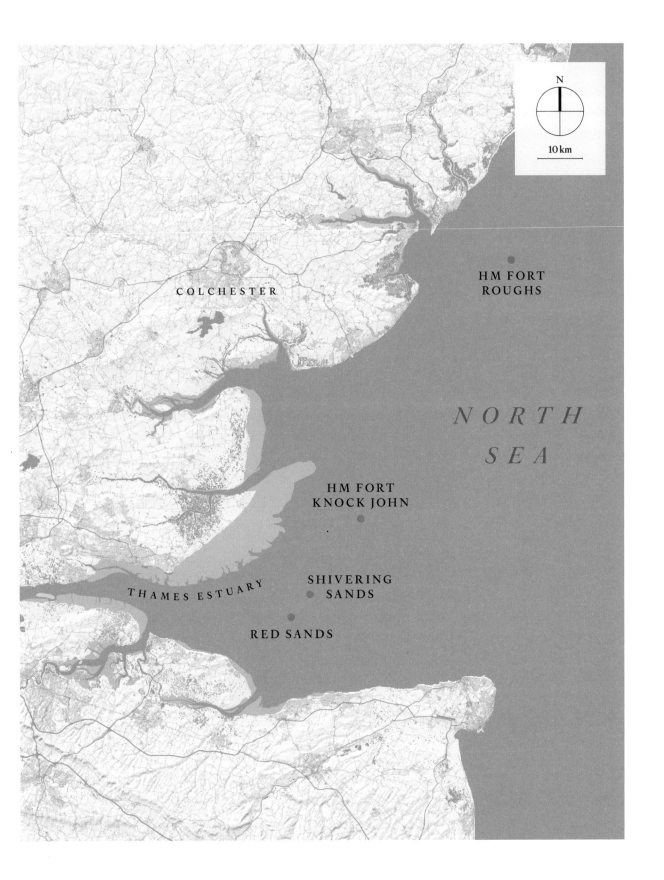

Of the Navy forts, by far the most famous is HM Fort Roughs. After being abandoned in 1956, Fort Roughs was occupied a decade later by former British Army Major Paddy Roy Bates. Realizing it lay just beyond British territorial waters at the time, Bates declared the fort the Principality of Sealand, an independent nation with its own flag, constitution and passports. No country on Earth officially recognizes Sealand, but Roy's son Michael reigns as Prince of Sealand today (he and others are sometimes resident on the platform). For £99 ($129) you can buy a knighthood from the website.

To the south lies HM Fort Knock John: this, too, was occupied by Bates senior but, unlike Sealand, has been left to the elements. Only a few explorers have gained access to Knock John in recent times – a swashbuckling feat that involves navigating the busy shipping lanes of the Thames and winching up onto the platform. Reports describe a place where the Second World War feels remarkably raw: within the hollow towers are timber bunks where sailors slept under the surface of the sea. Yellowing pictures of 1940s pin-up girls look out for their departed crews. Two further Navy forts have been lost: HM Fort Sunk Head was blown up by the Royal Engineers in 1967, while HM Fort Tongue Sands sank in a storm in 1996.

The Army forts look stranger than their Navy compatriots, with towers mounted on stilts, once connected by a series of walkways that have long since been lost to the swells. They rise monolithically, almost like a mirage in the sea. Two survive: Shivering Sands and Red Sands. Both served as radio stations during the pirate radio boom of the 1960s, a time when a colourful cast of rogue broadcasters exploited a loophole in the law by transmitting rock and roll from just beyond UK waters. More recent times have seen proposals to turn the abandoned forts into luxury hotels. A heritage group aims to restore Red Sands so that it can one day be open to the public (project-redsand.com).

For the time being, though, the Army forts are largely derelict and barnacled, with only visiting seabirds and passing container ships for company. They nonetheless have a proud past. During the war, Maunsell Forts were a successful defence, effectively targeting aircraft by laying magnetic mines in the estuary. They are also credited with shooting down 30 flying bombs, likely saving hundreds or thousands of lives in the capital. Flying into Heathrow and Gatwick today, you can sometimes see them in the estuary as you begin your final descent through the clouds – still standing like sentries at the gates of the capital.

1

1. After the Second World War the Royal Navy removed ladders and walkways between the seven towers that make up Red Sands to deter visitors.

The Maunsell Forts count among the last major fortifications built to defend London and the Thames

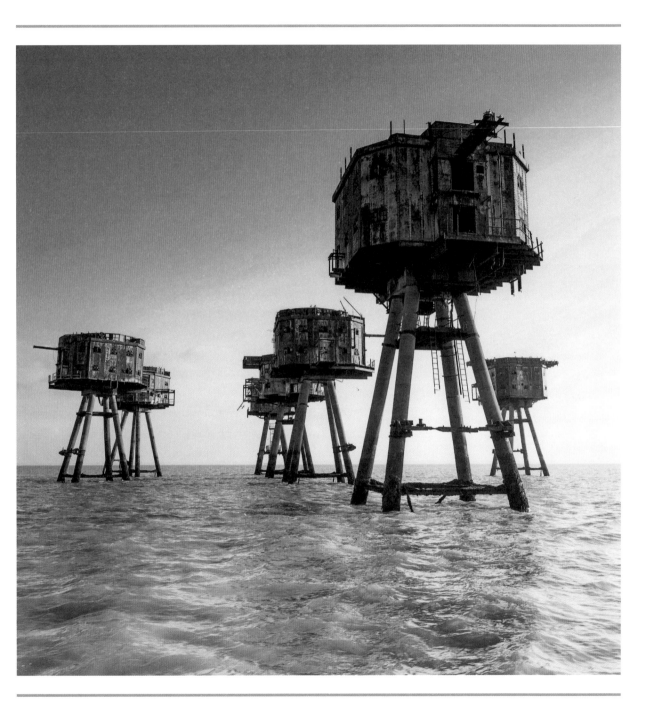

Aldwych Station

51° 30' 43.812'' N, 0° 6' 55.98'' W

LONDON, ENGLAND

An abandoned underground station that once stored ancient artefacts

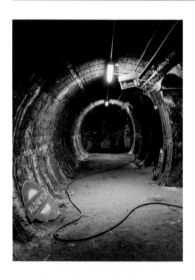

Look at a London Underground map from 1993 and there, right at the centre of the city, is what looks like a cartographer's error: a little spur fraying off from the Piccadilly Line to a terminus that no longer exists. Passengers on the line might glance out of the window and spot a phantom tunnel branching into the gloom, just as passers-by on the Strand notice a pair of little red doors, bolted shut and sometimes covered in flyposters. Aldwych Station broke the neat symmetry of the tube map. It also broke the finances of London Transport: having served only a trickle of passengers, it closed for good in 1994.

Left: A discarded roundel for Aldwych Station on the floor of an underground access tunnel.

Aldwych nonetheless counts as one of the most storied stations on the London Underground network and one that successfully turned its abandonment into a career. The story begins in 1907, when it opened as Strand Station, part of the Great Northern, Piccadilly and Brompton Railway. Evening trains shuttled glamorous crowds into London's theatreland. But not long after it opened, it became a spare part. Plans to extend the line south from Aldwych under the Thames came to nothing. The station was always on the road to nowhere: some of its tunnels and platforms were mothballed as early as 1917.

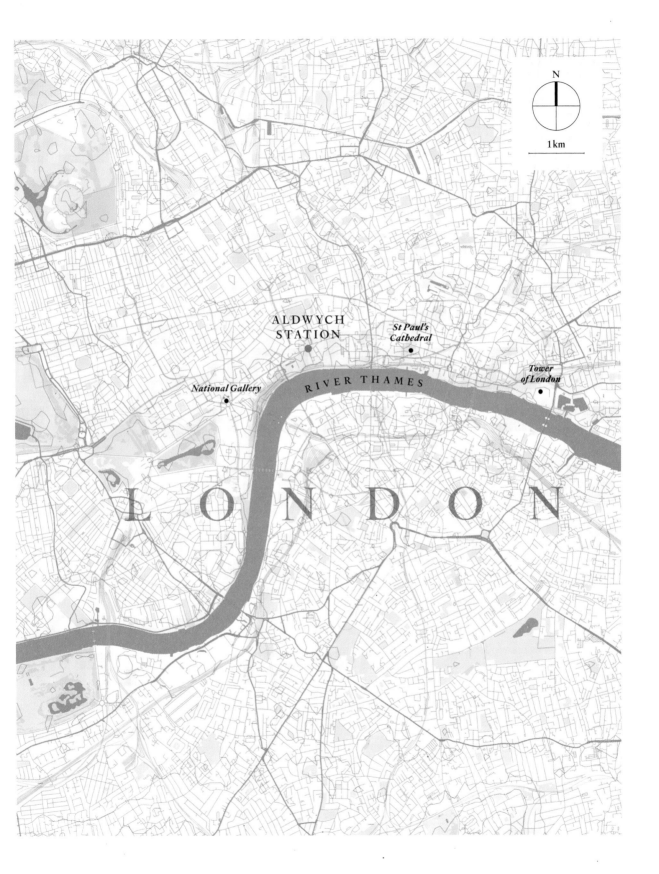

Aldwych instead served other purposes. In the Second World War, the station became an air-raid shelter: Londoners slept beside the rails, George Formby sang on the platform with his ukulele, and the riches of the British Museum were stashed in the tunnels.

On top of the abandoned station today is the Classics Department of King's College London – one wonders if they teach that the Elgin Marbles were once kept in the murk beneath the seminar rooms, that the centaurs of the Acropolis once inhabited the Stygian gloom of the Piccadilly line. Also stored down here was the Sutton Hoo hoard, the greatest archaeological find in British soil. Only excavated in 1939, the famous Anglo-Saxon treasure barely saw daylight before disappearing back into the underworld.

Aldwych's ultimate closure came when daily passenger numbers dwindled to 450 a day, and the lifts became too expensive to replace. Today, it is sometimes used for police and fire brigade drills, and is open for tours through the London Transport Museum.

To step inside Aldwych is to see a nook of the London Underground that sidestepped modernization: it retains its timber lifts, telephone booths and glazed tiles. At platform level, posters line the walls – advertising Madame Tussauds, cigarette filters and one that reads – with exquisite comic timing – 'Do you know how much British farmers will benefit if we join the Common Market?' These posters can be deceptive.

Aldwych's main vocation has been as a film set – a working 1972 tube train is parked on one platform for filming. It is hard to tell what is original and what is a relic of a recent production. Christopher Reeve stopped an underground train here with his bare hands in *Superman IV*; Keira Knightley's character sheltered here in *Atonement*; Churchill mingled with the masses in *Darkest Hour*; humans mingled with zombies in *28 Weeks Later*. Paradoxically, for a station once doomed to obscurity, it has become perhaps the most familiar face of the London Underground for cinema-goers.

Aldwych is just one of around 40 stations now closed across the network, many struggling to find a new purpose after the last trains departed. Quite uniquely, it served as an archive for some of the greatest artefacts of human civilization. Today it is itself an artefact of London's proud transport history.

1. The 1907-built wooden lifts, deemed too expensive to replace.

2. The eastern platform at Aldwych Station, which is often used as a film set.

3. The London Underground roundel has been a fixture of all stations since the 1920s.

4. Derelict steps descend to the platform.

A nook of the London Underground that sidestepped modernization

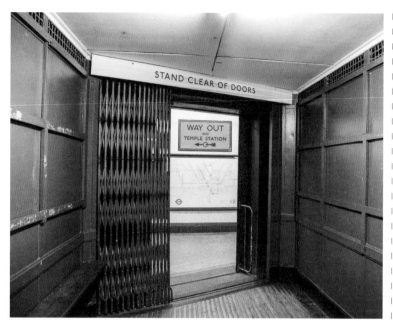

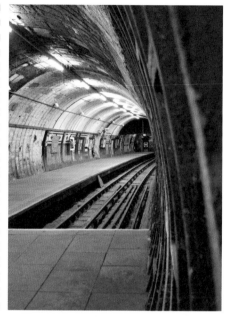

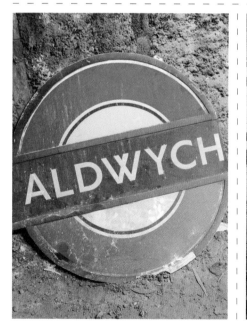

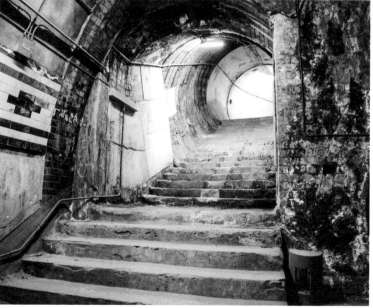

Paris Catacombs

48° 50' 2.4'' N, 2° 19' 56.712'' E

PARIS, FRANCE

A mirror-world beneath the French capital

As far as most guidebooks and casual tourists are concerned, the Catacombs of Paris are a 1.6-km (1-mile) long stretch of underground tunnels, filled with the bones of six million people after the city's cemeteries began overflowing in the 18th century. They have had a macabre appeal for tourists ever since. For a few euros, you can wander dimly lit avenues lined with skulls and femurs, visit an exhibition and re-emerge into daylight perhaps via the gift shop. To visit this attraction and say you have seen the Catacombs is analogous to stepping off a Eurostar at Gare du Nord and then saying that you have seen all of Paris.

Left: Many ladders in the Catacombs lead to manhole covers on the streets above.

This section, open to tourists, is but a minuscule fraction of a vast subterranean network that tunnels beneath the French capital – a shadow city with its own thoroughfares, junctions, meeting points and part-time inhabitants. Centred south of the Seine, this network is believed to measure 320km (200 miles), though no one is entirely sure as it has not been exhaustively mapped. Like its sister city above ground, it continues to evolve: new underground routes are discovered just as old tunnels become flooded or collapse. Entry to the Paris Catacombs – in this second, much broader sense – is strictly illegal, and the law is enforced by a dedicated police force.

N

2 km

PARIS

RIVER SEINE

AREA OF
CATACOMBS

In practice, it is far too vast to police effectively. The Catacombs have spawned their own district subculture – *les cataphiles* – torch-wielding Parisians who spend time exploring, creating art and partying in this mirror-world beneath the city.

The Paris Catacombs is a term used interchangeably with the Paris Mines or Les Carrières de Paris (the Quarries of Paris), for it was as quarries that the network began. Paris lies on a bed of Lutetian limestone, valued by the Romans for its luminous creamy colour. In later centuries, the stone that makes up the Louvre, Notre Dame and Les Invalides was hollowed from these gloomy corridors. From 1786 – as the capital's cemeteries began to fill up – parts of the network were repurposed as ossuaries: the exhumed bones were wheeled through the city at night, blessed by a priest as they descended into their new home. The quarries became interconnected with sewers, cellars and, later, underground railways. Collectively, this underworld exerted a spell over the Parisian imagination: Victor Hugo wrote about it in *Les Misérables*.

In the 19th century, the Catacombs found a new career as a site for industrial-scale mushroom farming, and in the Second World War the forces of the French Resistance and German occupation took shelter here at different times. Today, to enter the Paris Catacombs is to go rummaging in an archive of Parisian history. Banquets are held in old bomb shelters, street art swathes the mine shafts. In some chambers you can hear the rumble of metro trains, in others old bones appear. It is emphatically not a place for the faint of heart: one occasional feature of the network is the *chatières*, or 'cat flaps', tiny openings through which the *cataphiles* must crawl to pass between sections.

In the midst of this claustrophobia, there exists a powerful aura of freedom: sculptors chisel away freely at the walls, DJs perform sets without a licence, divers swim in flooded sections. The manholes and railway tunnels through which the *cataphiles* gain access to the network represent a kind of Narnia wardrobe, a portal through which to transcend rules and regulations, work life and home life, profit and loss – even night and day.

Importantly, no satellite can map the dark web of the Paris Catacombs. For the *cataphiles*, knowledge of the labyrinth must be earned, and not taken for granted.

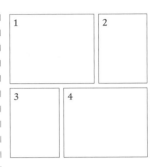

1. Graffiti swathes much of the Paris Catacombs.

2. Broken masonry can be seen on a section of passageway.

3. Rumours of disappearances swirl around the dark reaches of the network.

4. Low ceilings are a feature of the Catacombs.

The network represents a kind of Narnia wardrobe, a portal through which to transcend rules and regulations

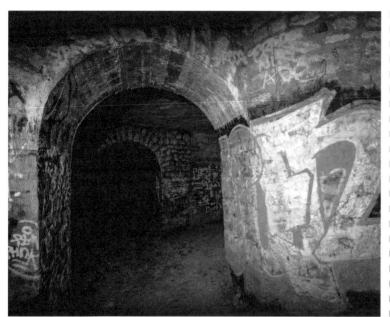

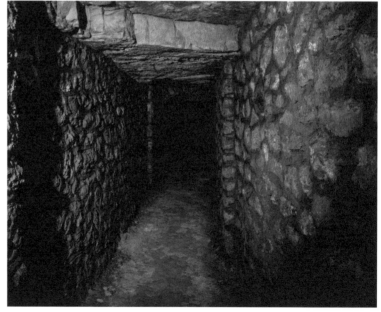

La Petite Ceinture

48° 49' 18.624'' N, 2° 20' 20.904'' E

PARIS, FRANCE

A phantom railway at the heart of Paris

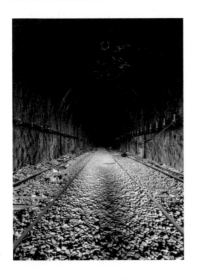

London has the Circle Line, Berlin the Ringbahn, and Moscow the Koltsevaya Line – all circular railways that orbit the cities, thronging with thousands of commuters every day. Paris's Petite Ceinture – a 32-km (20-mile) long railway looping around the French capital – pre-dates all of these. However, it has not seen a single passenger since 1934. Today, much of the line is derelict – a wild fringe synonymous with urban foxes and graffiti artists, where weeds sprout between the rails, undisturbed by passing commuter trains. Few visitors know this dark perimeter encloses the city of light.

Left: One of many abandoned tunnels that line the Petite Ceinture, some of which provide an entry to the Paris Catacombs.

The story of the Petite Ceinture (meaning 'little belt') begins at the dawn of railways in Europe. In the mid-19th century, the French government built the Thiers Wall – the final incarnation of Paris's city walls, a tradition that began before the Roman invasion of Gaul. The military envisaged a new railway moving troops along the fortifications, while urban planners wanted a new circular line to link the new termini strewn about the city. The Petite Ceinture became operational by 1862; in its heyday, smart oil-lit carriages departed stations every 15 minutes. Traffic peaked during the 1889 Universal Exposition, when it was used by 19 million passengers, at least a few of whom caught a train to marvel at the newly welded Eiffel Tower.

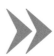

LAPETITE
CEINTURE

RIVER SEINE

PARIS

By the turn of the century, however, the new Paris Metro subway system had started to take demand away from the railway. By 1934, the Petite Ceinture was closed to passengers. It was wholly closed to freight by the 1990s. Much of it has existed in a state of limbo ever since.

The Petite Ceinture does not easily lend itself to circumnavigation on foot – a few parts are now used by other working railway lines. That said, a growing number of short sections are now legally open to the public. In the 15th arrondissement, anyone can walk a well-kept 1.3-km (⁴/₅ mile) stretch, which is home to an abandoned station and, reputedly, some 200 species of flora and fauna. Greener still is the shorter 1.2-km (¾-mile) section from Porte d'Auteuil to La Muette in the 16th, where the line is enveloped by thick woodland and birdsong disrupts the thrum of Parisian traffic.

The most celebrated redevelopment project on the line is La Recyclerie in the north – a café is housed in a former Petite Ceinture station, where the platforms now serve as an urban farm and lunches are served in the old ticket hall.

It is, however, in the northern neighbourhoods of the city that the Petite Ceinture is at its most untamed, where urban explorers have to slip through railings and vault fences to enter off-limits sections. In the 19th arrondissement, an abandoned girder bridge watches over the promenades of Canal de la Villette. In the 20th, the line enters a series of tunnels, one of which runs under Père Lachaise cemetery. Urban explorers here use torches to pick their way through the gloom, stepping almost directly beneath the graves of Oscar Wilde, Edith Piaf and Marcel Proust. It is a new perspective on the city. As Proust himself famously wrote: 'My destination is no longer a place, rather a new way of seeing.'

The future of the Petite Ceinture is uncertain. The Mayor of Paris previously backed plans to convert sections to cinemas and other uses. Environmentalists hope to resist what they see as the commercialization of the line. It remains the property of the French railways (SNCF), and some speculate it could one day be resurrected, to relieve demand on the Metro network that once brought about its demise. By that point, passengers will have been waiting almost a century for a train.

1. An abandoned stretch of line at Avenue de Saint-Ouen in the north of the city; the station building in the distance is now a cultural space.

It remains the property of French railways and some speculate it could one day be resurrected

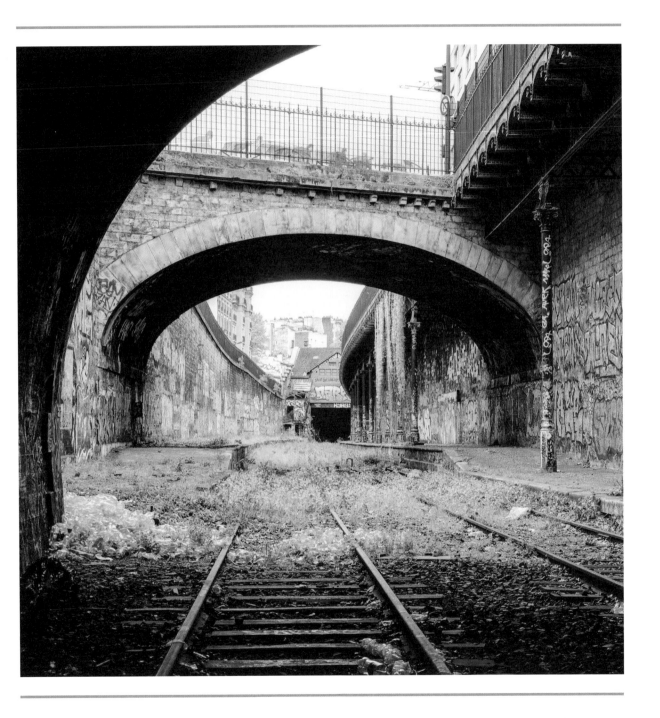

Craco

40° 22' 42.024'' N, 16° 26' 25.296'' E

BASILICATA, ITALY

A ghost town watching over the badlands of southern Italy

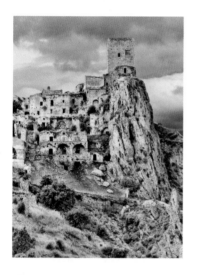

The Italian region of Basilicata was most famously described in Carlo Levi's 1945 memoir, *Christ Stopped at Eboli,* a town northwest of Craco. Levi was a doctor, painter and antifascist from Turin. With the rise of Mussolini, he became a political exile and was banished to the arid badlands of the Italian South. His new home could not have felt more distant from the prosperous, metropolitan North. He found himself in towns with no healthcare, electricity or running water; bandits roamed the countryside, and belief in magic and spells overshadowed Christianity. In one village, locals declared that 'Christ Stopped at Eboli' – that religion and progress had effectively bypassed this part of the country. Levi's book evoked a place adrift from Italy, Europe and, indeed, the 20th century.

Much has changed in Basilicata since Levi returned to the North. But the ghost town of Craco, set in the badlands only a couple of miles from where he lived, is a relic of that ancient and mysterious Italy that he once knew – where stony ruins bake in the midday heat, and where the past looms far larger than the present and future. Towering above the landscape on a rocky outcrop, the silhouette of Craco still stirs the imagination of passers-by.

Left: A Norman watchtower on a natural outcrop marks the highest point of Craco.

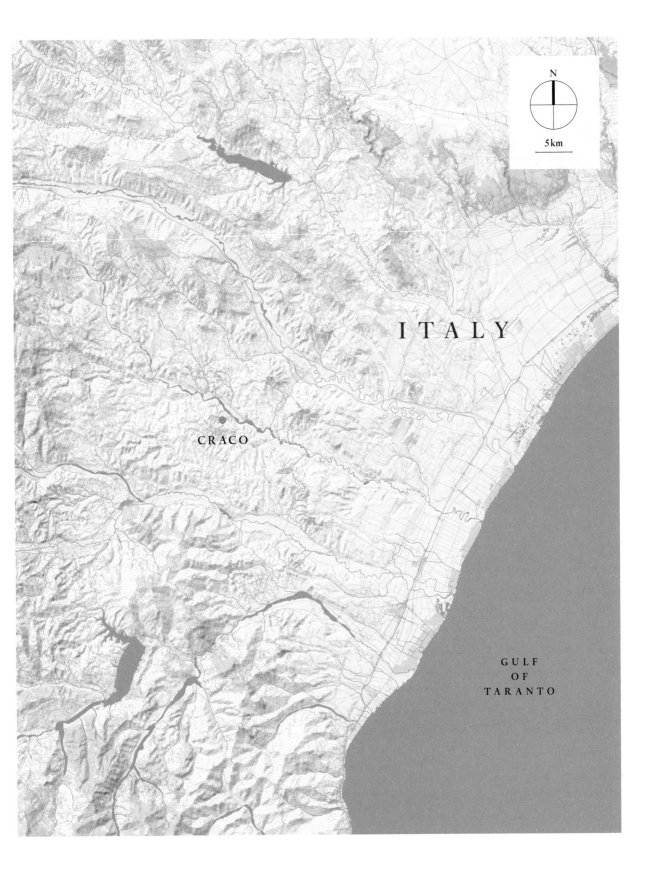

N

5km

ITALY

CRACO

GULF
OF
TARANTO

Craco was first settled by the Greeks in the 6th century AD, though tombs dating to the 8th century BC hint at an older incarnation. It owes its present layout to the medieval period: in the 12th century, a watchtower was added by the Normans, with a host of palazzi built in the following centuries. The town's fortunes ebbed and flowed with that of the wider region. It was caught up in the upheaval of Italian unification in the 19th century and, by the 20th century, saw an exodus of sons leaving for the New World.

It was an act of God, however, that proved to be Craco's final undoing. The town's precarious hilltop site, combined with a series of violent earthquakes and landslides, saw Craco deemed uninhabitable in the years after the Second World War. In 1963, almost all the inhabitants were moved to a new settlement in a valley nearby, and Craco was wholly abandoned in 1980.

Today, guided tours allow participants to explore the ruins wearing hard hats. From afar, Craco resembles a sketch by the Dutch graphic artist M C Escher, with stairways and houses stacked on top of each other. Up close, its advanced state of decay is obvious. There are towers where no bells chime, rusted balconies where families once hung their washing. Weeds sprout at the altar of San Nicola church, whose nave is open to the sky.

One or two churches are still maintained, including the church of Santa Maria della Stella, where a statue of the Virgin and Child was miraculously discovered by a passing shepherd (the Child went missing, but the original Virgin is still there). Other, far grimmer legends, recalling Levi's prose, include a tavern run by a temptress, who would seduce her patrons and turn them into vinegar.

In more recent times, Craco has found fame as a film set – scenes from the Italian movie adaptation of *Christ Stopped at Eboli* were shot here. Christ did, however, make it as far as Craco for the filming of Mel Gibson's *Passion of the Christ*.

Ghost towns have a particular poignance in Italy, where the birth rate is currently at its lowest since the country's creation in 1861 – Basilicata itself loses 3,000 young people every year. Craco withstood the tides of the invaders borne on the Mediterranean. Its story began with Greek sailors stepping ashore in the glory days of the Byzantine Empire – and ended only a few decades ago, when the last suitcase was zipped up.

1. The altar of the Chiesa Madre di San Nicola – the largest church in Craco.

Towering above the landscape on a rocky outcrop, Craco still stirs the imagination of passers-by

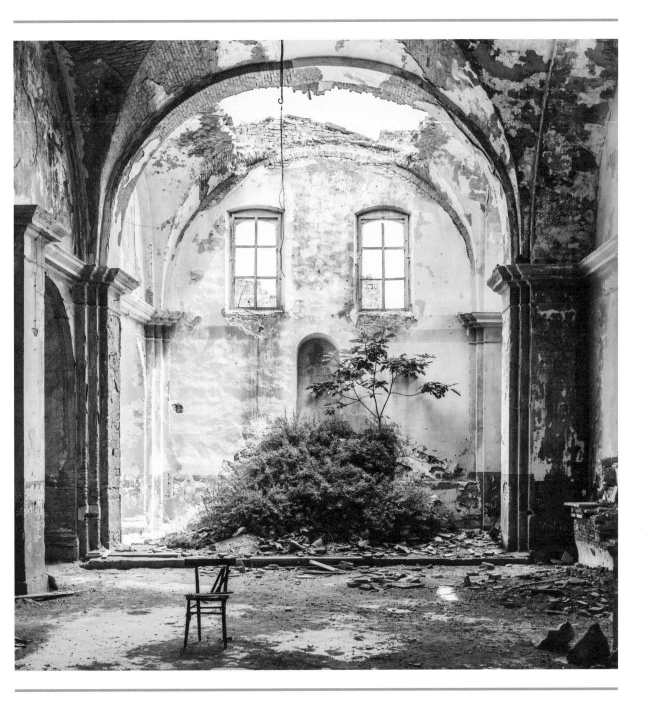

Teufelsberg

52° 29' 52.152'' N, 13° 14' 27.528'' E

BERLIN, GERMANY

Cold War remains on Berlin's urban mountain, within which secrets are buried

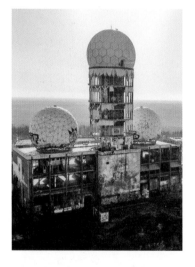

Teufelsberg commands a sweeping panorama over Berlin, including the dome of the cathedral, the spike of the Fernsehturm and the leafy expanse of the Tiergarten. It is this lofty perspective that saw it chosen as the site of an Allied listening station during the Cold War, a place from which to snoop on transmissions from the far side of the Iron Curtain. Today, Field Station Berlin is abandoned, but its ruins still watch dutifully out over the city. Far from being the secretive, sinister silhouette of the Cold War era, Teufelsberg is now a place Berliners visit to survey their hometown, to listen in on the rumble of traffic and ponder the strata of history that lie beneath their feet.

Left: Field Station Berlin rises on the skyline of the German capital.

The story of Teufelsberg starts with Hitler's vision for the redevelopment of Berlin, planned to take place after Nazi victory in the Second World War. One of the prototype buildings was the Wehrtechnische Fakultät, the military technology faculty designed by architect Albert Speer. The first phases of construction were underway by the 1930s. By the end of the war, the faculty had not progressed beyond an empty shell. Later, as West Berlin became an island marooned in the Eastern bloc, the Allies were faced with a problem: where to dispose of the rubble of bombed-out buildings from the Second World War.

N

2 km

Brandenburg Gate

TEUFELSBERG

GRUNEWALD FOREST

BERLIN

The Wehrtechnische Fakultät on the edge of the sector offered the perfect solution: the building proved too robust to demolish, so 26 million cubic metres (34 million cubic yards) of rubble were instead heaped on top, creating an artificial 120-m (395-ft) high hill. It was named Teufelsberg, meaning 'devil's hill', ostensibly after the nearby lake of Teufelssee. In time, a forest of pine and birch grew on the slopes, and in a happier turn of events, a little ski slope was added. In 1963, Field Station Berlin itself was built. Dubious rumours persist to this day that secret tunnels linked the listening station to Hitler's subterranean structure, and that Allied spies paced windowless corridors intended for the students of the Reich.

Little has been disclosed of the station's Cold War career beyond a few curious anecdotes: the Teufelsberg ski lift had to be shut down because it interfered with radio signals, and a nearby Ferris wheel was promptly ordered to stop rotating for the very same reason. Field Station Berlin closed soon after the fall of the Berlin Wall. It was briefly tipped to become a meditation centre under the direction of filmmaker David Lynch but, ultimately, no such plans materialized.

Today, the former Field Station Berlin is under private ownership and, after decades of unofficial visitors, was officially opened to the public in 2016 for an admission fee. Unsurprisingly, all sensitive technology has been stripped from the site – its command centres and stairwells give little indication of its military past. Instead, it is now a vast street art gallery: an ever-evolving canvas, where a cast of astronauts, tigers, 1970s footballers and others watch down from every surface. Murals even adorn the radomes, the vast, spherical structures that once protected antennae, whose panels are slowly falling away to reveal the Berlin skyline beyond.

Teufelsberg today is a popular day trip for families, people flying kites and model planes, and, during winter, occasional tobogganers, who make do without a ski lift. At night, wild boar have been known to patrol its forested slopes. For a hill physically created from the ruins of conflict, its new mission is perhaps best summarized in a mural on one of the external walls: *'Teufelsberg – Peace. No Violence. No Vandalism.'*

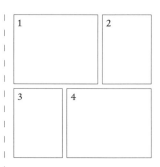

1. The central tower, seen at sunset with the Grunewald forest below.

2. Artists continue to bring props into Field Station Berlin.

3. The vast interior of one of the radomes.

4. One of the radomes that once housed antennae for snooping across the Berlin Wall.

Little has been disclosed of the station's Cold War career

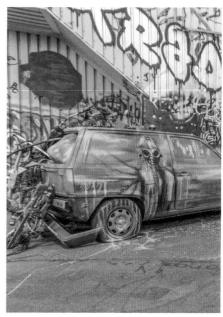

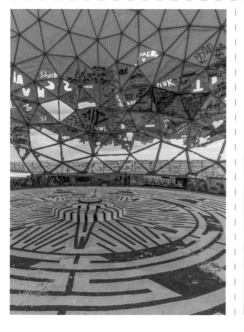

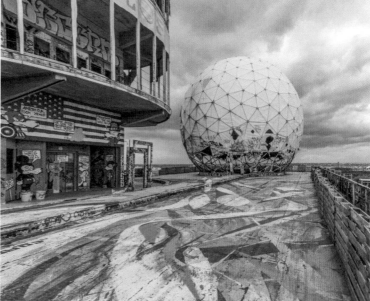

Beelitz-Heilstätten

52° 15' 30.636'' N, 12° 55' 40.332'' E

BEELITZ, GERMANY

A hospital at the heart of modern German history

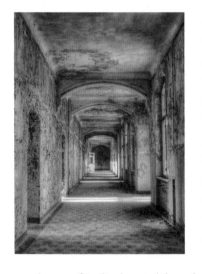

Abandoned hospitals are a favourite subject of urban explorers. They are places that provoke pathos: the buildings and equipment once intended to save lives are now themselves in need of being saved. And they are places of wonder, too, for the births, death and dramas that might have taken place within their walls. The history of Beelitz-Heilstätten hospital, however, does not require too much speculation. Two leaders of 20th-century Germany came here, some 70 years apart. Their visits to these corridors neatly frame the beginning and the end of the darkest era of the nation's history.

Left: A long, echoing corridor in the old sanitorium.

Beelitz-Heilstätten lies in forests to the southwest of Berlin, beyond the palaces of Potsdam. It was opened in 1898 as a lung and respiratory sanatorium, its woodland location offering respite from the smog of the capital. Soon after the turn of the century, it had 1,200 beds, its own bakery, butchers and a miniature power station, as well as verandahs where patients could recuperate, looking out over leafy, landscaped gardens. With the advent of the First World War, it was converted to a Red Cross hospital serving the German Imperial Army. In 1916, Private Adolf Hitler sustained a shrapnel wound to his thigh in the Battle of the Somme and came to Beelitz-Heilstätten to recuperate, returning to the front soon after.

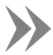

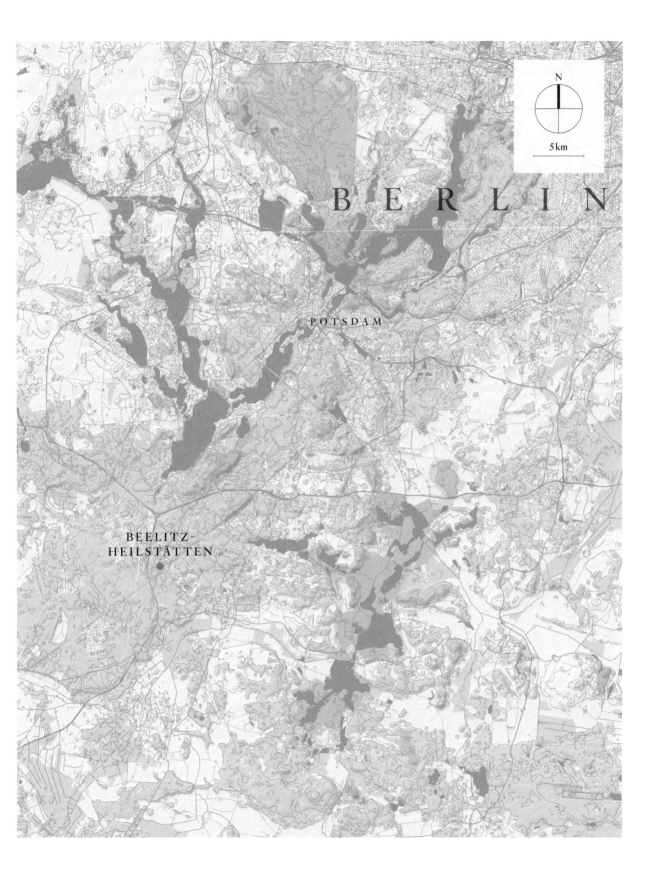

N

5km

BERLIN

POTSDAM

BEELITZ-
HEILSTÄTTEN

In the closing days of the Second World War, Beelitz-Heilstätten was commandeered by the Red Army, and it remained its biggest military hospital outside of the Soviet Union until the end of the Cold War. In 1991, it became a home to the deposed East German leader Erich Honecker: by living on what was technically foreign soil he could evade arrest warrants issued for the shooting of escapees on the Berlin Wall. The lawns and glades of Beelitz-Heilstätten were to count among Honecker's last impressions of the country he once ruled as the institutions of Communism crumbled beyond the woods. He soon left, flying to Moscow from a Soviet airfield.

Barring a few areas, the hospital was abandoned when the Russians left in 1995. Only one Red Army soldier remained: a rifle-wielding statue standing sentry before the complex. There are one or two other vestiges of its Soviet past, notably Cyrillic inscriptions on the walls. But for the most part it retains the proud ambience of an English country house at the turn of the century, with its ceremonial staircases, wrought-iron bannisters, classical columns and parquet floors missing only a few pieces. The grandest parts are the gymnasium and bathhouse – almost like a cathedral chapterhouse, with a plunge pool. It is tempting to imagine a young private limping around the corridors a century ago, and wonder how history would have changed if his wounds had gone untreated.

For decades, the rusted metal beds and empty corridors have been much photographed, and still-life images of Beelitz-Heilstätten have become famous worldwide. The past years, however, have seen the fingers of regeneration very slowly creeping across the site, with some areas once freely stomped by the urbex (urban explorer) community now fenced off and set aside for guided tours. A treetop walkway now allows visitors to look down on the Alpenhaus, a vast tuberculosis clinic ravaged by fire during the Second World War and now irredeemably conquered by nature. Over the coming years, some other corners of the hospital complex are to be redeveloped and converted into housing. Now may be a last chance to visit those parts of Beelitz-Heilstätten, before the ghosts of its past are discharged.

1. A derelict operating theatre, with broken surgical lighting.

Buildings and equipment once intended to save lives are now in need of being saved

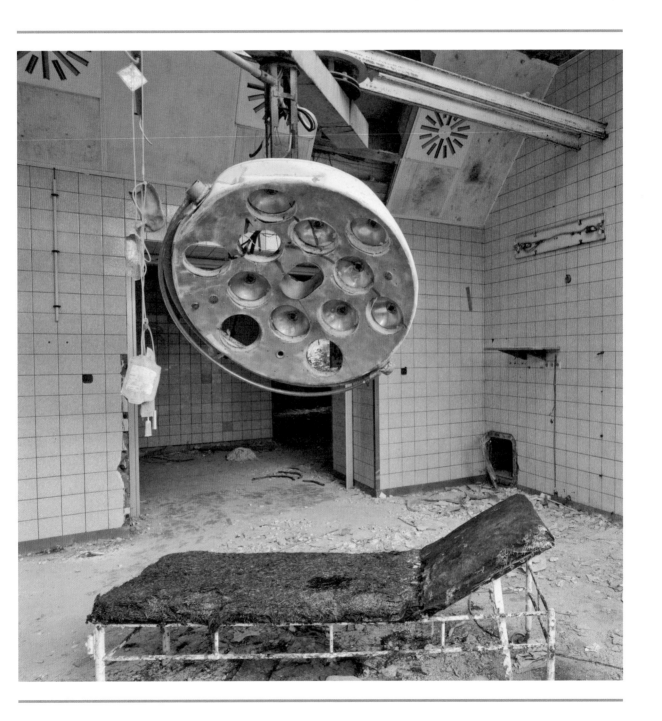

Red Star Train Graveyard

47° 32' 56.652'' N, 19° 6' 15.912'' E

BUDAPEST, HUNGARY

Mighty steam engines, rusting on the edge of Budapest

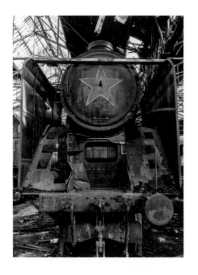

Budapest claims some of the most celebrated railway architecture in Europe, from the triumphal arch at Keleti Station to the Eiffel Company-designed Nyugati Station. Anyone boarding a Prague-bound train from the latter might glance out of the window and see – for one fleeting moment – another relic of railway history, in the suburbs of the Hungarian capital.

What Paris's Père Lachaise is to cemeteries, is what Budapest's Red Star Workshop is to train graveyards: a vast mausoleum to steam power, where leviathan engines rust in the sidings. The abandoned shed is a trainspotter's paradise, but its tale is also bound up with the arrivals and departures of Hungarian history, its greatest glories and its most tragic chapters.

Hungary's first railway was built in 1846, running from Budapest Nyugati to the town of Vac. The national poet Sándor Petőfi travelled aboard the inaugural train, and compared railways to blood vessels coursing through the human body.

Sure enough, Budapest found itself at the centre of the Austro-Hungarian imperial network, with services departing westward to Vienna and the Adriatic, and eastward towards Transylvania and the Iron Gates. To keep up with demand, a new workshop was

Left: The famous MAV-424, missing a buffer.

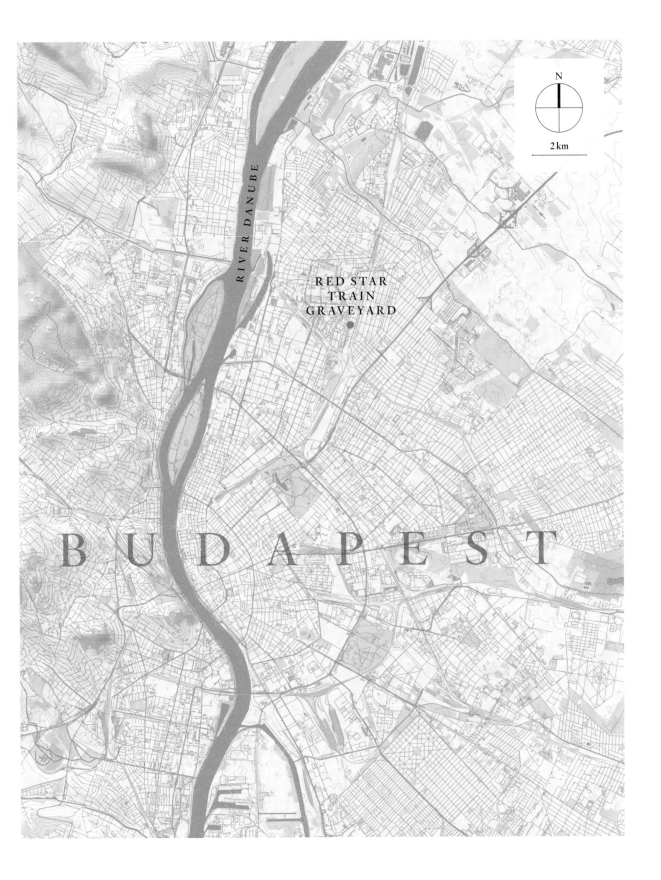

RIVER DANUBE

RED STAR
TRAIN
GRAVEYARD

BUDAPEST

N

2 km

opened at the turn of the century, set beside the original railway line to Vac that had first stirred Petőfi's pen. It was, at the time, the largest building in Budapest, covering some 24,000 square metres (29,000 square yards).

The building was bombed during the Second World War and, by the 1980s, the decline of steam saw it become a dumping ground for retired rolling stock. Plans for the shed to be integrated into the Hungarian Railway Museum have so far come to nothing, reportedly due to a lack of funds. Today, the Red Star Train Graveyard lies between a working mainline and a depot serving modern Swiss-built electric trains. It is very much out of bounds. Urban explorers must evade security guards and pick their way through a jungle of weeds to gain access.

Inside, collapsed chunks of the roof rest atop the wagons. There are empty pigeonholes in the parcel trains, rotting timbers in express coaches, boilers that have been cold for decades. One of the oldest engines in the shed is a MAV-326 – a design dating to 1892 and the heyday of Austria-Hungary – its pistons now knotted in creepers. For most urban explorers, however, the holy grail is the MAV-424, its smokebox still adorned with the Communist Red Star from which the graveyard takes its name. It would have likely trundled on the mainline during the Hungarian Uprising in 1956, rolling to the twilight of steam in Europe, which more or less coincided with the end of Communism.

An unsubstantiated legend goes that some wagons parked at the Red Star Train Graveyard were used to transport Jews to concentration camps during the Second World War. It seems hard to prove but easy to see how the sight of empty wagons conjures up associations with the darkest days of Central European history.

Visitors inside the shed report hearing the rumble of modern trains travelling northbound from Nyugati Station, onwards to Prague, Bratislava and the great cities of the Danube. These are the living blood vessels that still keep the European continent pulsing with life. Their sounds make a visit to the Red Star Train Graveyard more poignant – to see great machines once synonymous with progress, power and perpetual motion reduced to perfect stillness.

1. Trees can be found sprouting under the fraying roof of the old workshop.

2. A decaying MAV-301, dating back to 1911, which was once in use across Hungary and Romania.

A vast mausoleum to steam power, where leviathan engines rust in sidings

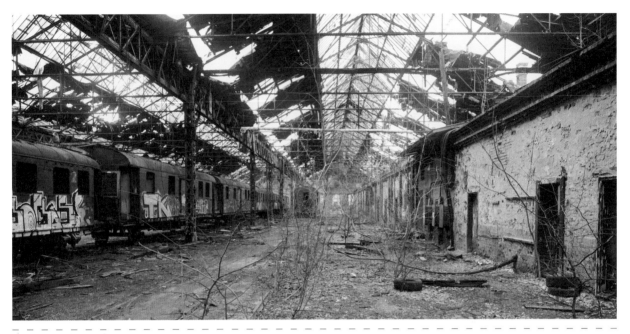

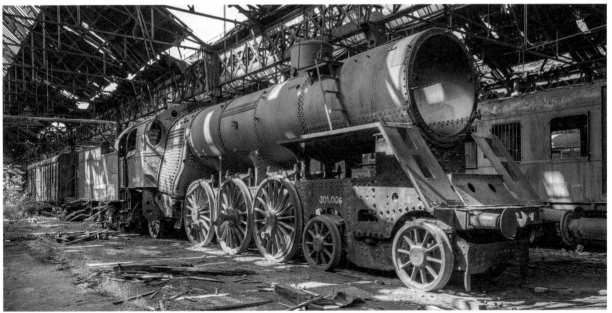

Pyramiden

78° 39' 21.96'' N, 16° 20' 32.1'' E

SVALBARD, NORWAY

A Soviet coal-mining town high in the Arctic Circle

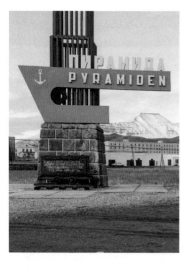

Pyramiden is a town that has – in a very literal sense – become frozen in time. It lies in Svalbard, the frosty frontier of the inhabited world, about 1,050km (650 miles) from the North Pole. Svalbard is an Arctic territory where polar bears outnumber people, where the sun is absent from mid-November until mid-January, and where temperatures commonly plunge to -20°C (-4°F).

And it is a political anomaly: though Svalbard technically counts as Norwegian soil, it is a demilitarized zone and free economic area. It is both a no-man's land and a land for all-comers. The Americans, Dutch, French and Danes have, at various points in history, kept bases on Svalbard for activities like whaling and walrus hunting. In 1927, the Soviet Union purchased the mining town of Pyramiden from the Swedes. The town was named for the pyramid-shaped mountain that looms over the streets, which to some frostbitten sailor might have once conjured up the balmy air of Giza.

After the Second World War, the Soviets set about transforming Pyramiden into a modern coal-mining centre. It had immense propaganda value: an example of a Communist utopia within the West. At its peak, it was home to 1,000 residents, with a school, a swimming pool and a cultural centre where a projector beamed movies to rapt audiences.

Left: A sign welcomes visitors to Pyramiden, with a single symbolic coal truck beneath.

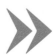

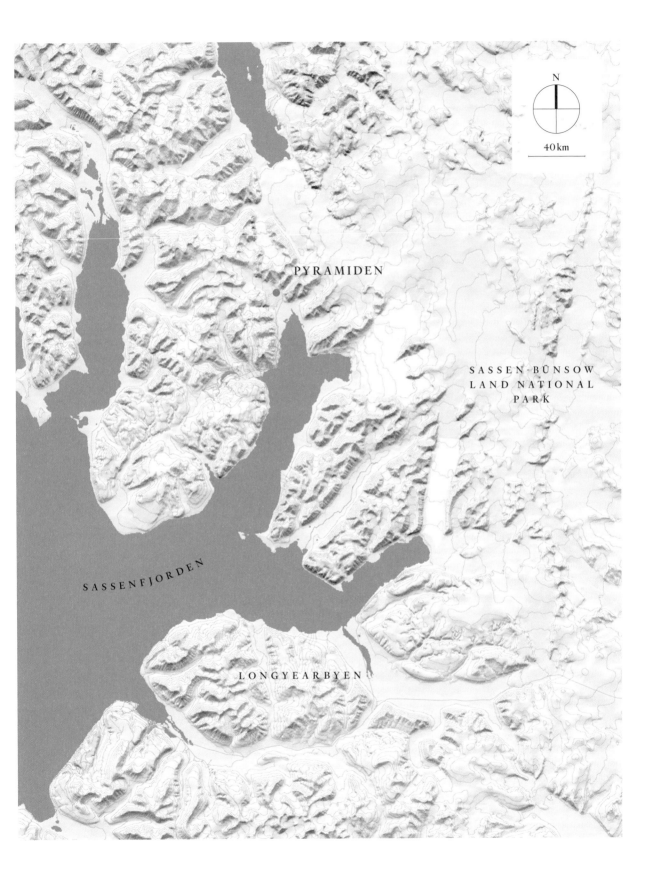

N

40km

PYRAMIDEN

SASSEN-BÜNSOW
LAND NATIONAL
PARK

SASSENFJORDEN

LONGYEARBYEN

At other times, the world's northernmost grand piano was ceremonially wheeled onto a stage. A bust of Lenin proudly surveyed a verdant lawn, grown on soil imported from the Ukrainian Soviet Socialist Republic – Arctic soil being too thin for growing anything much. During winter, when sea ice cut Pyramiden off from the world, resident cows and chickens kept locals supplied through the interminable January darkness.

Pyramiden survived the collapse of the Soviet Union, but in 1996 disaster came. A charter flight from Moscow to Svalbard crashed into a mountain on approach to Svalbard's capital Longyearbyen, causing the deaths of 141 passengers, many of them workers and their families from Pyramiden. Lawsuits from bereaved relatives, low morale and the growing expense of extracting coal led to the decision to close Pyramiden's mines – and with them the town – in 1998.

Pyramiden shares two common characteristics of abandoned places: it is both a relic of a fallen ideology, and it was built to exploit resources that can no longer be profitably extracted. What is more unusual is its remote latitude, which has saved it from redevelopment, demolition and, to some degree, the very worst of vandalism. The cold, too, has slowed the pace of decomposition.

In some parts, visitors might imagine they can hear the footfalls of departing comrades. There are balls on the basketball court. The film projector is loaded with reels. Yellowing sheet music for Verdi's *Falstaff* lies on an upright piano, now out of tune. A toy Santa Claus watches over an empty kindergarten. In truth, Pyramiden is not entirely abandoned: seabirds nest on the window ledges of old dormitories, arctic foxes skip about mining equipment and polar bears sometimes plod the streets.

In the past decade, Pyramiden's Soviet hotel has reopened to cater for a growing number of tourists who wish to see the town for themselves as part of an organized tour. It seems to have a powerful hold on the imagination. Perhaps it speaks to our current concerns: showing a world we can recognize, abandoned to an uninhabitable climate.

Pyramiden survives as a kind of museum to Soviet hopes and dreams, high on the roof of the world. But perhaps the strangest survival here is the lawn. Although it is no longer mowed, grass still springs to life from the Ukrainian soil every summer as the winter snow melts.

1. The docks flying the Norwegian and Russian flags, from where coal was once exported south.

This is a town that has – in a very literal sense – become frozen in time

Salpa Line

60° 57' 49.428'' N, 27° 49' 35.148'' E

FINLAND'S EASTERN BORDER

Second World War defences slowly lost to the boreal forests

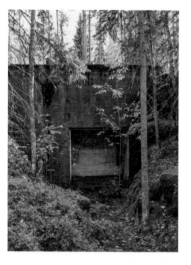

Left: Vahtivuori cave, equipped with a lookout position and a machine gun emplacement.

The story of 20th-century Europe is one of mighty defensive walls. France constructed the Maginot Line in the 1930s to defend its border against Germany; the Germans reciprocated with the Siegfried Line. The Cold War saw the rise and fall of the Berlin Wall, while Cyprus, Northern Ireland, the Balkans and elsewhere saw borders defined by barbed wire and concrete. Finland's Salpa Line is far longer than all of these defensive systems and yet it remains relatively little known. It is a strange legacy of the Second World War: an abandoned rampart through wilderness forests, to the continent's Arctic frontier.

The Salpa Line owes its existence to Finland's complex role in the Second World War – three conflicts as far as Finns are concerned. First came the Winter War: Stalin's invasion of Finland in 1939. Fierce battles raged as temperatures sank as low as -40°C (-40°F). The Finns held back the numerically superior Soviets, thanks to guerrilla tactics and their manoeuvrability on skis. The Winter War ended with a peace treaty in 1940. However, Finnish leaders suspected the Soviets of plotting a second invasion and set about the construction of the Salpa Line (translated as the 'Locking Bolt Line'), intended as a means of bolting a door shut on their enemies to the east.

RUSSIA

SWEDEN

SALPA
LINE

FINLAND

GULF OF BOTHNIA

HELSINKI

GULF OF FINLAND

200 km

N

Stretching some 1,200km (745 miles), the Salpa Line would guard the border from the Gulf of Finland to the Barents Sea. It remains to this day the biggest construction project in Finnish history, with some 35,000 civilians assembling over 700 bunkers, 225km (140 miles) of anti-tank systems and 300km (186 miles) of barbed wire. Finnish suspicions were well founded. A second Soviet invasion in 1941 began the Continuation War, when Finland allied with Nazi Germany and besieged Leningrad, before the signing of a second peace treaty with the USSR in 1944. There followed a third war – the Lapland War – with Finland expelling former German allies. Throughout these conflicts, battles raged to the east of the Salpa Line but it never saw action. It remained military property until the 1980s, still guarding a faultline between East and West.

Today, sturdy installations meant to halt Soviet tanks have also halted the effects of the passing years. For the most part, the Salpa Line has proved too robust and too troublesome to demolish. In one or two places, defences have become museums: the Salpa Line Museum in Miehikkälä has artillery pieces, while the Bunker Museum in Virolahti sees visitors descend into subterranean rooms.

A 50-km (31-mile) walking trail runs between these two museums, and here you can get a sense of the rest of the Salpa Line as it exists today – a place uncurated, abandoned to the boreal forests and the march of summer suns and winter snows. Rows of concrete pillars that once formed tank traps are swathed in mosses and lichens, resembling a Finnish Stonehenge. Brave souls might pack a torch and venture into abandoned bunkers, accessed by creaking metal doors, their firing holes trained onto nothing more sinister than pine, spruce and birch. Here and there are unfinished caves, where wounded troops from the battlefront were intended to rest and recuperate.

Though it didn't see action, the Salpa Line became a symbol of Finland's struggle for survival – a little country, isolated between global superpowers. The appeal of a visit today is a different kind of isolation. Anyone can walk among the trees and find themselves alone with the birdsong and battlements that have only ever known peaceful days.

1. A Salpa Line gun emplacement fashioned from a Soviet B5-5 tank.

2. Salpa Line defences in the woods in South Karelia.

An abandoned rampart travelling through wilderness forests up to the continent's Arctic frontier

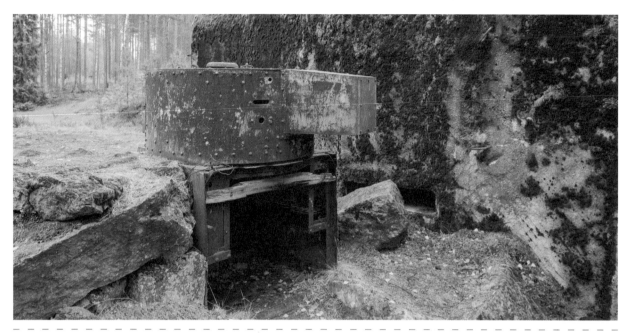

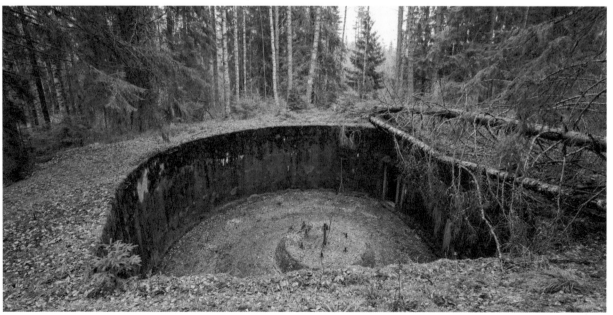

Buzludzha Monument

42° 44' 9.132'' N, 25° 23' 38.58'' E

CENTRAL BULGARIA

Space-age Communist architecture, atop a remote Bulgarian mountain

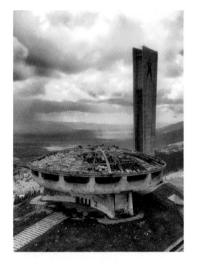

Communism and religion were never happy bedfellows. But standing inside the dazzling central hall of the Buzludzha Monument – the hammer and sickle glittering on the dome above – it feels like a building destined for a spiritual purpose, less like a monument to Communist glory, more an intergalactic temple.

The Buzludzha Monument is a ruin of unrivalled strangeness. It sits at the top of the eponymous 1,400-m (4,600-ft) high mountain at the centre of Bulgaria – a summit that featured at key turning points in the nation's history. In the 19th century, its slopes saw battles for Bulgarian independence against Ottoman rule. It later became a secret meeting place for the country's first Marxists.

With the advent of the Eastern bloc, Buzludzha was a point of pilgrimage for Bulgarian communists. In 1959, a competition was held to design new monuments to mark the mountain's historical importance. A young architect, Georgi Stoilov, won with a futuristic design influenced by modernists such as Walter Gropius and Le Corbusier, seasoned with the science fiction of the 1950s. Stoilov also cited inspiration from the Pantheon in Rome, the two-millennia-old Roman temple at the heart of the Eternal City.

Left: An aerial view of the Buzludzha Monument and the tower whose illuminated stars were once visible from afar.

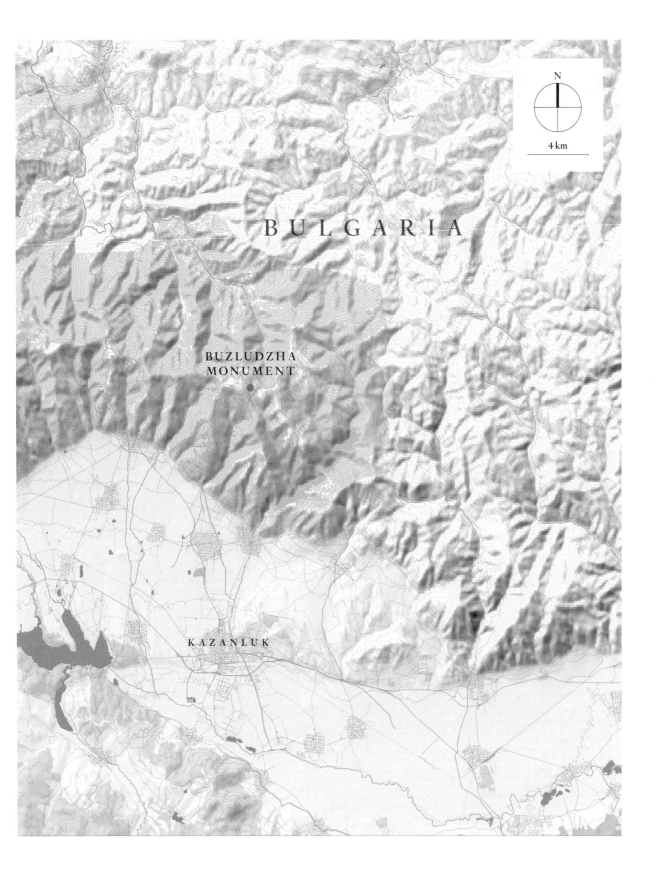

BULGARIA

BUZLUDZHA
MONUMENT

KAZANLUK

N

4 km

The interior was adorned with dazzling mosaics depicting Communist leaders. Outside, a 70-m (230-ft) high tower was crowned with illuminated red stars, said to be visible from the borders of Greece and Romania. The structure took seven years to complete and opened to much fanfare in 1981. Bulgaria's Communist leader Todor Zhivkov presided over the ceremony, announcing, 'May the paths leading here to this legendary peak...never overgrow!'

The monument was in use throughout the 1980s, serving as a venue for Communist Party events and award ceremonies. But within a decade, Zhivkov's nightmares of overgrown paths were realized. After the collapse of the Eastern bloc, the security guards patrolling the site were dismissed, the building was ransacked and its copper roof looted. Abandoned on the mountaintop, it has continued to disintegrate ever since, while becoming one of the holy grails of urban exploration.

A steep road snakes to the mountaintop and the monument abruptly appears, looking almost monastic perched up among the clouds. Stepping inside, a rubble-strewn stairway leads up to the observation deck, where Communist dignitaries once promenaded and looked down on the motherland in warmth and comfort. Today, the glass is gone and Balkan winds whip furiously about the corridors.

Those winds gust in the central hall, too. Here, the Buzludzha Monument has accidentally incorporated another design element of Rome's Pantheon: its roof has cracked open to the sky. Rain pours into the auditorium, and snowflakes settle on the seats where dignitaries used to sit. Watching over the scene are the mosaic portraits of revolutionaries: Marx, Engels and Lenin face off against Bulgarian leaders Dimitâr Blagoev and Georgi Dimitrov, still vivid despite a few missing pieces. Absent from their ranks is Todor Zhivkov, whose face was chipped off by countrymen ashamed at his abuses of power.

Buzludzha has now been decaying for more than three-quarters of its lifetime: its contested past and remote location have meant its bold architecture has been overlooked. Only in recent years has this started to change. Heritage groups and the Bulgarian government have expressed an interest in restoring the monument. Tellingly, for the first time in almost three decades, a security guard now patrols the site.

1. The building's observation deck seen on a winter's day.

A futuristic design influenced by modernists such as Walter Gropius and Le Corbusier

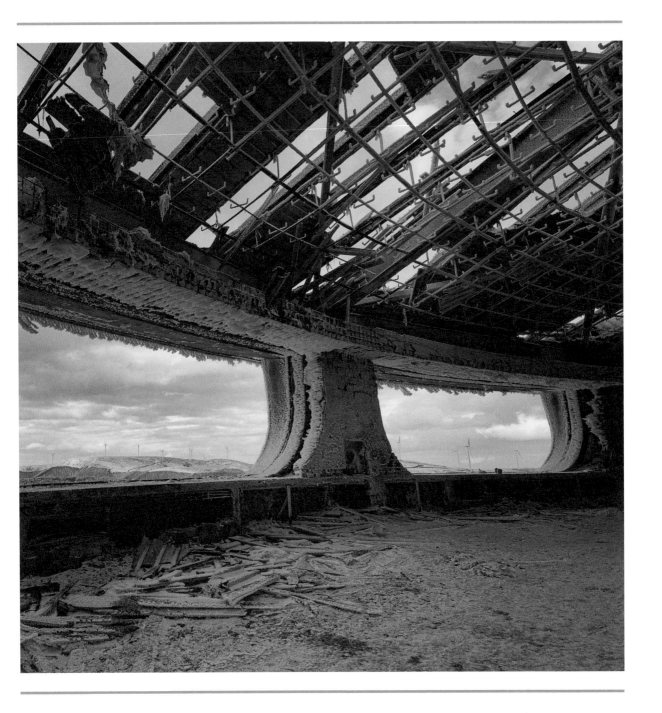

Pripyat

51° 24' 18.72'' N, 30° 3' 13.356'' E

NORTHERN UKRAINE

A town uninhabitable for 20,000 years

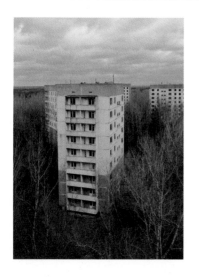

Cities and towns bounce back from disasters. Hiroshima today is a thriving modern metropolis. Dresden's baroque majesty has been restored. Dubrovnik lures in countless tourists. Pripyat in Northern Ukraine might be an exception. Decades after it was abandoned, it remains a town with no prospect of recovery. Its trauma continues because, to some degree, Pripyat's disaster is ongoing. At the time this book went to press, this disaster had entered an entirely new nightmarish dimension.

Left: An abandoned city; blocks of high-rise apartments and residential buildings in Pripyat.

The town lies in the Chernobyl Exclusion Zone – a largely uninhabited area about the size of Luxembourg – whose 1986 evacuation has led it to be called a 'post-human' landscape. When threats like nuclear warfare and climate change challenge us to imagine a planet without *homo sapiens*, it is Pripyat that normally steps up as an example: a museum of our own extinction.

Founded in 1970, Pripyat was a prosperous, modern Soviet town of 50,000. It had 15 primary schools, a Palace of Culture, a railway station and 3 indoor swimming pools. Tower blocks housed the families of workers at the Chernobyl nuclear plant, located 3km (1¾ miles) away. For 16 years, the rhythms of Soviet life went on uninterrupted – including on Saturday, 26 April 1986, when a fire raged at the nuclear power plant.

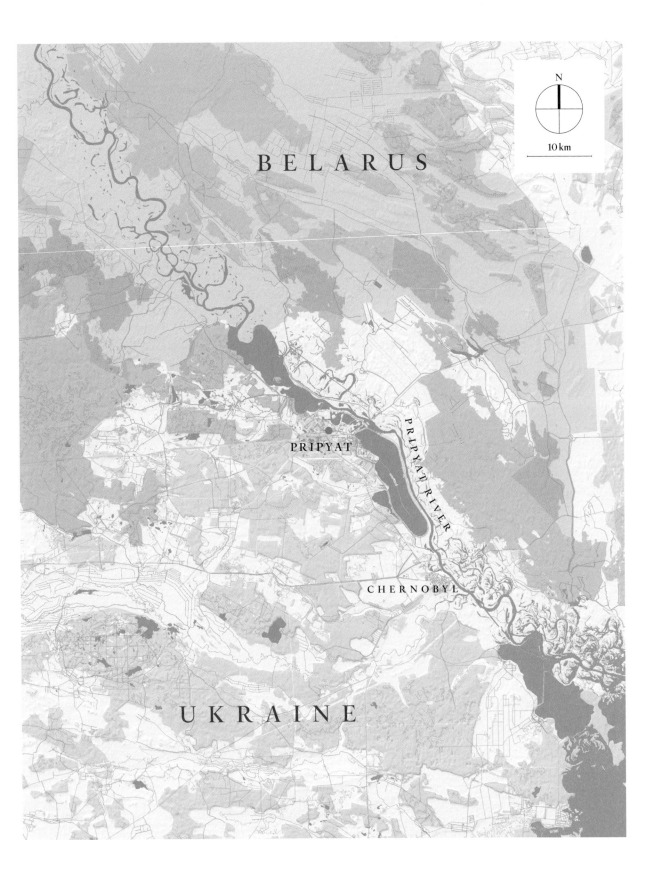

BELARUS

N

10 km

PRIPYAT

PRIPYAT RIVER

CHERNOBYL

UKRAINE

While plumes of smoke rose into the sky, wedding celebrations took place in Pripyat, the town's football team warmed up for a match, locals went fishing, children ate ice cream in the mall, and a funfair made preparations to open the next week. As Saturday drew on, it became clear something had gone wrong. Citizens came to the local hospital, complaining of headaches and a metallic taste in their mouths.

At 11am on 27 April, buses arrived to evacuate Pripyat – citizens were ordered to leave with no possessions. The clocks stopped dead at the time the electricity supply was cut. Pripyat has for decades been a still image of the Soviet Union that Sunday morning in spring. It counts as one of many abandoned relics of Communism but, unlike Pyramiden (see page 42) or Buzludzha (see page 50), it is curiously tied to one moment in history. In that respect, it is a modern Pompeii.

For some years before the Russian invasion of 2022, Pripyat had a thriving tourism industry. Radiation had been low enough to allow guided groups to take short tours. For most visitors, the enduring symbol of the town is the funfair – the Ferris wheel rising over rusting dodgems. The town's derelict swimming pool and the murals in the Palace of Culture were also popular stops. Dedicated urban explorers went off-piste, sometimes to apartments or buildings with a greater risk of exposure. Here, it was often the smaller details that made Pripyat's last days more vivid: a cash till, dolls in a kindergarten or a yellowing school book, ready for a Monday lesson.

The age of the internet saw Pripyat intensely photographed and documented. If this documentation showed anything, it is how rapidly the footprint of mankind fades. Pictures of the same site over a single decade show wallpaper fraying, trees bursting through tarmac. Set against this decay, the Chernobyl Exclusion Zone blossomed into a wildlife haven, with growing numbers of boars, wolves and lynx.

Radiation from Chernobyl has taken many lives – fallout is expected to render the area uninhabitable for around 20,000 years – but the ruins of Pripyat, too, have their own peculiar half-life. The still image of the town on a Sunday morning in spring can still be seen, but its finer details are becoming lost to wind, rain and scavengers, both human and animal. At the time of writing, war too was making a mark on this landscape.

1. The 'Azure' swimming pool in Pripyat – previously used by the people who cleaned up Chernobyl in the years after the accident.

2. Pripyat's Palace of Culture once boasted a cinema, theatre, library, gymnasium, swimming pool, boxing ring, and dancing and meeting halls.

Pripyat remains a town with no prospect of recovery

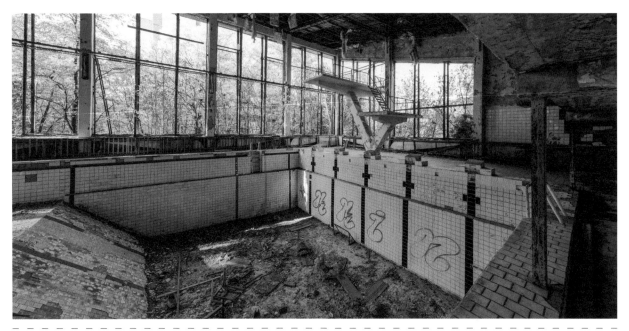

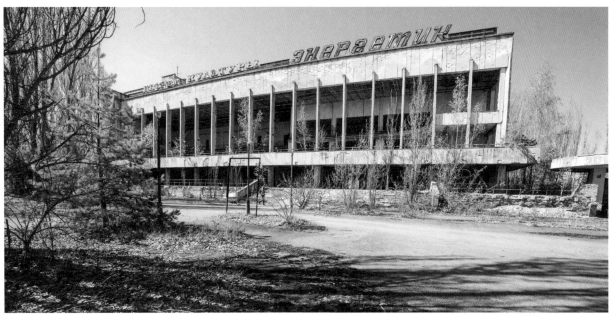

Wolf's Lair

54° 4' 50.88'' N, 21° 29' 39.192'' E

MASURIA, POLAND

Hitler's greatest hideout, deep in the forests of Poland

On first impressions, it might be hard to argue that the Wolf's Lair counts as an abandoned place. At the entrance is a little restaurant serving schnitzels, a hotel with potted plants in the window, a car park where tour buses idle. Beyond the ticket booth, however, is an unconventional tourist attraction. The Wolf's Lair was Hitler's largest command centre in Poland for much of the Second World War but it was deliberately destroyed by the Nazis as the Russians advanced and lay neglected through decades of Communism.

Left: Trees sprouting among the abandoned bunkers at the Wolf's Lair.

Today, it exists as a series of concrete monoliths crumbling in the Polish woods – many at topsy-turvy angles, their surfaces swathed in mosses, with young trees sprouting in the cracks. Dark tunnels lead to collapsed rooms, while ladders ramble off to nowhere in particular. Signs in various languages warn weakly of the dangers of climbing the ruins. Its abandoned state owes less to its location, more to its moral ambiguity. Its past makes it too problematic for it to be restored or conserved – but it is also too significant to be ignored.

Hitler gave himself the nickname 'Herr Wolf', and he kept a number of different headquarters across Nazi-occupied Europe – in Belgium, they were called 'Wolf's Gorge'; in Ukraine, his hideout was codenamed 'Werewolf'.

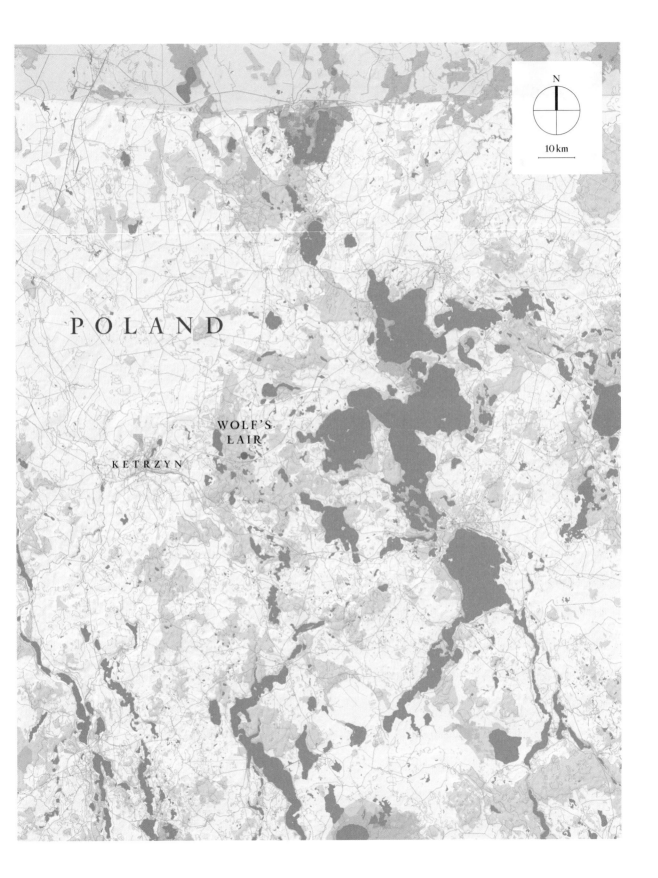

Wolf's Lair was built in 1941 to coincide with Operation Barbarossa, Hitler's planned invasion of Russia. Served by a little railway line, the base was deliberately hidden in the forests, its bunkers cloaked by netting and fake trees to avoid detection by passing planes. Its existence remained unknown to the Soviet Union until the war was almost over.

From 1941 to 1944, Wolf's Lair was Hitler's main residence. The Führer would spend mornings walking with his German shepherd, and his daytimes in operations rooms. Evenings were idled away in his quarters listening to Wagner and Beethoven on the gramophone, that is until the Battle of Stalingrad (1942–3), after which he is said to have no longer listened to music.

To sentries on the watchtowers, the base must have seemed impregnable. The threat was to come from within: on 20 July 1944, Colonel Claus von Stauffenberg led a conspiracy to assassinate Hitler at the Wolf's Lair, leaving a briefcase packed with explosives in a conference room. The ensuing blast killed four but Hitler emerged without serious injuries. Von Stauffenberg was caught and executed in Berlin the following day. Today, a stone inscription stands on the foundations where the briefing room stood, where, for one moment, world history almost changed direction.

The concrete bunkers are the main survivors at the Wolf's Lair. Hitler's personal bunker is the largest on the site, with its western face now cracked, but Field Marshal Göring's bunker is the best preserved – some visitors have scrambled up onto the roof, where anti-aircraft emplacements point out at birds' nests in the trees.

The Wolf's Lair is perhaps the most significant architectural relic of Hitler's personal presence, the place where his ghost looms largest – the Berghof in Bavaria has since been destroyed, and the Berlin bunker where he took his life is also long gone. Recent proposals to renovate the Wolf's Lair and host reenactments have been controversial. Many locals are content for roots and branches to envelop the site and slowly undo the structures – in an act of catharsis by nature.

These forests surrounding the Wolf's Lair are equally intriguing. Poland claims some of the last great tracts of primeval woodland in Europe, and you can sense how the entire continent might have been before the swing of the settler's axe. The region serves as a vital habitat for bison and lynx. Not far from the bunker are places where real wolf packs patrol the forest.

1. The interior of Hitler's personal bunker.

2. A building used by Third Reich secretaries to record notes on meetings.

3. Göring's personal residence in the Polish forest.

Perhaps the most significant architectural relic of Hitler's personal presence

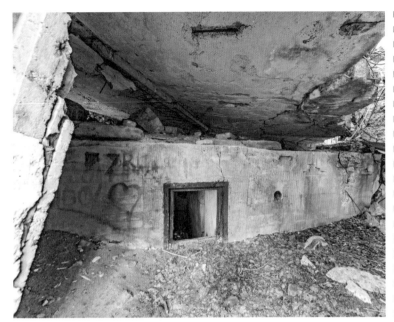

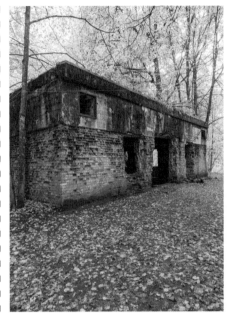

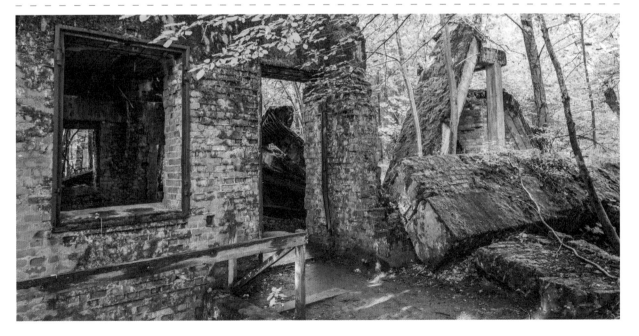

Project Riese

50° 50' 32.244'' N, 16° 17' 30.948'' E

LOWER SILESIA, POLAND

Hitler's enigmatic subterranean lair

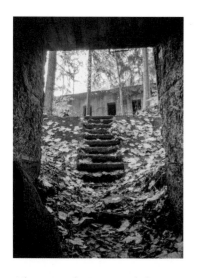

Left: Steps at the Osówka complex, south of Książ Castle.

It was a news story stranger than fiction; in 2015, Piotr Koper and Andreas Richter informed the Polish government that they had located a 'Nazi Gold Train' in the countryside near Książ Castle, western Poland. The train had allegedly been driven into a secret complex of tunnels during the last days of the Second World War, loaded with treasures – gold, jewellery, perhaps even works by Old Masters – from the cities and palaces of Eastern Europe. Years of excavation and exploration ensued but no train has been found. Some historians say that it is indeed fiction, a pseudo-historical fantasy. But there is one undisputed element of truth in this tale: around Książ Castle lies a vast tunnel network built by Nazi Germany in its dying days. With the codename Project Riese, meaning Project 'Giant', its purpose remains the subject of ongoing debate. About these gloomy tunnels swirl the most sensational conspiracy theories connected to the Third Reich.

Project Riese comprises not one but seven tunnel systems under Poland's Owl Mountains, which may have originally intended to link up with each other. Construction began in 1943, a time when Germany was suffering bombing raids from Britain and faced a resurgent Soviet Union, and infrastructure was being moved below ground.

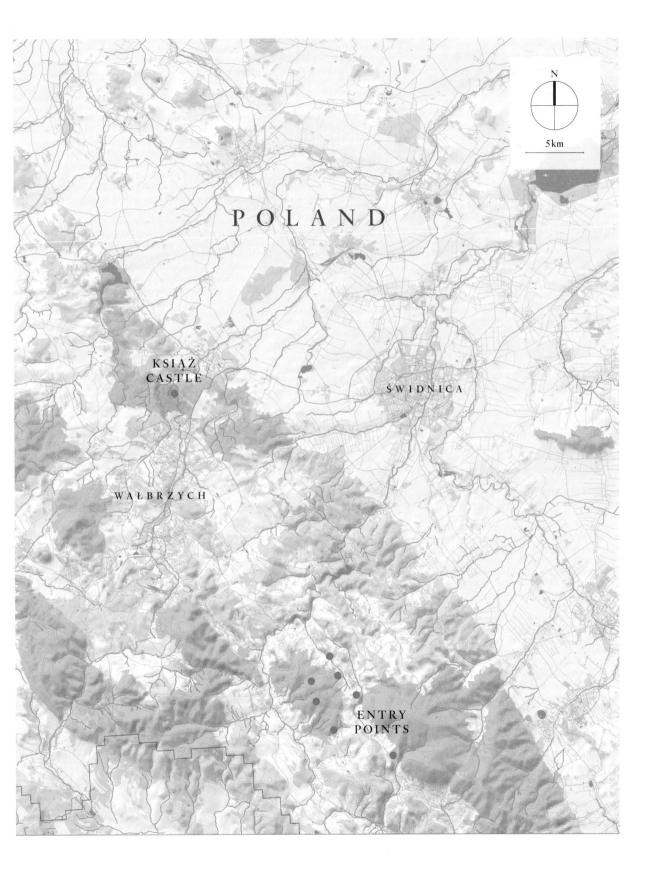

New railway lines supplied the site with building materials, as forced labourers and POWs blasted through the strata of gneiss. Hitler's advisors warned him that the network was a drain on resources – it cost almost five times as much as Wolf's Lair (see page 58) – but he remained undeterred. By 1944, construction was reassigned to prisoners from concentration camps, including Auschwitz. Amid typhoid epidemics and lethal working conditions, an estimated 5,000 of the recorded 13,000 workers perished. At the close of the war, the tunnels spanned a little under 100,000 cubic metres (130,000 cubic yards), just under half their planned extent.

Today, parts of the abandoned complex are open to tourists, many of whom have been seduced by rumours of the gold train. At the centre of the publicity is Książ Castle, a majestic fortress of 13th-century origins, seized by the Nazis and connected to a subterranean lair by a lift and staircase. Here, tourists can walk 1.5km (1 mile) of the abandoned network, which has reinforced concrete walls and evacuation shafts. Hitler's chief architect, Albert Speer, insisted Project Riese was meant to be a home for the Führer himself. Seeing the magnificent halls and salons of Książ Castle above ground, this seems plausible.

Another possible explanation is that Project Riese was to serve as a secret military manufacturing centre – some speculate for the development of nuclear and experimental weapons. The wildest conspiracy theorists link Project Riese with the so-called 'Nazi Bell', a time-travel machine or anti-gravity device (of which no evidence exists). Others have dwelled on the 'henge' at Ludwikowice, a circle of columns close to the tunnels, which internet forums cite as a landing site for UFOs (or, in much less exciting interpretations, just a cooling tower).

What is clear is that nothing came of Project Riese. Urban explorers and those on guided tours see much the same things they would in any mine: the remnants of narrow-gauge railways, flooded sections and blocked passages. Much is made of the possibility that there may still be undiscovered sections of Project Riese, which could yet hint at its true purpose. Less is made of the thousands of lives cut short here, for no discernible purpose at all.

1. Tunnels in the Osówka complex, part of Project Riese.

2. Underground sections of Włodarz near the town of Walim, part of Project Riese, have been converted to a museum.

3. Mighty reinforced passageways in the Osówka complex.

4. The medieval Książ Castle, beneath which lie some of the Project Riese tunnels.

Project Riese comprises not one, but seven tunnel systems under Poland's Owl Mountains

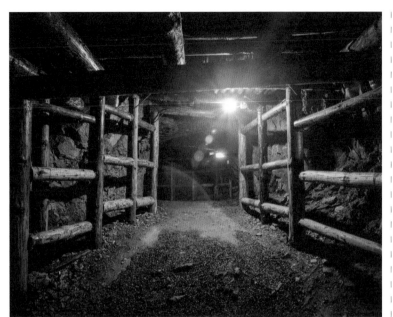
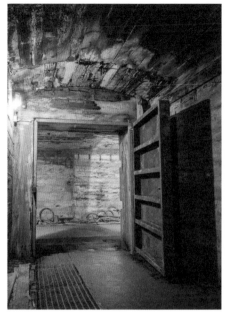
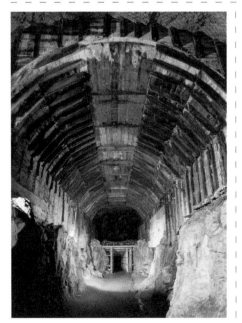
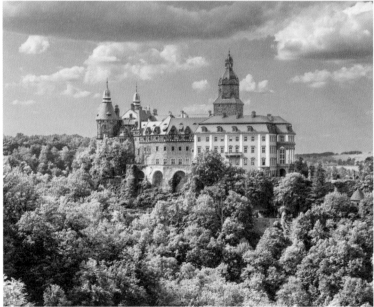

Sarajevo Bobsleigh Track

43° 50' 24.864'' N, 18° 26' 36.456'' E

SARAJEVO, BOSNIA AND HERZEGOVINA

A relic of the Winter Olympics, in a city struck by tragedy

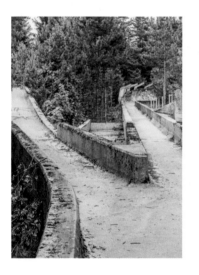

In February 1984, Sarajevo was a place of jubilation. The Winter Olympics were opening in a Communist country for the first time. Dancers filled the city stadium, and athletes thronged the streets. The Olympic torch had proceeded through the Yugoslav Republics of Slovenia, Croatia, Montenegro and Serbia to blaze proudly over the Bosnian capital. Sarajevo's crowning glory was its new bobsleigh track, which snaked through the wooded slopes of Mount Trebević, high above the city. Some 30,000 spectators cheered as Yugoslavia entered its first bobsleigh team, and groaned as East Germany scooped up the medals.

Left: A junction by one of the start houses – where bobsleigh teams once began their descent.

Within a decade, the Winter Olympics had become a distant memory. The Yugoslav republics through which the torch had travelled were now themselves aflame in a series of civil wars. From 1992 to 1996, Sarajevo was besieged during the Bosnian War – the bloodiest conflict in Europe since the Second World War – with ethnic Serbs and Bosniaks contesting the capital. The same mountain geography that had made it the perfect site for the 1984 Winter Olympics made it an ideal vantage point for snipers and artillery. Serb forces created artillery positions along the bobsleigh track.

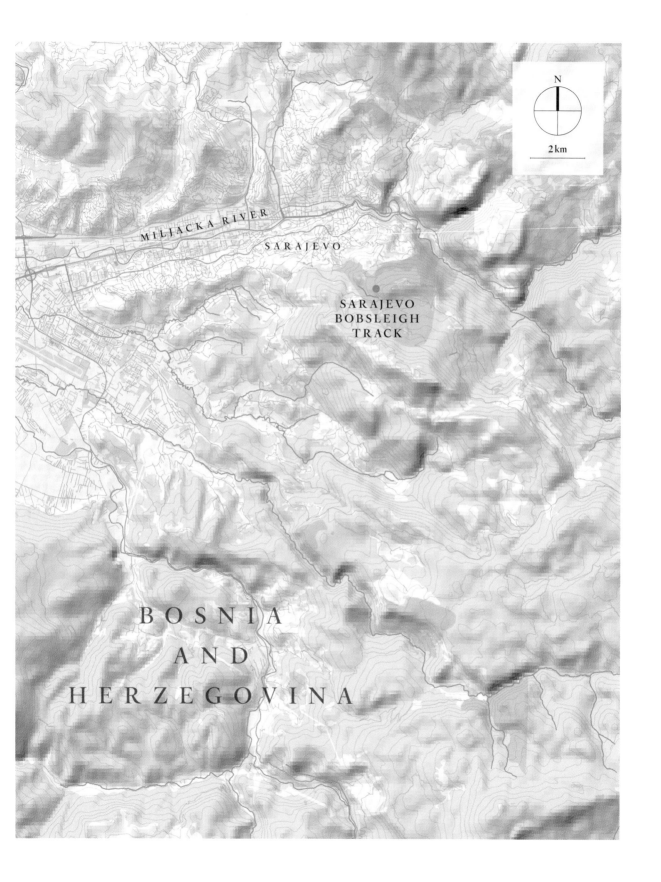

MILJACKA RIVER

SARAJEVO

SARAJEVO
BOBSLEIGH
TRACK

BOSNIA

AND

HERZEGOVINA

N

2 km

Today, the bobsleigh track lies abandoned, pockmarked by bullets. It is part of a long tradition of derelict Olympic sites: Athens, Rio and other cities have struggled to find new purposes for facilities after the world's attention has moved on. But Sarajevo's bobsleigh course has a uniquely powerful resonance. It is a bittersweet reminder of the city's previous life before the bloodshed.

The trackbed is extensive, twisting and turning for some 1,300m (1,422 yards), incorporating 13 turns, and subdividing into beginner, intermediate and fast sections. The start houses, where bobsleigh teams readied for their descent, are in ruins, and the floodlights are gone. The course has become a street art gallery of wall paintings, from a modern-day rendering of Klimt's *The Kiss* to nostalgic depictions of Vučko, the cartoon wolf that was the mascot of the 1984 games and endured beyond the war as a beloved icon of Sarajevo.

With the construction of a new cable car up Mount Trebević, the course has become popular for weekend strolls through a tunnel of greenery. Where bobsleighs once barrelled down at 100kph (62mph), Bosnian couples now dawdle at a leisurely pace, listening to their footsteps on the leaf litter and to the birdsong in the trees. During the Siege of Sarajevo, the slopes of Trebević were covered in landmines. Most have now been cleared, but the bobsleigh track still guarantees safe passage through the woods.

A brittle peace endures in Bosnia. Following the 1995 Dayton Agreement, the country is split into two autonomous entities: the largely ethnic Croat- and Bosniak-inhabited Federation of Bosnia and Herzegovina, and the largely ethnic Serb-inhabited Republika Srpska. Though the bobsleigh track is set in the former, the border between the two entities runs just a few hundred metres to its west.

In recent years, efforts have been made to restore the track: the lower portion has been repaired to function as a luge training course, with wheels running on concrete, rather than steel runners on ice. Paradoxically, a course originally built for the Winter Olympics now only comes alive in summer.

Some locals have expressed wishes to restore the track's refrigeration systems, so bobsleighs can thunder down once more in winter. They say it would be an impressive winter sports asset, to combine with the ski slopes that already slalom above the city's rooftops. And you sense that, in some small way, it might re-create that distant day when the world's eyes were on Sarajevo, for all the right reasons.

1. Leaf litter lines the course, which is swathed in street art.

The bobsleigh course has become a street art gallery of wall paintings, from a modern-day rendering of Klimt's *The Kiss,* to depictions of Vučko

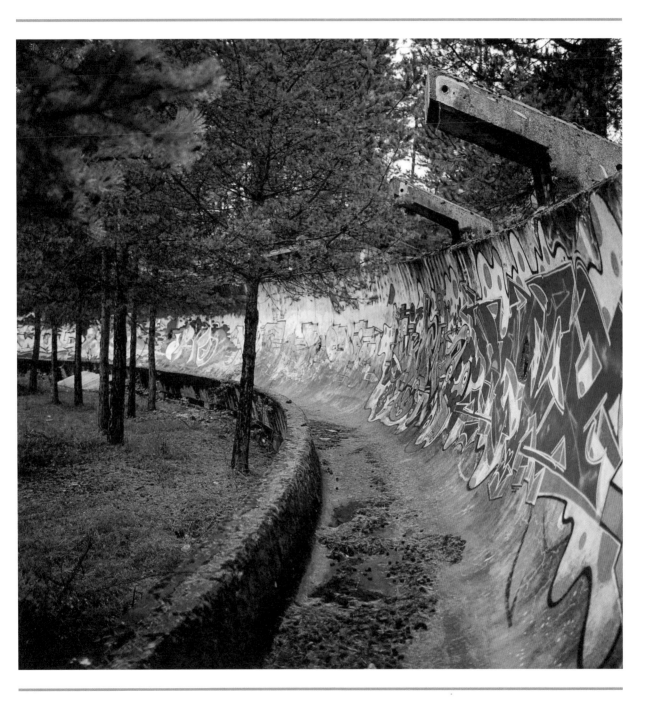

Albanian Bunkers

41° 19' 40.476'' N, 19° 49' 11.1'' E

THROUGHOUT ALBANIA

Hundreds of thousands of bunkers guard the Balkan nation

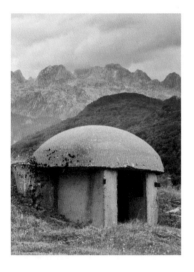

The Albanian QZ bunker is, at first glance, a pretty unremarkable piece of engineering. A concrete-and steel-built dome, it is big enough for one or two soldiers to fit in. It is about the size of a garden shed and superficially resembles any derelict pillbox you might find on the beaches of Normandy or Norfolk. Nonetheless, the creation of these bunkers counts as one of the strangest episodes in European military history because of the staggering number of them strewn across the little Balkan country. Some estimates put the figure at 175,000, while other projections reach a mighty 700,000, but numbers are notional because, really, there are too many to count. They inhabit cities and villages, back yards, schoolyards, railway yards and vineyards. They seem less like a planned addition to the landscape and more like a kind of Old Testament plague wrought on the country. Rarely in Albania are you ever out of sight of a bunker.

Albania was isolated throughout much of the Cold War, allied with neither NATO, the Eastern bloc nor its non-aligned neighbour Yugoslavia. It was briefly an ally of Maoist China before going its own way as a diplomatic pariah in the Balkans. Much of this was down to Albania's dictator – Enver Hoxha – a man as eccentric as he was cruel.

Left: Bunkers can be found high in the Dinaric Alps, on the border with Montenegro.

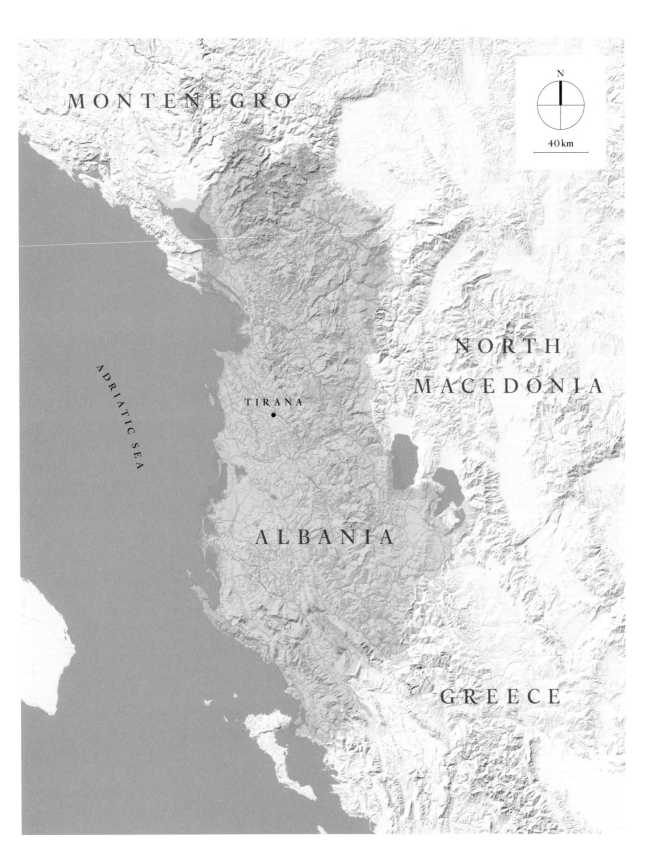

Paranoid that his country would be invaded from all sides and subverted from within, he embarked on the policy of 'bunkerization': the mass construction of bunkers, into which local people could rally to defend their homeland at a moment's notice. Built from the 1960s through to the 1980s, the bunkers were the focus of regular drills by civilians (who were ordered to keep them tidy). The small QZ bunkers reported to far larger PZ bunkers, which in turn were dwarfed by subterranean defence installations across the country. Albanians joke that there were far more bunkers than soldiers or, indeed, rifles to fire from them.

Hoxha died in 1985, and with him died the philosophy of bunkerization. Ironically, only after he was dead did they serve any practical purpose. Some on the northern border were used by civilians to shelter from shelling during the Kosovo War, and a small number briefly saw action in the Albanian Civil War of 1997, sparked by the failure of pyramid schemes. But the overwhelming majority never saw a shot fired in anger. Albania is one of Europe's poorest countries, and the bunkers have mostly proved too expensive and robust to remove. They endure today as a strange legacy of Hoxha's paranoia.

To a visitor, the bunkers appear with comic regularity: they greet you on the thoroughfares of the capital Tirana, watch over you from the lawns of your hotel and sunbathe alongside you on the sands of the Albanian Riviera. You can climb the loftiest summits of the Dinaric Alps – far from people and towns – and still find bunkers waiting for you up among the snow. Eventually, like most Albanians, you stop noticing them. They are as much a feature of the landscape as trees, houses, roads and cars.

Their existence has not been entirely sinister. A few have been adapted as small houses, chicken coops, garden sheds, mushroom farms, beehives, beach bars and even a sort of glamping pod. Many have had a street art makeover and are adorned with floral motifs and smiley faces. There have been suggestions to convert bunkers into solar farms and even pizza ovens. Most, however, will stay abandoned. In an often-repeated line, Lonely Planet founder Tony Wheeler once wrote: 'Albanian virginity is lost in a Hoxha bunker as often as American virginity was once lost in the back seats of cars.'

1. A bunker beside Lake Ohrid, on the border with North Macedonia.

The bunkers are as much a feature of the landscape as trees, houses, roads and cars

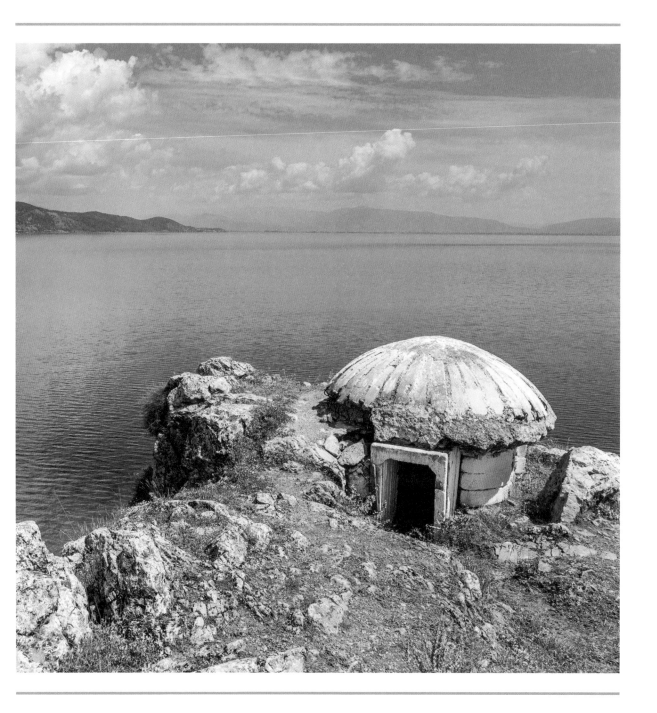

Rummu Quarry

59° 13' 44.004'' N, 24° 13' 33.204'' E

VASALEMMA, ESTONIA

A Soviet prison submerged in a flooded quarry

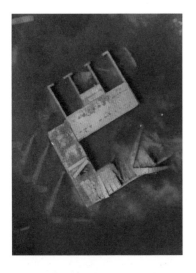

On summer weekends, Lake Rummu could be considered an Estonian riviera. Children splash in the shallows; sunbathers bronze themselves on the rocky shores. The water has the colour not of the dark Baltic, a few miles to the north, but the dreamy azure of the Caribbean. Beach balls, bikinis and Speedos are a strange postscript to Estonia's troubled history that dates back to the country's darkest years.

Murru Prison was founded when Estonia was under Soviet rule. In 1938, up to 400 prisoners were put to work mining Vasalemma limestone – a rock with similar properties to marble, used to create gravel. In time, the prison evolved from wooden huts to more substantial concrete structures. By the 1970s, limestone deposits were no longer so economical, so a vocational school was added to the complex, with prisoners ordered to do metalwork and woodwork.

Estonia became fully independent from the Soviet Union in 1991, and forced labour was deemed morally unacceptable. The machinery that had pumped groundwater from the empty quarry to supply surrounding farms was switched off. Incrementally, the quarry turned into a lake, submerging structures where inmates had once toiled.

Left: An aerial view of the flooded vocational school.

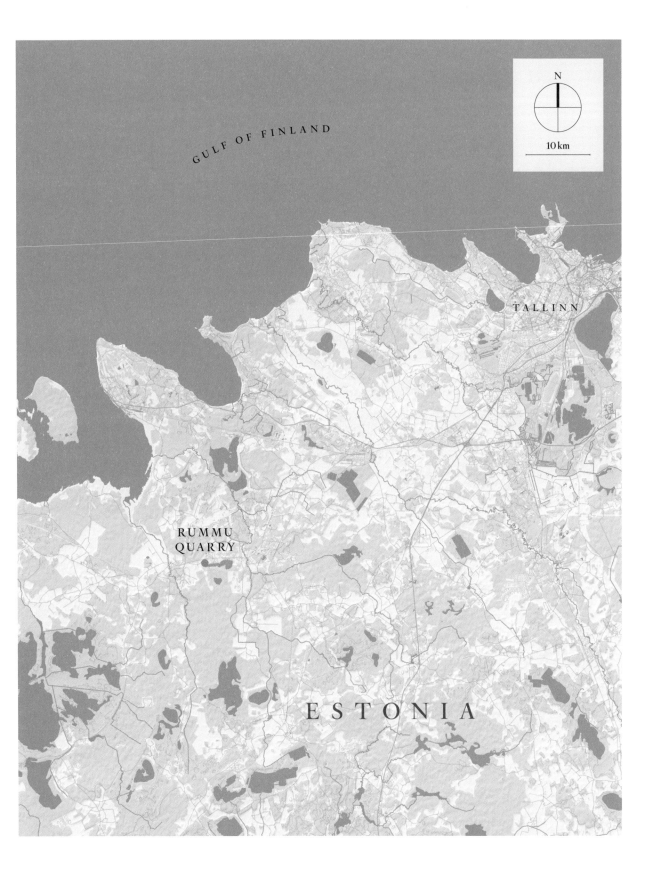

In 2012, the surviving part of Murru Prison was shut down and visitors began to creep into the site, to charter the murky fathoms of Soviet history.

Some remains of Murru Prison stand on dry land at the north shore of the lake, but they are still guarded by barbed wire and floodlights, with watchtowers surveying overgrown yards. But the underwater part of the prison is more extraordinary. Experienced divers swim through the murky interiors of the old vocational school, passing doorways where weary prisoners once stepped and barred windows through which they might once have wistfully pondered freedom. Divers' photographs also depict underwater floodlights, submerged stairways, heaps of discarded bricks and rubble. Equally surreal is a forest of dead trees under the lake, their leafless branches appearing to strain towards the sunlight. Scuba divers can descend to depths of up to 14m (46ft), often with excellent visibility.

There are other ways to explore the lake and prison. Kayakers paddle out to the protruding structures, others scale or abseil from the surrounding limestone cliffs to get a better view. In summer, people like to dive from the concrete as if it were a sea cliff; in winter, skaters have been known to glide over the ice-bound lake. Like many submerged buildings across the world, changing water levels can reveal more of their past, bringing sunlight to stones that have been under water for decades or else drowning them for years at a time. Lake Rummu is a minor, modern addition to the tradition of drowned buildings and submerged cities, and a mythology of flooded places stretching back to Genesis in the Old Testament and the *Epic of Gilgamesh*.

Though only a few decades old, Lake Rummu shows how swiftly memories of the past dissolve underwater: equipment is rusted beyond recognition, signage and paintwork are gone. It takes some effort to imagine inmates hatching escape plans while gliding silently over the perimeters that once enclosed them. Estonia's time under Soviet rule was fraught with repression and tyranny. Perhaps there is a kind of relief in seeing some of its finer details washed away.

1. Limestone cliffs rise above Lake Rummu, with the remains of the old prison buildings, some of which are now underwater, on the right.

Lake Rummu is a minor modern addition to the tradition of drowned buildings and submerged cities

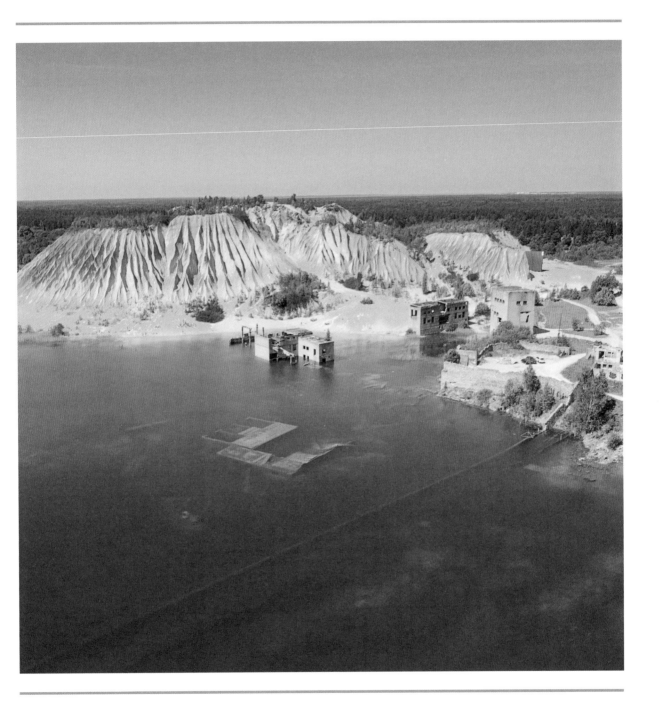

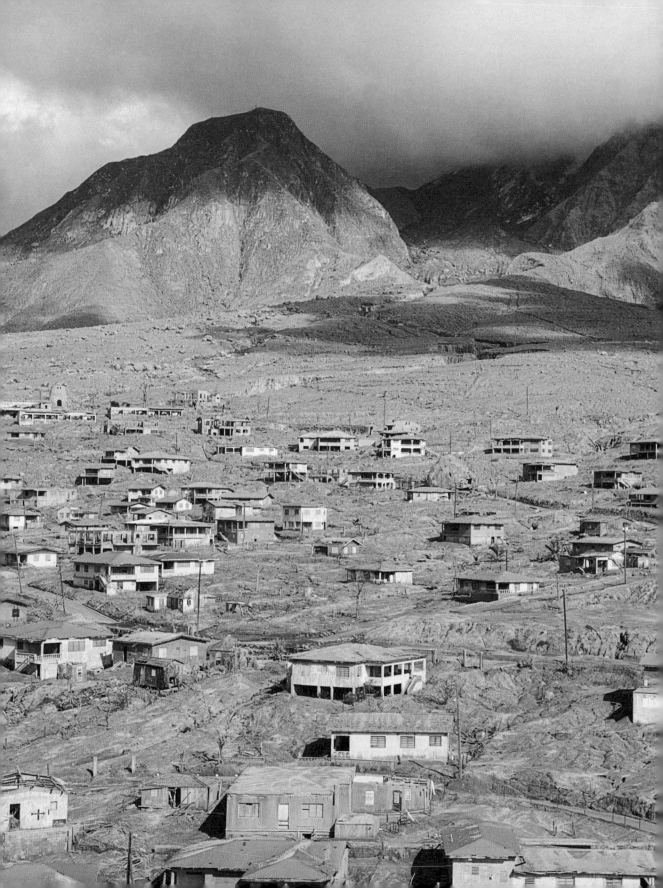

The Americas
& the Caribbean

New Bedford Orpheum Theater

41° 37' 5.34'' N, 70° 55' 12.576'' W

NEW BEDFORD, MASSACHUSETTS, USA

A historic theatre on which the curtains closed

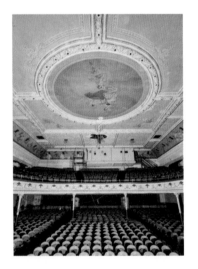

Left: An allegorical fresco watching down over the auditorium.

Abandoned theatres have a powerful resonance: there is a quiet tragedy in buildings that once traded on laughter and applause, reduced to stillness and silence; in architecture that retains its aura of anticipation long after any spectacle has left the stage. Most likely it is the sight of so many empty seats that makes their abandonment seem so acute. The United States has not a few abandoned theatres from a golden age before multiplex cinemas. One of the grandest of them all is the Orpheum Theater of New Bedford, Massachusetts.

The Orpheum Theater opened on 15 April 1912, the date the *Titanic* sank. As rescue operations mounted in the Atlantic, the citizens of New Bedford would have been milling excitedly about the theatre's marble staircases, ready to claim one of 1,500 seats beyond. The theatre was part of a grand Beaux-Arts building owned by the French Sharpshooters Club, a benevolent organization, which also housed a rifle range, a ballroom and a gymnasium. It stood at the heart of the whaling city – the bas-relief faces of Greek muses looked down from the facade to trolley cars that rattled along the street.

The theatre was leased to the Orpheum Circuit, a chain of popular entertainment venues that attracted a wide variety of people, which originated in California.

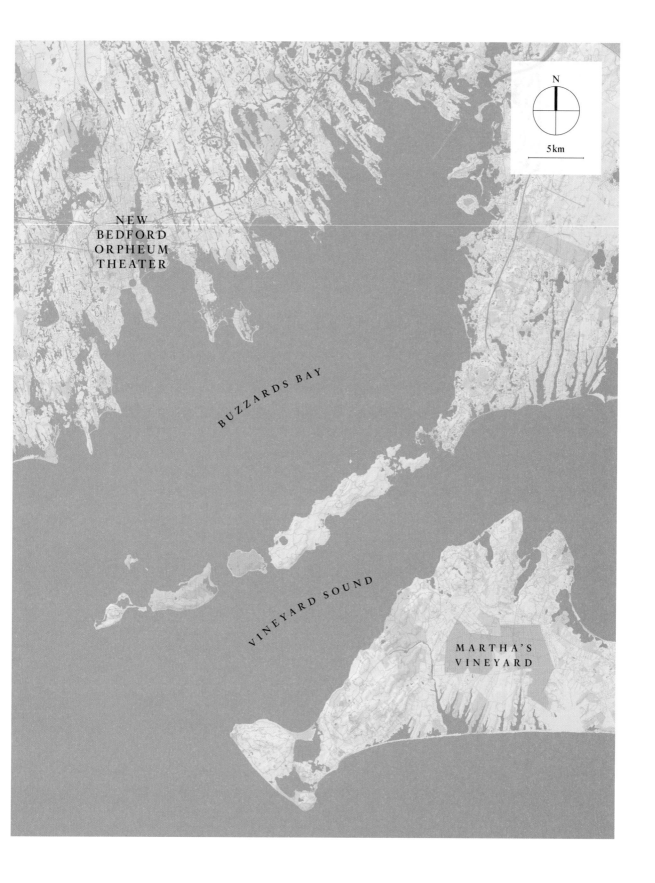

Central to its success was Martin Beck, who proclaimed that the mission of his theatres was to 'bring the highest forms of art within reach of the people with the slimmest purses'. The vaudeville performances put on here spanned comedy, sketches and songs, while among the performers on the Orpheum Circuit were W C Fields, the Marx Brothers and Harry Houdini.

As times changed, so did the forms of entertainment. Cinema screens were installed as the Orpheum Circuit eventually evolved into the movie studio RKO, whose films included *King Kong* and, most notably of all, *Citizen Kane*. Audiences would have watched Second World War newsreels as the army practised at the French Sharpshooters Club rifle range. It was in the late 1950s that the theatre closed its doors for the first time. In later years, a supermarket took up residence at the back of the building. A highway now whooshes past the facade, the motorists barely noticing the divine gaze of the muses.

Inside, the building retains the splendour that wowed its first audience hours after the *Titanic* slipped onto the seabed. There are honeycomb-tile floors, stucco patterns, and crossed gun heraldry symbolizing the French Sharpshooters Club. High on the ceiling of the auditorium is a faded fresco of cherubs among wispy clouds, and a lyre held by female figures; backstage, there are ladders, winches and switches. The furniture in the dressing rooms, where stars would have once prepared, is worn. In most pictures, dust and droppings shroud everything, but its lustre still shines through.

A group of activists plan to help restore the Orpheum Theater to its bygone majesty and create a multipurpose venue for the citizens of New Bedford. At the time of writing, they are fighting plans from a property developer to turn much of the complex into apartments, which, in their words, would turn the auditorium into a 'carcass'. For now, it feels like the theatre is to New Bedford what Rosebud was to *Citizen Kane* – a once-prized possession that invited childlike wonder and fantastical escape. It can only be hoped its true value is realized before it is too late.

1. The Orpheum takes its name from Orpheus: a legendary musician and poet of Ancient Greece.

The building retains the splendour that wowed its first audience

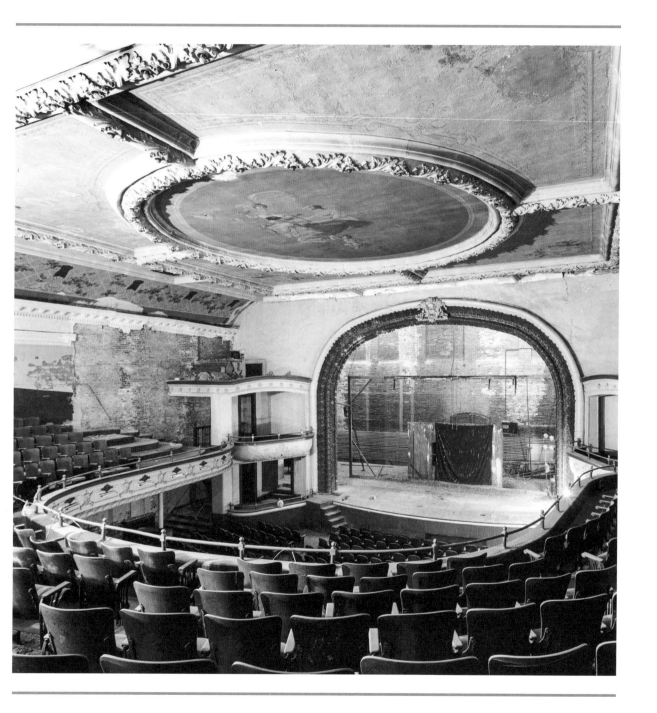

City Hall Station

40° 42' 49.392'' N, 74° 0' 24.12'' W

NEW YORK CITY, NEW YORK, USA

A sleeping beauty beneath Manhattan

Thursday, 27 October 1904 was a momentous day in the history of New York City. It marked the unveiling of the Interborough Rapid Transit, a 14-km (9-mile) long underground railway running from City Hall Station, past Grand Central Station, Times Square and Central Park up to 145th Street. By the late 19th century, London, Berlin and Boston already had their own subway systems but New York was lagging behind. It was to catch up in style. Two hundred policemen were called to hold back the curious crowds, and the Mayor of New York took the controls of the inaugural train. He had so much fun he refused to hand them back to the driver.

Left: One of the soaring skylights at City Hall Station, which open into the grounds of New York City Hall itself.

Since that first journey, New York's subway has extended its tentacles across the Harlem River to the Bronx, and over the East River to Queens and Brooklyn. It now serves 472 stations, the most of any subway in the world. But, by an accident of fate, the station from which that very first train departed is no longer among this number – it is merely a stretch of track through which subway trains still rattle but no passengers disembark.

Located under Manhattan's City Hall, it was one of the grandest and most opulent subway stations in New York City, indeed in the world. At the time of its unveiling, New York's streets were traffic-clogged and strewn with horse manure.

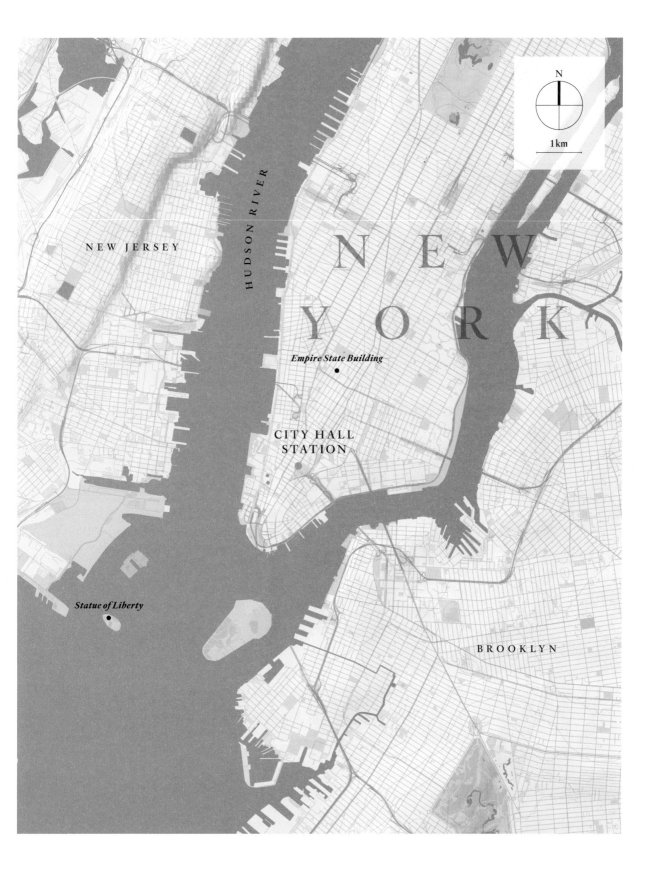

N

1km

HUDSON RIVER

NEW JERSEY

N E W

Y O R K

Empire State Building
•

CITY HALL
STATION

Statue of Liberty
•

BROOKLYN

Some elevated railways yielded mixed results, and a bizarre pneumatic underground railway hadn't progressed beyond one novelty station. City Hall, then, had to be a statement of serious intent. Built in the Romanesque Revival style, it featured brass chandeliers and ornate tiled ceilings. For passengers beneath its vaults, the atmosphere was almost ecclesiastical – some bought a ticket from the oak booths, only to stand dumbstruck on the platform without boarding a train. A bronze plaque marking its opening was produced by Gutzon Borglum, the sculptor and creator of the American presidents' faces at Mount Rushmore, South Dakota. Here was a station fit for a nation departing into the new century.

As the demand for the subway grew, so did the length of the trains. City Hall Station, however, proved too short to accommodate these longer services – and too close to the much busier Brooklyn Bridge Station to be considered for redevelopment. Through the Roaring Twenties and the days of the Great Depression, City Hall Station fell out of fashion. By 1945 it was permanently shut.

Since then, skyscrapers have soared across Manhattan, but City Hall Station has remained a sleeping beauty beneath the city that never sleeps. Only occasionally visited by guided tours, it has struggled to find a new purpose. It was once considered as the home for the New York Transit Museum and, in the 1980s, it was briefly touted as a restaurant. Its spirit, at least, has been much evoked: City Hall Station provided the inspiration for the Teenage Mutant Ninja Turtles' lair.

There are one or two telltale signs of the station's presence above ground, notably the skylights in the grounds of City Hall, which were blacked out with tar during the Second World War. But the best view to be had is from the 6 and <6> trains when they reach their terminal at the modern Brooklyn Bridge/City Hall Station, transiting through the old station as they trundle from the southbound to the northbound platform. For one fleeting moment, passengers can glance to the right and see City Hall Station as it might have appeared to the eyes of a top-hatted passenger long ago: shining tiles and chandeliers – a subterranean palace of urban transport. This view lasts for a few seconds, and is gone again.

1. The curved platform at City Hall Station, which proved too short for modern trains.

A stretch of track through which subway trains still rattle but where no passengers disembark

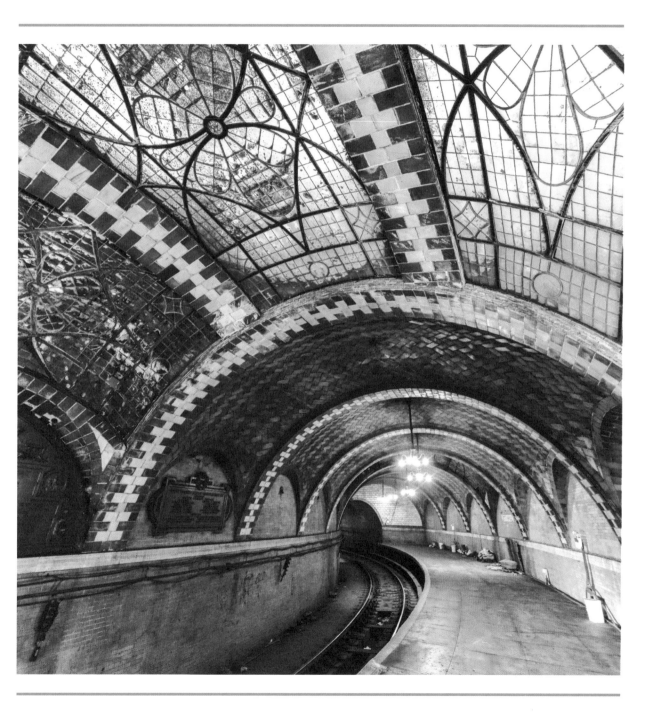

Bodie

38° 12' 44.712'' N, 119° 0' 51.3'' W

CALIFORNIA, USA

A pocket of the Old West preserved among the sierras

The term 'ghost town' has associations with one particular place and time: the American West of the 19th century. It summons up images of rickety timber saloons with silent pianos, of tumbledown cemeteries and broken wagon wheels, of clouds of dust roaming streets where nothing else stirs. All these things can be found in Bodie. Perhaps the most evocative of America's many ghost towns, its frontier spirit has endured long after the West lost its wildness.

Bodie lies on the easternmost edge of California, on a high-altitude plateau between the lush green valleys of Yosemite and the deserts of Nevada. It was named after the New York prospector W S Bodey, who struck gold nearby in 1859. Later that year, W S Bodey had the misfortune to perish in a blizzard not far away, never to see his namesake town thrive nor, indeed, to see his name accidentally misspelled.

The 1870s saw Bodie transformed from a sleepy backwater to a boomtown with the discovery of even bigger gold deposits. Bullion from the town's mills was dispatched by rail to San Francisco. At its peak, Bodie had 10,000 residents and around 250 buildings. It boasted a bank with a stately neoclassical facade, two churches and – quite remarkably – some 65 saloons into which prospectors piled with their earnings.

Left: A 1937 Chevrolet Master Deluxe Coupe – abandoned when Bodie was already long past its prime.

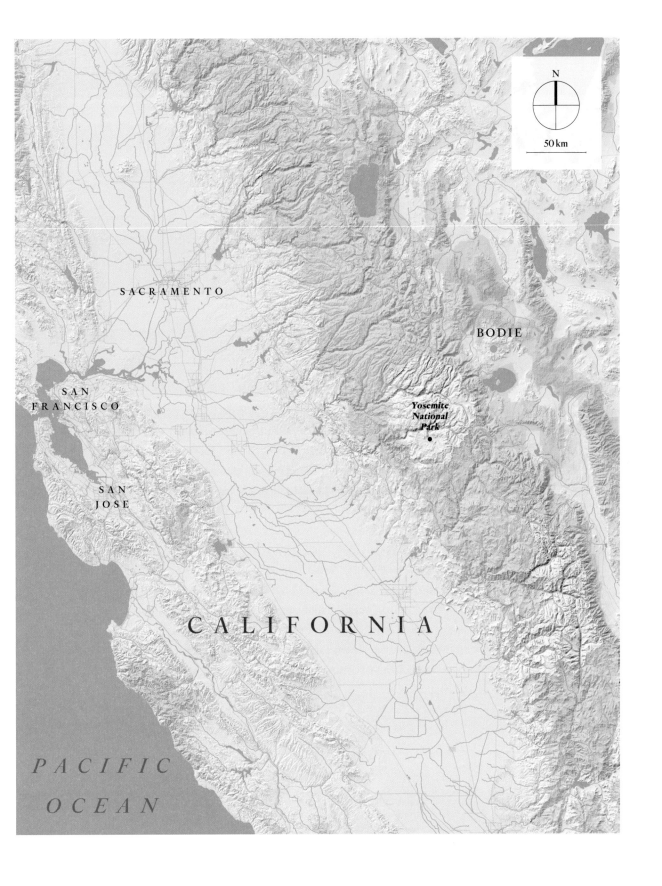

Out of these saloons flowed much of the carnage synonymous with the wildest days of the Wild West. Gunfights and brawls gave Bodie a fearsome reputation and fodder for breakfast table newspapers across the United States. Reports went that residents would inquire every morning: 'Have we a man for breakfast?', which was a way of asking if anyone had been murdered the previous night. Miners also frequented the many brothels, as well as the gambling joints and opium dens of Bodie's Chinatown (which, in a more wholesome corner, had a Taoist temple).

The beginnings of Bodie's decline had set in by the 1880s, and it was wholly abandoned in the 1940s. By then, many structures had been lost to fires, and the town was a shadow of its former self. In 1962, Bodie was designated a State Historic Park, and ordered (with some foresight) to be preserved in a condition of 'arrested decay', meaning its buildings would essentially be suspended in their dishevelled state. This means the town survives as a time capsule of the wild frontier, its authenticity diminished by neither restoration nor vandalism.

It can sometimes feel like the last residents left in a hurry, just as the first of the day's visitors arrived. A 1937 Chevy Coupe rusts in the long grass, having no wheels on which to escape. The Fire House is at the ready with hoses and ladders. In the saloons, you can find billiard tables and roulette wheels. Intimate details can be found in the houses, too: hurricane lamps, sewing machines, cupboards stacked with dusty dishes. They have been left alone: 'The Curse of Bodie' goes that objects stolen from the ghost town have brought tragedy and even death to their new homes. Items are still regularly returned to Bodie in the post, with notes of repentance from sorry thieves.

The town jail cuts a formidable presence. It was from here that a local murderer was snatched by the 'Bodie 601 vigilante group': '601' supposedly stands for '6 feet under, 0 trials, 1 rope'. Inside the Methodist church, a wood-burning stove sits in a corner, ready to banish the worst of the winter cold. To this day, winter snows mean that, from time to time, Bodie becomes inaccessible by road. One wonders how it must be for those rangers standing watch on white days when no one passes by – whether their thoughts turn to the ghosts of Bodie's past. Or, indeed, to the fate of W S Bodey himself, lost long ago in a blizzard in the Sierra Nevada.

1. The Swazey Hotel – a one-time clothing store and casino.

2. A workshop in Bodie in 'arrested decay'.

3. The Wheaton and Hollis Hotel – formerly the town's Land Office.

4. A living room, with the town's Methodist church visible from the window.

The town survives as a time capsule of the wild frontier

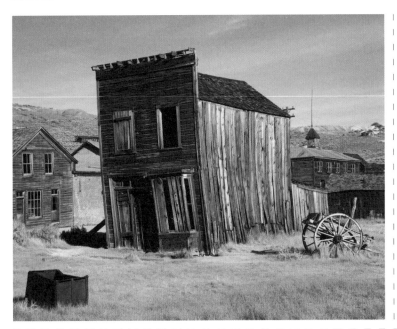

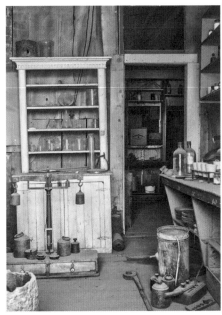

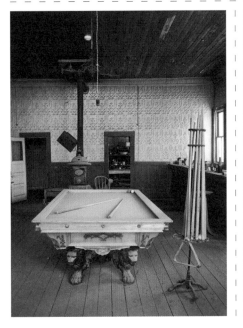

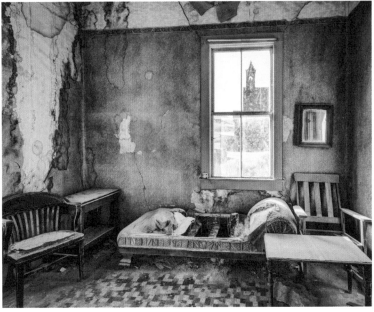

The Boneyards of Western USA

32° 10' 21.792'' N, 110° 51' 8.172'' W

TUCSON, ARIZONA, USA

Vast retirement homes for grounded planes

One side effect of the Covid-19 pandemic was the gigantic parking lots created for aircraft with suddenly no passengers or destinations to which to fly. Singapore Airlines and Cathay Pacific parked part of their fleet in the expanses of the Australian outback. British Airways and Lufthansa planes sat motionless among the arid highlands of Aragon, Spain. The homeland of the aircraft 'boneyard', however, is the western United States, where armadas of aircraft – machines big and small, military and civilian – have lined the deserts for decades. These storage facilities are a hypnotic sight: acre upon acre criss-crossed with aircraft, their wings and fuselages interlocking like a patterned quilt. Some planes are resting until their engines fire up again. Some have taken off for the last time, destined to spend their days in thrall to gravity.

Davis-Monthan Air Force Base outside Tucson, Arizona, is the aircraft storage facility for the American military and the largest boneyard in the world. Some 4,200 planes and helicopters are strewn across an unpaved desert measuring 10 sq km (4 sq miles). The location is no accident: minimal rainfall and low humidity mean they can be kept for years before corrosion sets in, on a base of hard soil that doesn't need to be tarmacked.

Left: A General Dynamics F-16 Fighting Falcon, with the cockpit painted white to deflect the sun.

PHOENIX

ARIZONA

PINAL
AIRPARK

TUSCON

DAVIS-
MONTHAN
AIR FORCE
BASE

The purpose of boneyards is twofold: to keep planes in reserve until they need to be reactivated – for instance, during wartime – or to cannibalize them for spare parts for working aircraft or scrap. Their state of managed abandonment – stripped of weapons, their inlets sealed with tape – makes for a curious sight. Helicopters have lost their rotors, while warplanes have been painted a priestly white to keep them cool.

Through the avenues of the airbase you can read the modern military history of the United States. There are the A-10 Thunderbolts that might have strafed Saddam's forces in Operation Desert Storm; F-4 Phantoms that could have soared over the Ho Chi Minh trail during the Vietnam War; the F-14 Tomcats that Tom Cruise flew in *Top Gun*. The B-52 Stratofortresses are the giants of the base, with about 100 parked at its southern edge. Most have been dismantled in compliance with treaties with Russia limiting the number of aircraft capable of delivering nuclear weapons. They are deliberately put on show, their wings and horizontal stabilizers unceremoniously chopped off, so passing Kremlin satellites can check on their remains. Famous planes have passed through the Davis-Monthan Air Force Base, too: the B-29s Enola Gay and Bockscar, which dropped atomic bombs on Hiroshima and Nagasaki.

On the opposite side of Tucson is Pinal Airpark– the world's largest civilian aircraft boneyard – where the Covid-19 pandemic saw planes from Jet Blue and Air Canada mothballed beside the runway, awaiting a renaissance in domestic travel. The giants of the air are not immune from the boneyard either: recent years have seen Qantas and United park their Boeing 747s in boneyards over the border in California.

Intensely policed, these facilities seem impregnable to urban explorers who might hope to climb inside the aircraft and flick old missile switches or thumb in-flight magazines. Instead, they are destined to be seen from bus tours or beyond barbed wire fences, the silhouettes of tails patterning the horizon, a thicket of landing gear rising from the dusty earth. Indeed, it is easy for anyone to inspect Davis-Monthan like Russian spies – the immensity of the site becomes evident on Google Earth. It is a strange vision. Planes that once spent solitary hours in the air are huddled inches from each other on terra firma, under blue desert skies that might recall days roving above the clouds.

1. An aerial view of Davis-Monthan Air Force Base, with the broken-up B-52 bombers visible to the south.

Acres upon acres of aircraft interlocking like a patterned quilt

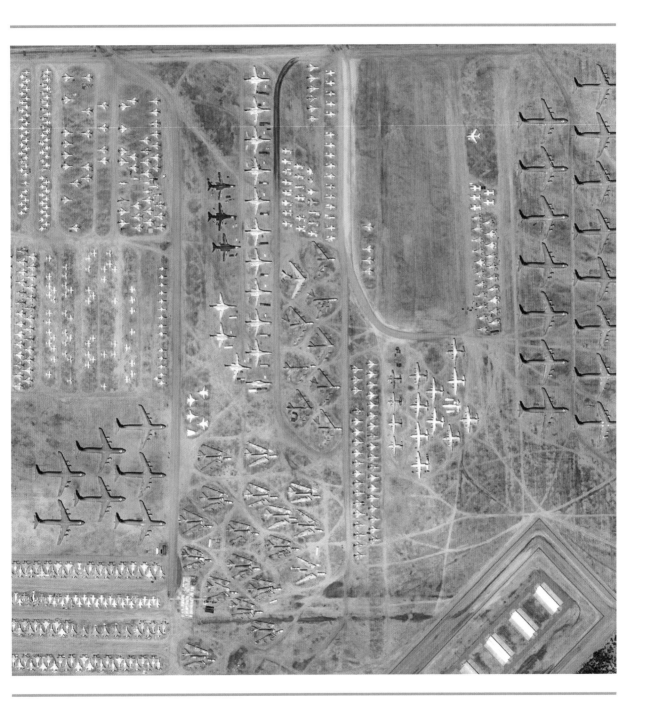

Bannerman Castle

41° 27' 19.728'' N, 73° 59' 19.608'' W

POLLEPEL ISLAND, NEW YORK, USA

A Scottish Highland castle upstream from New York City

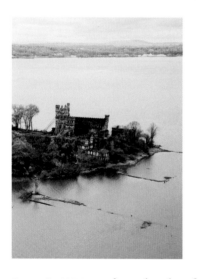

Left: Bannerman Castle on the shores of Pollepel Island, with parts of the submerged harbour just visible.

Upstream from New York City, the Hudson River takes on a different character. Gone are the skyscrapers and piers that define its southernmost sections. Instead, the river meanders lazily beneath the forested slopes of the Hudson Highlands. About 80km (50 miles) north of Manhattan, passers-by might do a double-take when they see a castle on an island in the Hudson, its architecture seeming to suggest European chivalry. The origin of Bannerman Castle is, however, one of strident American capitalism.

Francis Bannerman was three years old when he moved from Dundee, Scotland, to the United States in 1854. He showed a talent for business as a child, fishing scrap from New York dockyards to be refurbished and resold. He built a vast fortune as the proprietor of Bannerman's – 'the largest dealer in the world in military goods' – which was stocked with surplus items bought after the American Civil War and, later, the Spanish-American War. His inventory ranged from cannons and machine guns, to uniforms and Zulu warriors' spears, while his clients were as diverse as Buffalo Bill's Wild West Show and, it was whispered, rebel armies from all corners of the world. By the turn of the century, Bannerman had outgrown his store at 501 Broadway.

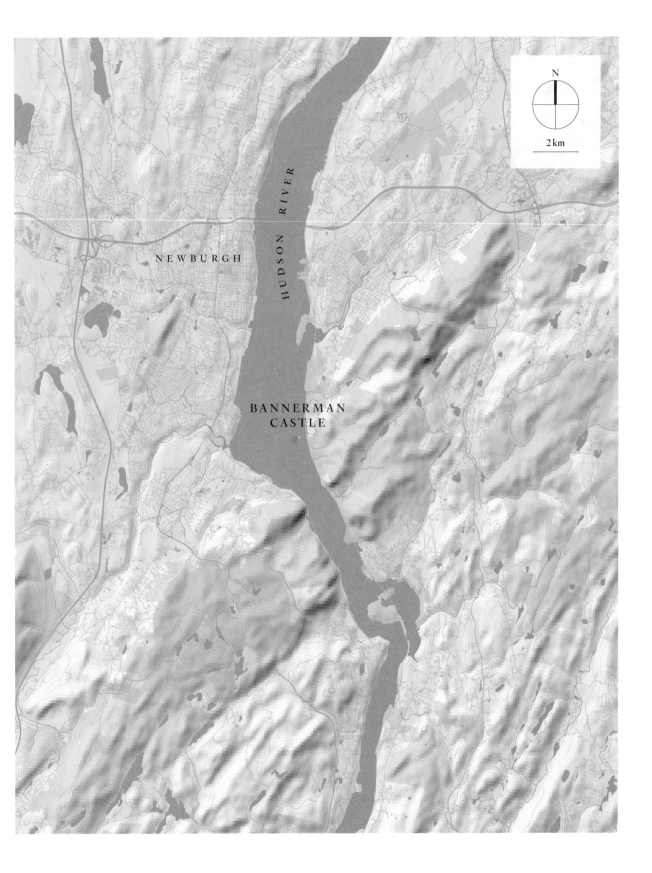

Additionally, the city of New York became uncomfortable with the thought of munitions stored at the heart of Manhattan.

Pollepel Island was believed to be haunted by Native American tribes but Bannerman's son took a more optimistic view when he paddled by on a canoeing expedition and suggested it as an ideal location for a new arsenal. Bannerman Castle was subsequently built as a storehouse without the aid of architects – labourers worked to designs sketched by the maverick arms dealer himself. Bannerman proclaimed descent from a warrior at the Battle of Bannockburn in 1314, and his castle was a New World evocation of Scottish baronial splendour, its moat lined with thistles. In the castle's shadow stood a family summer home, its fireplaces carved with biblical passages. The terraced gardens were lovingly tended by his wife Helen.

Bannerman Castle was, however, always destined to be a powder keg. Soon after Bannerman died in 1918, the powder house exploded, shattering windows across the river and narrowly avoiding killing his widow relaxing in a hammock nearby. By the 1950s, the business was in decline, and the castle was sold before being consumed by fire, which left only its stone exterior. In 2009, there followed a third collapse at Bannerman Castle, with a section of tower crumbling during winter snows.

Today, the remains appear less like a storehouse and more like an eye-catcher or folly commissioned for a stately home, with arrow slits framing the open sky. Coming closer, the once-mighty harbour is now visible only as turrets protruding from the current; the magnificent portcullis is swagged in greenery. The castle is a brittle shell propped up by steel supports installed by the Bannerman Castle Trust, though you can just discern the lettering 'Bannerman's Island Arsenal' emblazoned on the northern rampart. The Bannerman family home is in a much better condition, the terraced gardens once again thriving.

Many visitors still travel here aboard canoes or kayaks – as Bannerman's son once did – making landfall on an island that could not feel further from the megacity downstream. To passers-by in cars or commuter trains, it is a building that might conjure up strains of Gatsby-esque romance. The castle's grim contents have long been blown up or shipped away. All that remains is a childhood dream of lairds and lochs and faraway glens, braced against the current of the Hudson.

1. As seen from the Hudson River, steel braces were added to shore up the tower in 2014.

Bannerman Castle was a New World evocation of Scottish baronial splendour

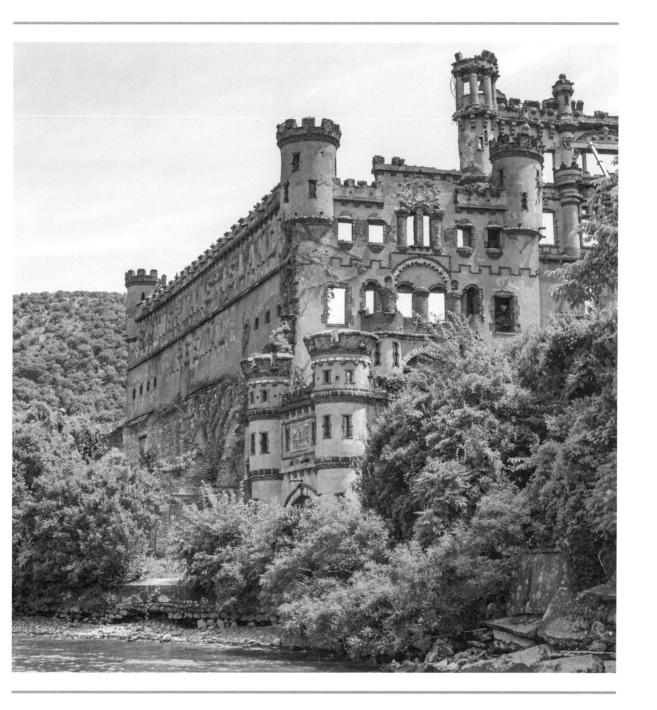

Palace of Sans Souci

19° 36' 17.46'' N, 72° 13' 7.32'' W

MILOT, HAITI

A grand palace built for a Caribbean king

Sans Souci translates from French as 'without worries'. It is a cruelly ironic name for a ruin with a sad and bloody history, in a country that has had more than its fair share of worries into modern times. Sans Souci is nonetheless an aspect of Caribbean heritage overlooked by holidaymakers craving white sand beaches. Though it is now abandoned, the building is quite unlike any other in the western hemisphere.

Left: Sans Souci Palace, seen from the southwest.

The Haitian Revolution was a slave insurrection that invoked comparisons with Spartacus's revolt against Roman rule. By 1804, an alliance of former enslaved people had successfully liberated themselves from their French colonial masters, making theirs the first black-led republic in the world. One of the leaders of the revolution was Henri Christophe, a former enslaved person, who went on to proclaim himself monarch of the northern part of the country.

Henri I served as the first and only king of Haiti; he created a peerage, instituted a feudal system and ruled over his subjects with an iron fist. He set about the construction of chateaux across the country, the grandest of which was Sans Souci. Some say that the palace took its inspiration from the palace of Sanssouci in Potsdam, near Berlin. Others dubbed the structure 'The Versailles of the Caribbean'.

NORTH

ATLANTIC

OCEAN

PALACE OF
SANS SOUCI

GONAIVES

HAITI

PORT-AU-PRINCE

N

15 km

Accounts describe terraced gardens, mahogany hallways draped with tapestries and bronze lions guarding monumental staircases; lithographs show the gurgling fountains of the palace grounds among nodding Hispaniola palms.

There was a deeper purpose to the palace's extravagance. Its Haitian architect, Baron Valentin de Vastey, claimed that Sans Souci was proof that Haitians 'have not lost the architectural taste and genius of our ancestors who covered Ethiopia, Egypt, Carthage, and old Spain with their superb monuments'. Under the shadow of slavery and amid the threat of the French returning, it seems Henri wanted to show a distinctly Afro-Caribbean splendour and prove how loftily a former enslaved person could rise in his brave new kingdom. His royal coat of arms displayed a phoenix rising from the ashes.

Henri I's policies of forced labour made him unpopular with many of his subjects. At the age of 53, after being crippled by a stroke and fearing an imminent coup, he committed suicide in the palace grounds, using a gun loaded with a silver bullet. Ten days later, his son and heir apparent, Jacques Victor, was bayoneted by revolutionaries at Sans Souci. In 1842, an earthquake destroyed much of the palace. Its ruins were looted and abandoned. Photos from the turn of the century show trees sprouting from its facade and creepers knotted around its balustrades – Henri's dream of an Afro-Caribbean renaissance was in tatters.

Years of political instability and natural disasters in Haiti have meant comparatively few tourists have visited the ruins of Sans Souci. Those who do can wander through the roofless palace – through the throne room and the halls where banquets were once held, the brick walls with no hint of their former majesty. A solitary Italian marble statue lies in the grounds, missing its nose.

Most visitors to Sans Souci also travel 6km (3¾ miles) up the hill to The Citadelle, a hulking fortress built by Henri I to repel French attacks, and where his body was said to have been interred after his suicide. For many years, another stop for visitors would be the Royal Chapel of Milot, where Henri was crowned king. It remained a functioning place of worship long after Sans Souci – to which it stands adjacent – fell into disrepair. In April 2020, a blaze ripped through the chapel, destroying its swooping dome and ravaging its interiors. There are, though, hopes that the Royal Chapel, at least, can rise phoenix-like from the ashes.

1. The monumental stairways where Henri I once walked.

The building is quite unlike any other in the western hemisphere

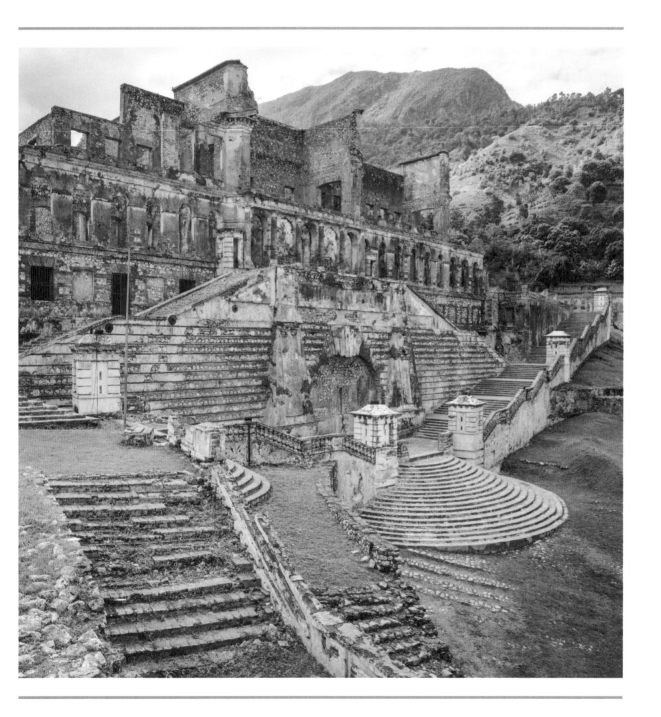

Montserrat Exclusion Zone

16° 42' 33.228'' N, 62° 12' 55.584'' W

SOUTHERN MONTSERRAT, LEEWARD ISLANDS

A paradise island scarred by volcanic eruptions

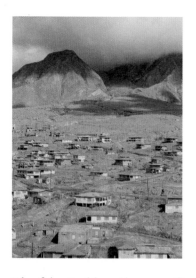

Montserrat is an island of two parts. The north is the heavenly Caribbean island largely untouched by mass tourism: blue bays, green hills and pastel-hued villas. The south is a lunar hellscape, where grey lava reaches down from a brooding volcano to the seashore. This is Montserrat's exclusion zone, in the midst of which are the entombed remains of Plymouth, the only capital of a political territory in the world that also happens to be a ghost town.

Left: The Montserratian capital Plymouth with the Soufrière Hills in the distance.

A British Overseas Territory, Montserrat was first spied by Christopher Columbus in the 15th century. It went on to be known as 'The Emerald Isle of the Caribbean' because of its Irish settlers. The 1990s were to see this landscape lose its emerald sheen. The Soufrière Hills had been in slumber for three centuries, since the days when pirates plundered the Caribbean. In 1995, the volcano awoke, sending plumes of smoke rising to the sky. Initially a curiosity, this period of activity was to prove long, persistent – and devastating.

In September 1996, an eruption effectively erased the villages of St Patrick's and Morris from the map, while another in June 1997 proved lethal, killing 19 people. Further pyroclastic flows and lahars (mudflows) crashed down on the southern part of the island.

CARIBBEAN

SEA

NORTH

ATLANTIC

OCEAN

MONTSERRAT

AIR Studios

EXCLUSION ZONE

*Soufrière Hills
Volcano*

PLYMOUTH

Most communities had long since been evacuated to safety but the capital was deemed lost, destroyed by August that year. It now has another, less loved nickname: The Pompeii of the Caribbean.

Plymouth presents a deeply surreal sight. The clock tower protrudes from the mudslides; a red British telephone box lies buried nearby. A stopped clock is the only visible portion of the Plymouth Courthouse, and a spire the only discernible part of the old Catholic church, which – without its accompanying tower – looks like a tepee pitched in the wastes. Boulders have barged their way through the windows of shops and the doors of government buildings. Photos reveal other kinds of devastation across the island: windows warped by volcanic blasts, trees scorched to their stumps and, notably, an airport control tower for a buried runway.

On the edge of the exclusion zone are the remains of AIR Studios. Founded by Beatles producer George Martin, they were frequented by acts such as The Rolling Stones, Elton John and Michael Jackson. Dire Straits recorded *Brothers in Arms* here; The Police laid down *Every Breath You Take*. Today, the studios lie abandoned as a result of an earlier tragedy on Montserrat: Hurricane Hugo swept through the island in 1989. Photos show a swimming pool full of grimy water, vestiges of recording equipment dotted about the control room. One of the first albums recorded here was Jimmy Buffett's *Volcano* in 1979: 'I don't know where I'm going to go when the volcano blows,' he sang on the title track.

When the volcano did eventually blow, George Martin had already moved AIR Studios to Hampstead, north London. The residents of Plymouth relocated to the north of the island or else moved abroad – a population of 15,000 dropped to nearly 1,000 in the years after the eruption, and only in recent years has it started to rebound. Local politicians have expressed interest in using the volcano for geothermal energy and making Montserrat a hub for volcano tourism. For now, only a few tourists detour from the heavenly beaches of the Lesser Antilles to visit Plymouth, the exclusion zone and Montserrat's unearthly vision of paradise lost.

| 1 | 2 |
| 3 | 4 |

1. Lahars (mudflows) have devastated the landscape of southern Montserrat.

2. An abandoned home coated in ash.

3. The roof of the Montserrat Courthouse protrudes from the debris.

4. The pulpit of a destroyed church in the exclusion zone.

A lunar hellscape where grey lava reaches down from a brooding volcano to the seashore

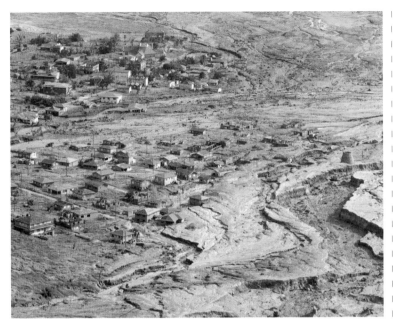

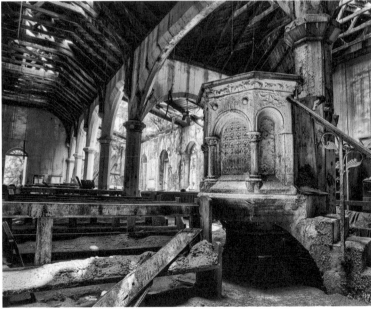

Ciudad Perdida

11° 2' 17.268'' N, 73° 55' 30.684'' W

SIERRA NEVADA DE SANTA MARTA, COLOMBIA

A pre-Colombian city concealed in the jungle

Centuries ago, the cities of Petra, Angkor and Machu Picchu were abandoned by the civilizations that built them. As time passed, the world rediscovered them, and they became overlaid with ticket booths, barriers and souvenirs. The wonder the first outsiders might have felt gazing upon their stones may have diminished – it is hard to hear the departing footfalls of ancient inhabitants among an incoming stampede of modern tourists – but one ancient place where this magical membrane of 'abandonment' might cling on is Ciudad Perdida, Colombia. Its very name means 'Lost City'.

Left: The terraces of Ciudad Perdida on which structures once stood.

Ciudad Perdida was only discovered by outsiders in the early 1970s. After its existence became widely known, it remained off limits to visitors, as conflict raged in Colombia. Even today, access is not straightforward. Ciudad Perdida is accessed by a spectacular four-day hike – the entrance ticket involves effort and time, so there are few crowds. Visitors here might indulge in Indiana Jones-esque fantasies of parting the ferns to find an El Dorado in the jungle. The reality is more complex.

Ciudad Perdida is known in local languages as Teyuna. Its first stones are believed to have been laid by the indigenous Tayrona people around 800 AD, some six centuries before the construction of Machu Picchu, the Inca citadel in Peru.

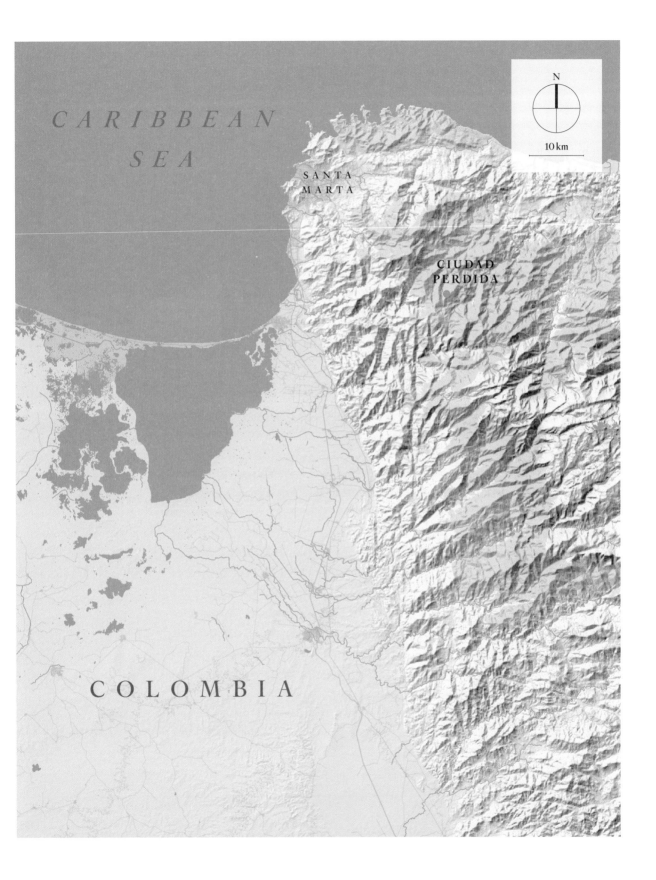

Ciudad Perdida was thought to be the hub for a network of settlements stretching across the Sierra Nevada de Santa Marta, a wild mountain range that rises from the azure tides of the Caribbean up to snow-capped summits at over 5,000m (16,400ft). At its peak, the city might have been home to between 4,000 and 10,000 people, with the surrounding jungle cleared to create farmland.

Colombia's Caribbean coast was one of the first places that the Spanish conquistadors landed in South America. They settled at the foot of the mountains in 1525, before sweeping south through the continent, bringing with them plagues from the Old World. It was around this time that Ciudad Perdida was abandoned. As the centuries passed, it remained a secret to European settlers – hidden in plain sight, not far from the ports of Santa Marta and Cartagena. Only in 1972 did a group of looters on a hunting expedition shoot a turkey and find it had landed on mysterious stone steps. They followed the steps to discover the ruins teetering on a ridge at 1,300m (4,265ft). They dug into the earth to pillage hoards of gold and ceramics, and eventually got into gunfights with other groups of looters. The Colombian authorities heard about the site in 1976, and researchers have been excavating it ever since.

Today, the 45-km (30-mile) trek to Ciudad Perdida goes through some of the most sublime terrain in the country. Organized tours see participants traversing rushing rivers on rope bridges, passing waterfalls where hummingbirds dart through the humid air, and sleeping in hammocks listening to the night-time symphony of the forest. Eventually, they arrive at the same staircase where the unfortunate turkey fell decades ago, the steps swooping skywards to a series of terraces upon which wooden structures once stood. Here, far away from the purr of motors and the clamour of crowds, you might come closer to imagining the lives lived here, and the shamans who spoke to the deities from their city in the clouds.

In truth – just like Petra, Angkor and Machu Picchu – Ciudad Perdida has never wholly been lost. Its existence was kept secret by the descendants of the Tayrona, among them the indigenous Kogi people who run the campsites and infrastructure along the trail, for whom the ruins have always been sacred land. For two weeks a year, the city closes again to the outside world so they can perform purification rituals and rid Ciudad Perdida of negative energy. To outsiders, it is a lost city; for those residents of the forest, it is a cherished one.

1. Looking northward towards Colombia's Caribbean coast.

As the centuries passed, it remained a secret to European settlers – hidden in plain sight

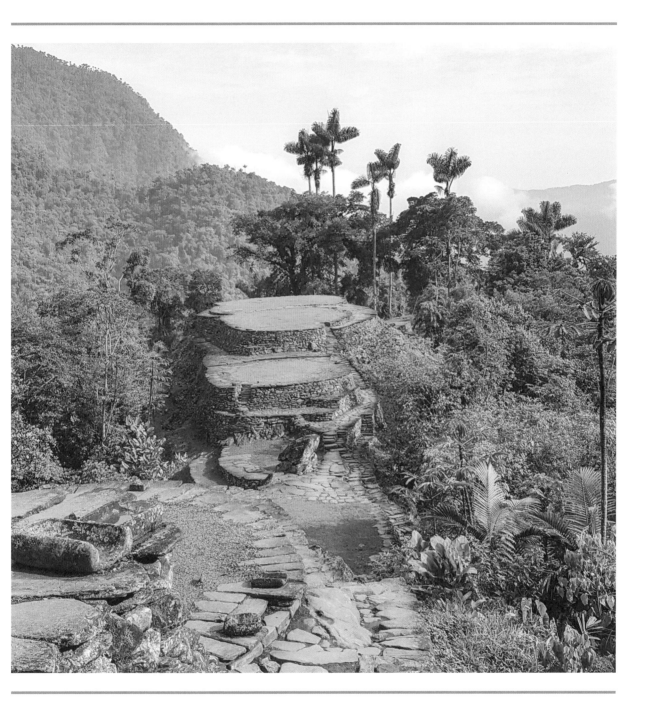

Humberstone and Santa Laura

20° 12' 29.628'' S, 69° 47' 44.988'' W

ATACAMA DESERT, CHILE

Twin mining towns rusting deep in the Atacama Desert

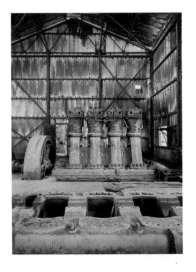

The Atacama Desert – a void between the Andean snows and Chile's Pacific coast – is the driest place on Earth, with settlements few and far between. Many of these take their names from saints: San Lorenzo, San Enrique, San Andrés. In the midst of them is Humberstone, named not after a disciple or a martyr, but after James Thomas Humberstone, born in Dover, England, in 1850. Humberstone moved to South America to work in the saltpetre industry. Today, the business he once knew is almost gone, but his name endures as the foremost of the many ghost towns strung across this desert.

Left: Rusting machinery at the saltpetre works in a corrugated iron building.

In the late 19th century, the Atacama was at the centre of a rush for saltpetre, or 'white gold', as it was then known. The mineral was shipped to European and North American markets to be used as a crop fertilizer, helping to feed booming populations. It proved an immensely profitable resource but one paid for in blood. In the 1870s, Chile successfully fought a Peruvian-Bolivian alliance for control of this mineral-rich region in the War of the Pacific, leading to tens of thousands of deaths.

First carrying the name La Palma, Humberstone was founded as a saltpetre refinery in 1872, the same year as its much smaller neighbour, Santa Laura. By the 1940s, Humberstone had grown into a town of some 3,700, with buildings of vaguely European

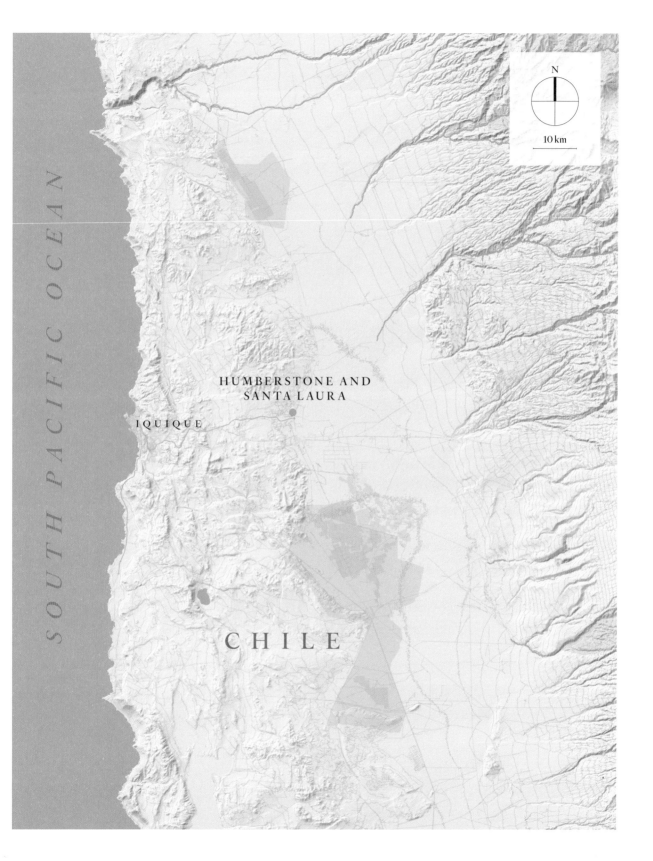

SOUTH PACIFIC OCEAN

HUMBERSTONE AND
SANTA LAURA

IQUIQUE

CHILE

N

10 km

architectural styles, reflecting British-owned mining interests in Chile at the time. It had rows of bungalows for workers, a church built of Oregon pine, a ballroom, tennis courts and even a theatre, where workers could watch Mexican movies. Its swimming pool was fashioned from the cast-iron hull of a ship.

The First World War saw Germany cut off from its saltpetre imports. As a result, its scientists went on to develop synthetic fertilizers, which led to the slow decline of Humberstone and Santa Laura. Both were abandoned after the saltpetre works eventually shut in 1961. Left to wither, they were declared UNESCO monuments in 2005, by which time almost everything in the two towns had turned the rusty brown hue of the surrounding desert.

In Humberstone, memories of departed residents have been preserved in a small museum, with simple metal beds and pictures of Christ hanging on the wall. The schoolhouse still has its rickety benches, the theatre retains its majestic crimson curtains and mint green walls – there are also reports of ghostly shadows shifting about the stage – but the swimming pool is dry. Santa Laura is in an even more dilapidated state, its chimney soaring high over the rusted railway infrastructure. Some machinery still carries the imprint of faraway towns – London, Birmingham, Kassel – where it was built.

There are other vestiges of the nitrate boom in the Atacama: the British cemetery at Tiliviche, where Humberstone himself is buried beyond a wrought-iron gate, and simpler cemeteries for labourers, with crooked crosses under which no flowers are laid. Far to the south of Humberstone is the mining town of Chacabuco. Abandoned in the 1930s, it was repurposed as a concentration camp under the brutal regime of Augusto Pinochet. And to Humberstone's northwest is Pisagua, the port to which saltpetre was shipped by train, now a village, with no rails serving the derelict station.

Parts of the Atacama see only a millimetre of rain every year; amid these bone-dry expanses, it is hard to imagine a thriving industry and thousands making their home there. It is also strange to think that the minerals of these lifeless deserts were sent to Europe, to make its green fields turn greener.

1. The skeletal Santa Laura saltpetre plant, 2km (about 1½ miles) from Humberstone.

The memories of departed residents have been preserved

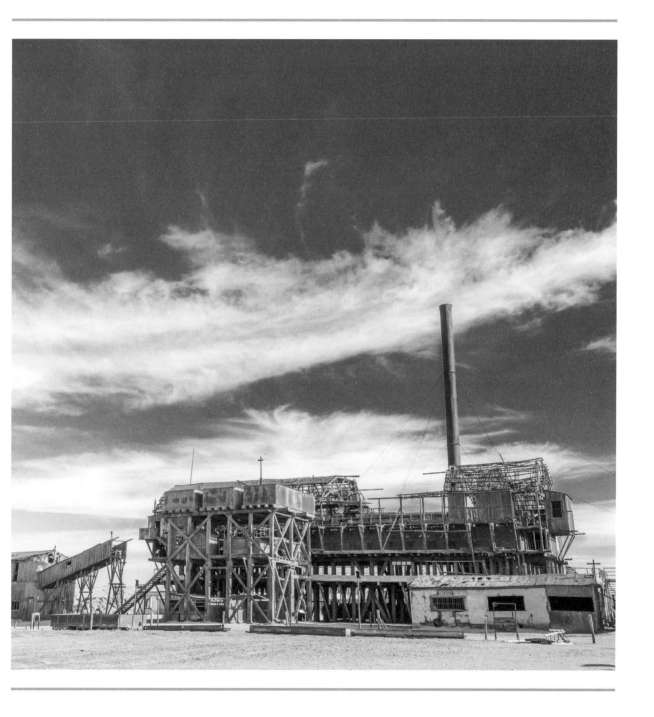

Uyuni Train Cemetery

20° 28' 52.896'' S, 66° 50' 16.728'' W

UYUNI, BOLIVIA

The end of the line for locomotives, high among the Andes

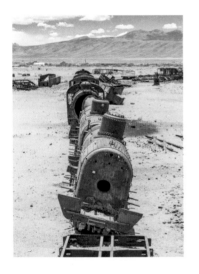

Beyond the little Bolivian town of Uyuni lies the world's largest salt flat: a spirit-level flat expanse reaching to a horizon of dark volcanoes. When it is dry, the Salar de Uyuni radiates a brilliant white. When it rains, the earth becomes a mirror to the Andean sky. It is a landscape as surreal as a Pink Floyd album cover. Almost as dreamlike is Uyuni's Cementerio de Trenes, the train cemetery on the edge of the salt flats, where, against a backdrop of cordilleras, engines, carriages and wagons decay in the sidings. Their strange presence in this strange landscape has made them a much-photographed corner of South America.

Left: Engines rusting in the saline air, with the town of Uyuni in the distance.

Uyuni stands at a strategic transport crossroads. In the 1870s, construction commenced on the Ferrocarril de Antofagasta a Bolivia, a railway line that would eventually link the Chilean sea port of Antofagasta to the Bolivian capital La Paz. It was a bold endeavour: its rails were to traverse some of the driest landscapes on the continent. Water was piped from the Andes to supply steam engines, with one spur claiming the distinction of being the world's highest railway at the time of construction. The rewards were mighty: the railway would extract the mineral wealth of the interior – nitrates and silver – and carry them to the Pacific.

N

30 km

POOPÓ LAKE

POTOSÍ

SALAR DE
UYUNI

UYUNI
TRAIN
CEMETERY

BOLIVIA

Uyuni was an obscure trading post some 600km (373 miles) east along the line from Antofagasta, at a junction where the railway forked south to Argentina.

By the 1940s, the mineral market had slumped, the Great Depression had set in and railway traffic collapsed. Cementerio de Trenes is a legacy of this slump, a resting place for rolling stock that was suddenly surplus to requirements and never woken from its rusty slumber. This harsh environment has seen the trains decay in fast-forward playback: the saline winds have accelerated corrosion, so that what remains today are the frames of the machines.

The cemetery is neither fenced off nor ticketed – people have long been able to climb on, scrawl on and salvage scrap from the train graveyard without consequence. Faces have been painted onto the engines; someone has installed a rope swing where a boiler used to be. Tourists on the South American overland route come for photo opportunities, though most soon get cold and climb back into idling 4×4s.

Railway enthusiasts linger longer, and some have been able to identify the locomotives. The oldest are Alco Rogers 2-8-0s imported from New Jersey, USA, dating to 1906; the most powerful are the Beyer Garratts of Manchester, UK, a mighty engine that tackled steep gradients across many continents. It is curious to imagine what the men who welded these engines into existence would have made of this resting place, in another continent and another century. An urban legend tells that one engine was robbed by Butch Cassidy and the Sundance Kid. Since both died in a shootout with the Bolivian Army in 1908, the timing makes it seem unlikely.

The railway line to Antofagasta is still moving minerals westward. As well as copper, vast lithium deposits have been found near Uyuni, ready to be put to use in smartphones and batteries worldwide. The old steam engines will play no part in moving them. As the graffiti on one engine goes: *Así es la vida*, meaning 'Such is life'.

1. **The rusted pistons of a steam locomotive.**

2. **The inside view of a partly crushed carriage.**

3. **Indigenous Andean-inspired artwork adorns the smokebox of one engine.**

4. **A Kitson Meyer engine, possibly built in Leeds, UK.**

A resting place for rolling stock that was suddenly surplus to requirements

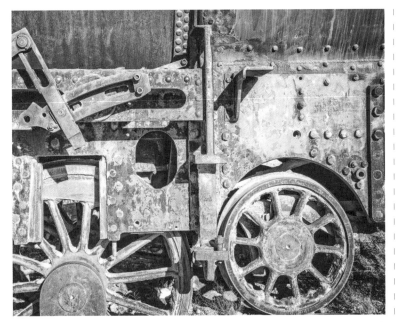

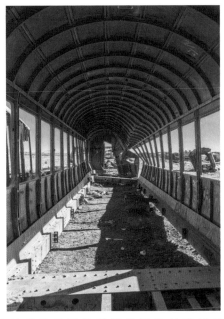

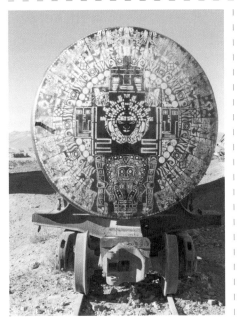

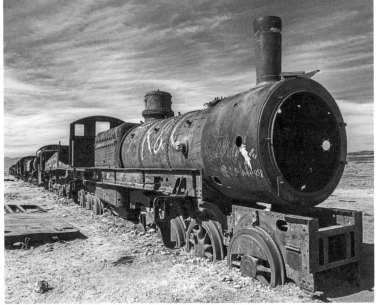

Fordlândia

3° 49' 44.04'' S, 55° 29' 48.66'' W

AVEIRO, BRAZIL

A tycoon's dream city, deep in the Amazon jungle

Henry Ford transformed America. He brought motorcars to millions of homes and highways, and revolutionized manufacturing. He paid his staff generous wages and formalized the five-day week. His innovations touched the life of almost every citizen in the United States. So, in the 1920s, he turned his attention to transforming somewhere new: South America.

At the time, the European powers held a near-monopoly on rubber, and Ford relied on British imports from Sri Lanka, which made the tyres and hoses for his cars expensive. Rubber trees grew naturally in the Amazon, and so Ford drew up plans to create a sister to his world-changing plant in Dearborn, Michigan, deep in the Brazilian hinterland. It was billed as both a business decision and a messianic mission to build a utopia in one of the world's last great wildernesses. 'We are not going to South America to make money...' Ford proclaimed, 'but to help develop that wonderful and fertile land.'

The site of Fordlândia lay 965km (600 miles) inland from the Atlantic port of Belém, accessible only by the Tapajós River. Locals expected the tycoon to come sailing through the jungle. Instead, in 1928, there came a steamer and barge loaded with a prefabricated town: a sawmill, a disassembled warehouse and a railway locomotive with tracks.

Left: The famous water tower that once carried the Ford logo.

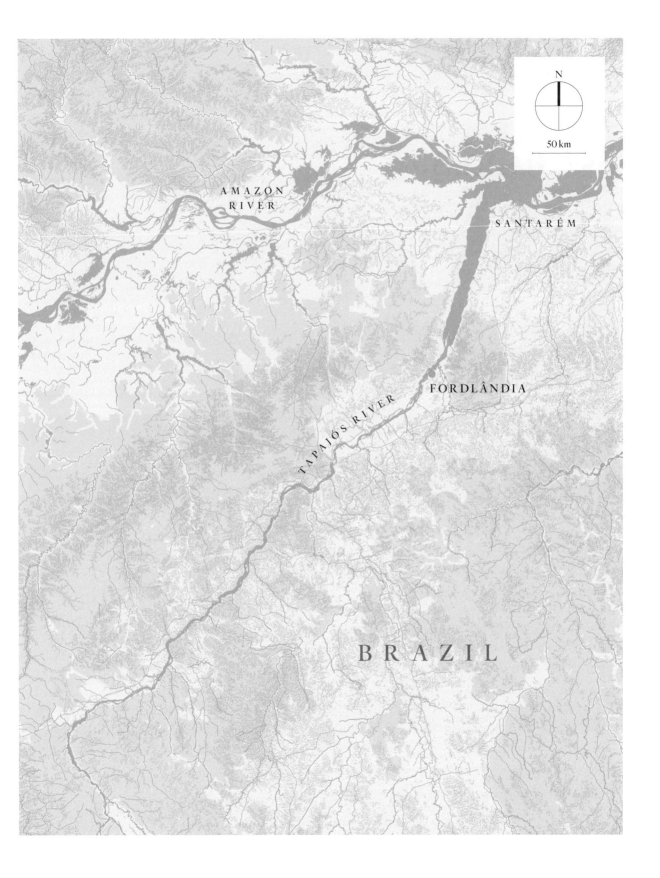

Gradually, the town expanded into a Midwestern suburb transplanted to the tropics: the Vila Americana ('American Village', for American workers) had little clapboard houses, plus a hospital, a school and a library, an 18-hole golf course and a dance hall for weekends. Ford's philosophy pervaded every aspect of his employees' lives: alcohol, tobacco and football were banned, and a strict diet was enforced. The totem of the town was its water tower. Welded in Michigan and emblazoned with the Ford logo, it soared high over the treetops.

The project proved a disaster from the outset. With Ford reluctant to hire a botanist, rubber trees failed to grow, falling victim to blight and pests. Foreign workers became feverish and many perished in the malarial heat – one went mad and committed suicide by jumping into a river full of crocodiles. As time passed, resentment simmered between Brazilian workers and their managers. The locals were sick of eating American hamburgers and working nine to five in the midday heat, rather than during the cooler hours of sunrise and sunset. In 1930, a fight in the canteen grew into a riot. The Americans abandoned Fordlândia, chased by machete-wielding Brazilians, returning only when the army flew in.

Fordlândia was abandoned a second time in 1934, and the site was sold back to the Brazilian government in 1945 at a loss. Today, it is a wrecked parody of Ford's utopian dreams. The fairways of the golf course are nowhere to be seen, the hospital is roofless and looted, the main factory is a husk. Erosion has tipped over some of the headstones in the cemetery, and fire hydrants rust in the undergrowth. The water tower is still upright, though the Ford logo has long since faded. The locals who stood on the riverbank expecting the world's richest man to sail by would still be waiting: Henry Ford never once set foot in the town that bore his name.

He was one of many who mistook this wilderness for a land of opportunity. British adventurer Percy Fawcett disappeared in the Amazon in search of the ancient city of Z in 1925. Werner Herzog's movie *Fitzcarraldo* was a parable of messianic ambitions, both in its storyline and its production, set on Amazon tributaries. Joseph Conrad's *Heart of Darkness* seems to echo through the story of Fordlândia from the moment the two barges sailed up the river. But there is another way to look at these sad ruins. They present a counterpoint to our present-day reality, a rare victory for the Amazon over the most destructive tendencies of capitalism: planet triumphing over profit.

1. The main rubber plant at Fordlândia, now used as a garage for a school bus.

2. A Junkers electric generator that supplied electricity to Fordlândia.

3. Derelict interiors lined with bird droppings.

A wrecked parody of Ford's utopian dreams

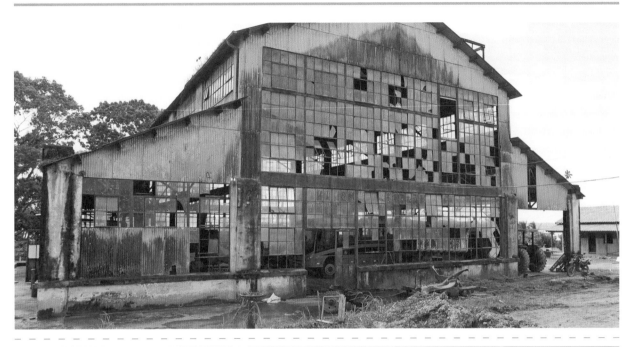

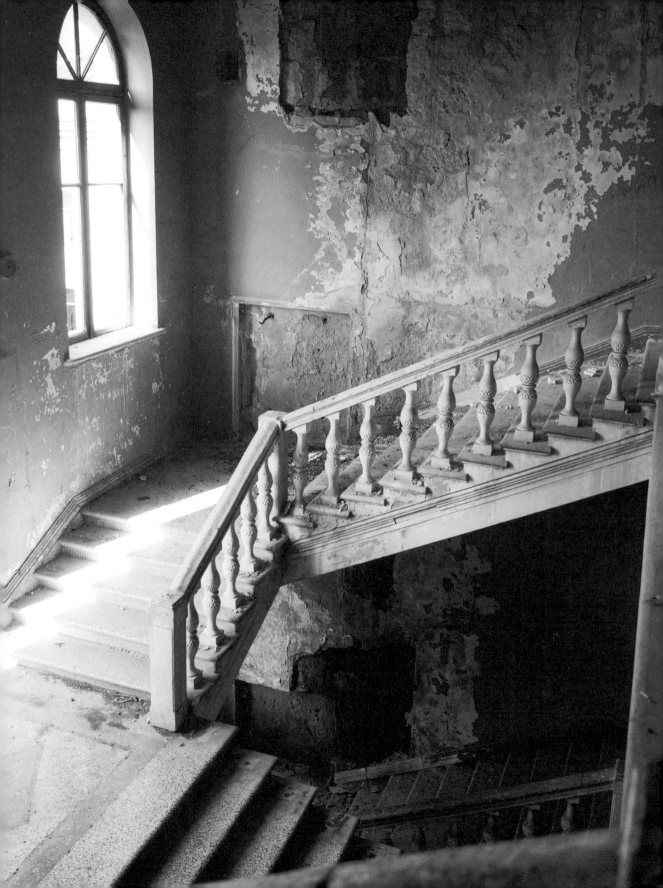

The Middle East & the Caucasus

Kayaköy

36° 34' 31.224'' N, 29° 5' 28.752'' E

LYCIAN COAST, MUĞLA, TURKEY

An idyllic Mediterranean village emptied out by war

The Lycian Coast is one of Turkey's busiest holiday destinations: a sweep of sandy beaches and resorts where millions come to bask each summer. It is a strange irony that a five-minute drive from pulsing nightclubs and all-you-can-eat buffets you can find the still, uninhabited village of Kayaköy, perched on a hillside among pine forests. It is, in fact, one of many ruins along the Lycian Coast – millennia-old tombs and temples that mutter of the *Iliad* and *Odyssey*. Kayaköy, however, was abandoned in 1923, the result of a modern exodus that still casts a shadow over the Mediterranean.

Left: Little chimneys rising over Kayaköy.

Kayaköy was one of countless Greek-speaking villages along the coast of Asia Minor (Anatolia). It had the Greek name Livissi, and may have been founded as a safe haven for those fleeing pirate raids along the shore. The 15th century saw the fall of Constantinople and the end of the Christian, Greek-speaking Byzantine Empire – but the Greek residents of Kayaköy stayed put, mostly living in harmony with their Muslim neighbours under the new Ottoman Empire.

Five centuries later, the Ottoman Empire began to collapse, and its ethnic minorities (Greeks among them) became subject to persecution, torture and genocide amid a rising tide of Turkish nationalism.

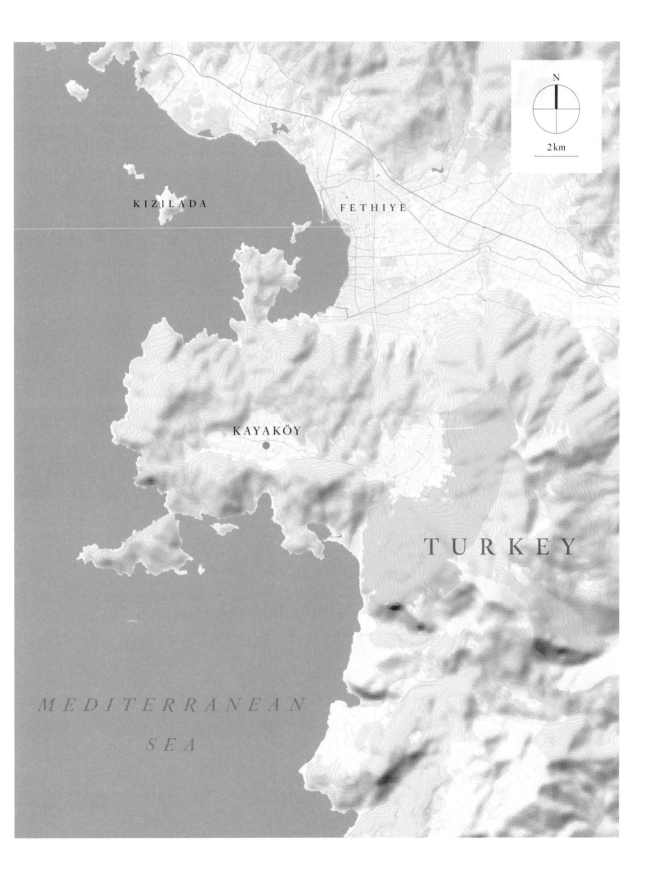

By 1918, many of Livissi's 6,500 residents had been sent on death marches to the Anatolian interior, and the village lay largely abandoned. The ensuing Greco-Turkish war saw atrocities committed by both sides, and concluded with a population exchange: ethnic Greeks in Turkey were sent to Greece; ethnic Turks in Greece were exiled to Turkey. Some villagers of Livissi survived and escaped to nearby Greek islands. But no new Turkish refugees came to settle Kayaköy, some say because of its steep, hillside setting; others because they did not want to be haunted by the ghosts of Livissi's murdered souls.

Today, it takes little effort to imagine ghosts in Kayaköy. From afar, it could be any other hillside village on the Lycian Coast, its stones rising over olive groves and vineyards, fig and pomegranate trees. Up close, all that remains of the village are the bare bones. In the 400 or so houses, wildflowers fill the fireplaces, staircases lead to collapsed floors, and roofs are open to the clouds and the stars. One or two cats stalk cobbles once stomped by people on their way to school, market or church. In 1957, the Fethiye Earthquake shook Kayaköy into an even more acute state of disrepair, from which no one has attempted to lift it.

Turkey's relationship with Greece is still one of unresolved grievances, and so, like Armenian remains in Anatolia, the village has an ambiguous position in the modern country. It has been a setting for expressions of peace and unity between both peoples, and occasionally there have been plans to redevelop parts of Kayaköy – most recently a message of intent by the local government to restore its churches and chapels.

For now, these churches and chapels are the most sombre corners of the lost village, with no glass in their windows, no altars, no icons, only frescoes fading faintly in the ceilings. Nor is there much sign of Christ, whose earliest disciples travelled across Anatolian soil, to tell his story to the world in the Greek language.

1. Kayaköy seen from the pine forested hills above.

2. Inside Panayia Pyrgiotissa, the village's main Greek Orthodox church.

3. Some parts of the village have been preserved.

All that remains of the village are the bare bones

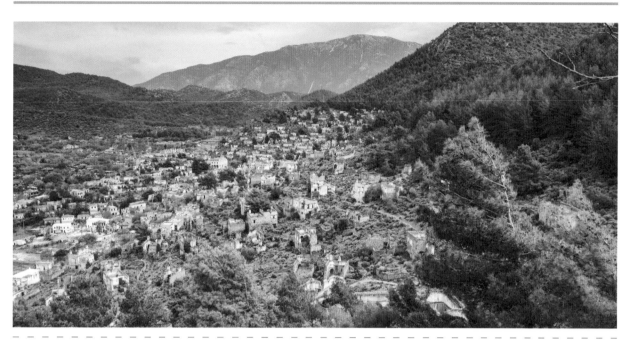

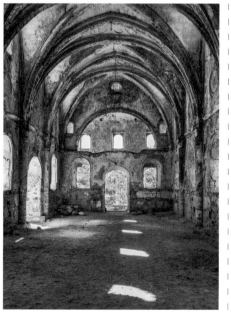

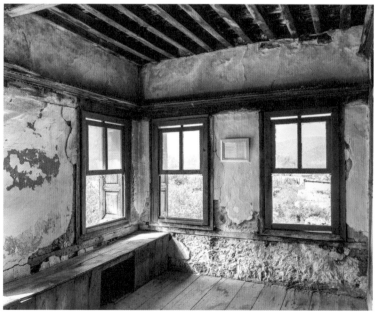

Burj Al Babas

40° 26' 41.1'' N, 31° 12' 16.488'' E

MUDURNU, TURKEY

A fairy-tale development with an unhappy ending

In Burj al Babas, hundreds of castles line the hillsides outside the Turkish town of Mudurnu, midway between Istanbul and Ankara. Looking less like a work of architecture, more an accident created in Photoshop, the buildings might bring to mind the châteaux of the Loire or the turrets of Neuschwanstein or perhaps the Disneyland castle. With occupants, these castles would present an unusual sight. Abandoned, they are a settlement of almost unparalleled peculiarity.

Construction on the $200 million Burj al Babas resort began in 2014 – the Arabic word *burj* translates as 'tower', a hint at the developer's target market. Turkey has long been a popular retreat for those seeking respite from the sweltering hot summers of the Arabian Gulf, and the 700 proposed castles were pitched at Kuwaitis, Emirati and Saudis.

Glitzy brochures boasted of the verdant landscapes and cool, oxygen-rich air, with promises of 'unforgettable' moments for those who were prepared to pay up to $500,000 for their own little fortress. Interiors were intended to be 'where luxury and comfort met': high-end mock-ups showed homes full of neo-Louis XIV furniture and impressive glittering chandeliers.

Left: The fairy-tale castles of Burj al Babas.

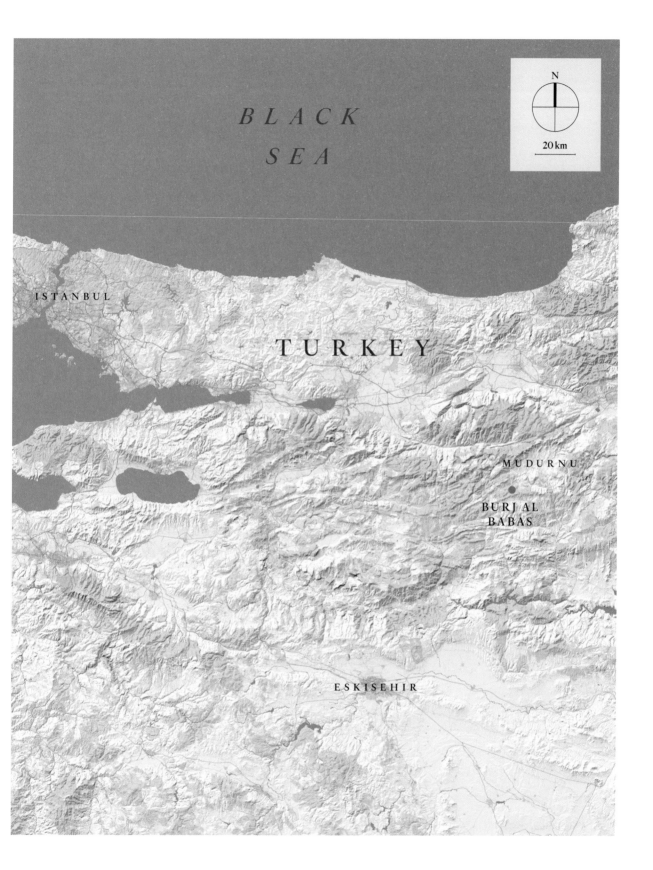

Prospective castle owners would be able to step out onto their balconies and see a neoclassical shopping mall adorned with stately domes, plus a palatial spa whose thermal waters could cure all manner of ailments. There would be a waterpark for kids, restaurants and cinemas. 'If the best isn't good enough for you – here is something even better,' said the brochure. It was the swaggering, superlative architecture of Dubai.

The early 2010s saw a construction boom across Turkey during the Presidency of Recep Tayyip Erdoğan, with monolithic new developments proving controversial across the country. Burj al Babas soon became unpopular with locals as well as some politicians, who considered its architecture an affront to the Ottoman townhouses of Mudurnu.

Things got worse for the developers. A collapse in oil prices made it difficult for some customers in the Gulf to pay up. Meanwhile, the weakening Turkish lira led to spiralling construction costs. In 2018, the Turkish courts imposed a bankruptcy order on the developers.

At the time of writing, hundreds of the castles are empty shells. A few are vaguely recognizable from the brochures: spiral staircases wind up to bare concrete rooms, adorned with little more than plug sockets, stray wiring and empty holes where indoor pools were meant to be installed. A giant central building – perhaps a mall – currently resembles a multistorey car park, with gaping holes where ornamental domes were meant to rise.

Construction is allegedly ongoing but, in the meantime, the building site at Burj al Babas has become a favoured haunt of urban explorers, filmmakers and music video producers. It offers an aesthetic quite unlike any other. Typically, castles are symbols of individuality and prestige but in Burj al Babas they represent a kind of uniformity. Somewhere among these dreamlike fairy-tale towers is a metaphor about aspiring to be different but ultimately ending up the same as everyone else.

The developers allegedly saw the project as mixing the magic of European chivalry with the tightly huddled houses of American suburbia – all in among the verdant hills of Anatolia, peppered with the extravagance of the Arabian Gulf. Something, somewhere might have been lost in translation.

1. A circular park at the east of the development, with the mall visible in the distance.

Burj al Babas has become a favoured haunt of urban explorers and filmmakers

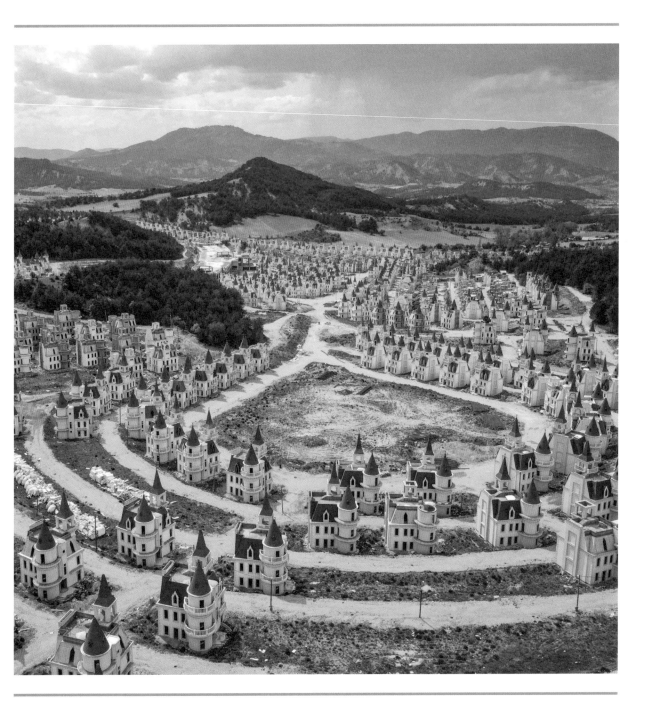

Varosha

35°06'39''N, 33°57'13''E

FAMAGUSTA, CYPRUS

A sunny, seaside resort caught in a hostile borderland

Varosha's previous life is depicted in old postcards showing parasols and deckchairs spread across an arc of golden sand, and bikini-clad holidaymakers sipping orange juice on the balconies. They show luxurious high-rise hotels – Hotel Argo, The King George Hotel, The Grecian Hotel – rising proudly over blue waves. As the brochure for the Florida Hotel once promised: 'The perfect seaside holiday ... Here is everything.'

Left: The King George Hotel stands right on the seafront.

This seaside suburb was once somewhere tourists came in order to forget their troubles. Until one August day in 1974, trouble came to Varosha. It found itself in the midst of a battle between two island communities and it has been in no-man's land ever since, its abandoned state a sad symbol of an island divided.

Varosha – known in Turkish as Maraş – is a neighbourhood of the town of Famagusta, which, in its heyday, was reputedly Cyprus's foremost holiday destination. Its hotels were frequented by Hollywood A-listers – Richard Burton and Elizabeth Taylor, Brigitte Bardot and Raquel Welch – and its name was spoken in the same breath as Saint-Tropez and Miami. But while cocktails were clinked and parasols unfurled in Varosha, tensions were boiling over in the hinterland.

MEDITERRANEAN SEA

N

5km

CYPRUS

VAROSHA

AYIA NAPA

LARNACA

Years of violence between the island's ethnic Greek and Turkish culminated in a 1974 coup by a Greek-Cypriot faction, whose leaders advocated unification with Greece. Five days later, Turkey invaded the island for the stated reason of protecting Cyprus's ethnic Turkish minority. Varosha itself was an ethnic Greek community, and, as Turkish forces advanced, fearful residents fled with little more than the clothes on their backs. The island was then divided into territory held by the predominantly Greek Republic of Cyprus and the predominantly Turkish Northern Cyprus, a de facto state recognized only by Turkey. That status quo endures more or less to this day.

The 'Green Line' that divides the two entities runs slightly south of Varosha – the old resort came to serve as a buffer zone under the control of the Turkish military. For decades, images of the ghost town have only occasionally come to the attention of the wider world, amid reports that visitors who strayed inside risked being shot on sight. Just behind the old barricade on the beachfront lies The King George Hotel, whose arched terrace is collapsing into the sea. Further south is The Grecian Hotel, whose signage remains but whose entrance is overgrown with vegetation. And then there's the Hotel Argo – allegedly the preferred address of Elizabeth Taylor – overlooking a beach that, with no tourists, has become a nesting site for sea turtles.

Other mementoes of Varosha's glory days include a Toyota dealership, its showroom rumoured to be replete with dusty 1974 models with zero mileage, and shuttered banks and cafés on streets overgrown with bougainvillea and cacti. Beyond lie homes whose interiors have barely been seen by human eyes since the doors were hastily bolted half a century ago. But that might not be the case for too much longer.

The year 2020 saw the start of a new chapter, with the authorities in Northern Cyprus opening up a stretch of beach to tourists. Against a backdrop of escalating tensions between Greece and Turkey, Varosha was visited by President Erdoğan, who said he supported plans to eventually redevelop the ghost town. The move provoked fury from many Greek Cypriots and Greece, which cited a UN Resolution deeming it 'inadmissible' Varosha be settled by anyone other than its previous inhabitants.

For now, Varosha is largely abandoned but far from forgotten – and it's not the only ghost town created by conflicts between these two historic adversaries across the Aegean. A lasting peace seems elusive, even if parasols may soon return to its beaches.

1. **Makeshift barricades surround Varosha, running right down to the beach.**

2. **Many buildings in this ghost town are gradually crumbling.**

3. **Abandoned hotels line the seafront in Varosha.**

4. **The Toyota dealership, much speculated about by car enthusiasts for the period models it may house.**

Its abandoned state is a sad symbol of an island divided

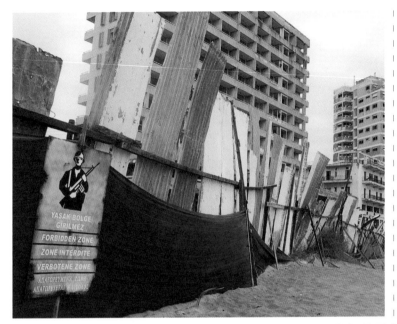

Tskaltubo

42°19'35''N, 42°36'02''E

GEORGIA

A Georgian spa town where Stalin once came to bathe

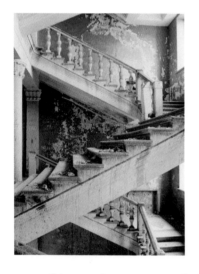

Whenever Soviet dignitaries were stressed out – be it from the strains of Five-Year Plans or the skirmishes of the Cold War – they would book themselves a trip to Tskaltubo. Here, in the verdant foothills of the Caucasus Mountains, they would stew in bathhouses, breathe fresh country air and emerge renewed, ready to serve the motherland with vigour.

In the 1970s, Tskaltubo welcomed up to 100,000 people a year, disembarking direct trains from Moscow, seizing on their 'right to rest' enshrined in the Soviet constitution. Today, that number is reportedly as low as 700 people, with most of the grand structures in which comrades once recuperated now shambolic ruins. Far from a place associated with sunlit holidays and revitalization, Tskaltubo has for three decades been associated with disintegration.

Tskaltubo's so-called Waters of Immortality had been known for centuries, but it was only in the 1950s that the town evolved into a major balneology resort, serving visitors from distant Soviet republics. Town planners plotted more than 20 grand sanatoriums around a leafy central park. Stalin came home to his native Georgia to bathe here and (perhaps) assuage his paranoia. So did his sometime chief of secret police, Lavrenty Beria.

Left: The staircases of the Sanitorium Iveria, currently under restoration.

GEORGIA

TSKALTUBO

POTI

KUTAISI

BLACK

SEA

BATUMI

TURKEY

N

20km

The end of Communism spelled the end of state-sanctioned holidays, and the gradual decline of Tskaltubo. The neighbouring state of Abkhazia had also been a popular holiday spot, with comrades basking on its Black Sea beaches, but it was besieged by war in 1992, amid the turmoil surrounding the collapse of the Soviet Union. Refugees fled inland, hoping to find temporary shelter in the abandoned sanatoriums of Tskaltubo. An estimated 5,000 remain there to this day.

Internally displaced people are still resident in the abandoned Hotel Saqartvelo and neighbouring Intourist hotel – brutalist 1980s blocks from the years of perestroika and glasnost – as well as in the better-preserved Hotel Metalurgi, where chandeliers dangle over the foyer and children play football in the corridors.

Entering inhabited parts of these hotels should be done with sensitivity: some abandoned sanatoriums are trodden by few people. At the southern end of Tskaltubo is the Hotel Medea. Approached by regal steps, it has the aura of a Grecian ruin: nymphs cluster around its fountains, and Corinthian columns swoop splendidly over the lobby. Beyond, many interiors are derelict, with rambling staircases and rising damp.

Recent years have seen a Georgian billionaire (backed by foreign investors) promising to redevelop Tskaltubo for modern tourists and restore its bygone majesty. The Sanatoriums Shakhtar and Iveria are now surrounded by fences and patrolled by security amid rumours of imminent restoration, though a few explorers have still sneaked in. The last reports show Stalinist architecture in quiet slumber: stucco-adorned ballrooms without dancers, balconies without balustrades, colonnades full of weeds.

There are many more derelict bathhouses across Tskaltubo, some shaped like UFOs, others like neoclassical temples. Bathhouse Number 6 is one building that has remained well preserved and functioning, with coffered ceilings rising over polished marble floors, and a frieze showing Stalin merrily shaking hands with awestruck comrades and their children. This was allegedly Stalin's favourite bathhouse, where the dictator would take a dip in a little pool adorned with mosaics of starfish and horseshoe crabs.

Prior to the pandemic, Georgia was an increasingly popular holiday destination, though it will take many more visitors and many more years of work for Tskaltubo's sanatoriums to rise from these sad ruins. For now, the bathtubs are empty: the waters of immortality have run dry.

1. Inside the Sanitorium Iveria; it is said to have had 300 beds for recuperating comrades.

Tskaltubo showcases Stalinist architecture in quiet slumber

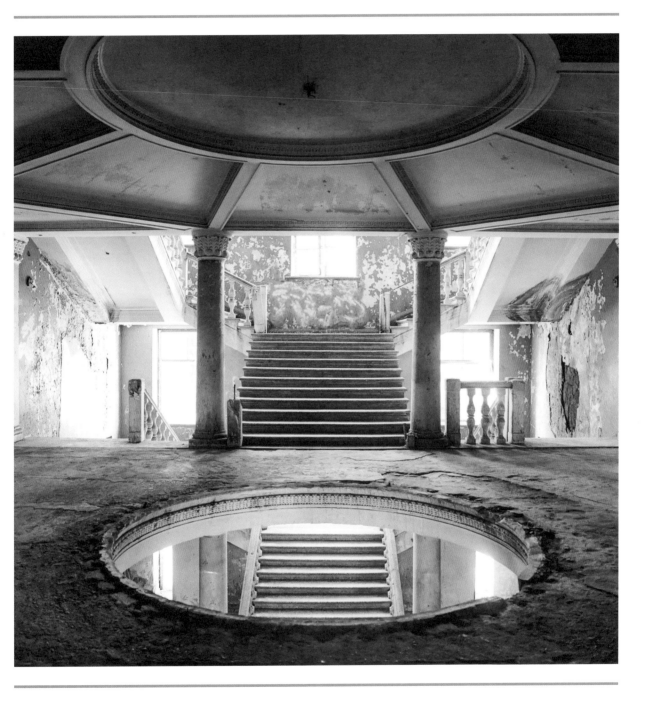

Palaces of Saddam

35° 32' 36.204'' N, 44° 25' 1.272'' E

IRAQ

The many hideous haunts of the Iraqi dictator

Left: One of Saddam's ruined palaces, the photo taken soon after the invasion in 2003.

In times of crisis, Saddam Hussein built palaces. At the time of the First Gulf War, it was believed the Iraqi dictator had around 20 palaces. Over the following decade – amid American airstrikes and the constant threat of invasion – the US State Department estimated he had built another 48 palaces across the country, at a cost of some $2.2 billion. Palaces for Saddam were like castles to medieval kings: a vindication of his authority, and a daily reminder of his omnipotence over the subjects who lived in their shadow. In 2003, those palaces became the defining symbol of Saddam's fall from grace: ominous, muscular buildings were abandoned and suddenly seemed tawdry, impotent and silly.

Loaded with symbolism was his palace in Babylon, the biblical city of Hanging Gardens, which counted as one of the cultural titans of the ancient world. Just as Mussolini saw himself as a successor to the Roman emperors, Saddam believed himself to be a reincarnation of Nebuchadnezzar, the Babylonian ruler who led campaigns in what is now Israel and Iran in the 6th century BC.

To the dismay of archaeologists, Saddam rebuilt the ancient Babylonian ruins in the manner of a theme park, and even inscribed his name and portrait on some stones.

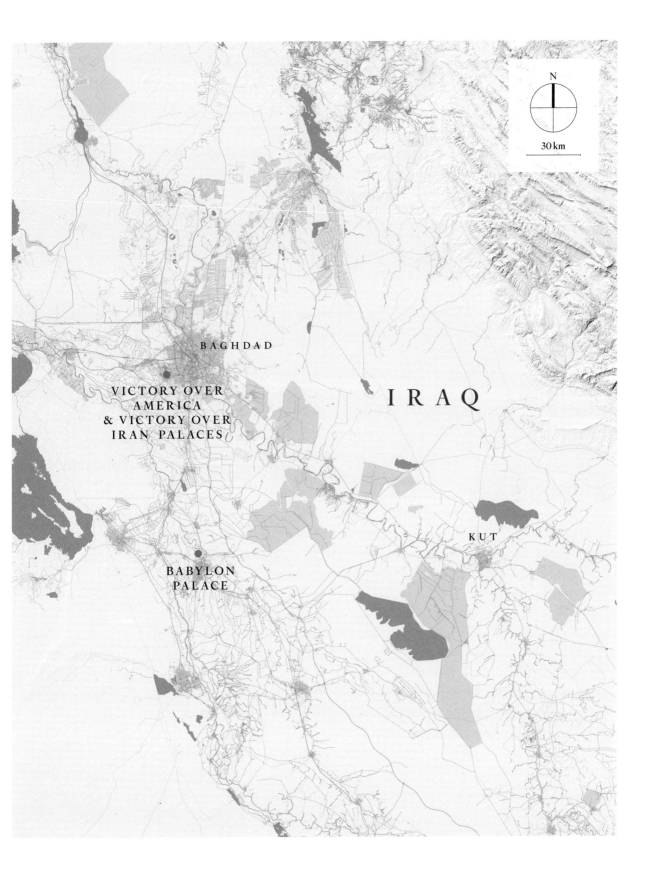

N

30 km

BAGHDAD

VICTORY OVER
AMERICA
& VICTORY OVER
IRAN PALACES

I R A Q

KUT

BABYLON
PALACE

A village was bulldozed to make way for his palace, designed in the style of a Sumerian ziggurat and set on an artificial mound rising over the Euphrates River. Long since looted of all valuable objects, the palace is now swathed in graffiti, its glass windows smashed, its chandeliers broken but still hanging. Barbed wire blocks the ceremonial stairway, whose bannisters are broken. Painted on the ceiling are gaudy frescoes spanning the millennia of Iraqi history: Babylon's blue Ishtar Gate, the 1994-built Saddam Tower and a fluttering Iraqi flag. At weekends, the palace has become a tourist attraction for Iraqis who potter the marble floors and idle on its verandahs for views across the cradle of civilization.

A number of palaces are clustered around the international airport in Baghdad, among them the intriguingly named Victory Over America Palace, built by Saddam to commemorate the First Gulf War. Set beside an artificial lake, the palace was never completed and suffered a direct hit from a missile in the Second Gulf War. The most recent images show an ornamental hall of pink marble columns and interior balconies, with debris strewn across the floor. Confusingly, at the rear of the building is the Victory Over Iran Palace, built to commemorate the Iran–Iraq War.

Many more palaces – from the mountains of Kurdistan to the marshes around Basra – used by Saddam and his household were abandoned after the Second Gulf War. It is alleged there are as many as 60 palaces in Tikrit, the town close to where Saddam was born and later found hiding down a manhole after his regime crumbled. All of them follow a common pattern: dry swimming pools, faux-Versailles furniture, flattering depictions of the moustachioed dictator. Many were used as military bases in the years following the Coalition invasion. A few have gone on to find a new use: Baghdad's Al-Faw Palace is now an American university and the Basra Palace is a museum.

It is, however, the abandoned Babylon Palace that seems to loom largest in the public consciousness, perhaps because, as Saddam hoped, it places his rule in the context of the many dynasties that have ruled over the Tigris and the Euphrates. The civilizations of Iraq are remembered for producing the first known system of writing and the first systems of law, laying the foundations on which the modern world rests. By contrast, Saddam's contribution is small: thuggery, war, corruption, vanity – and more tacky palaces than anyone can count.

1. Inside the Babylon Palace: a fresco that mixes ancient symbology and landmarks of modern Iraq, and, in the distance, a terrace overlooking the ancient city.

The palaces became the defining symbol of Saddam's fall from grace

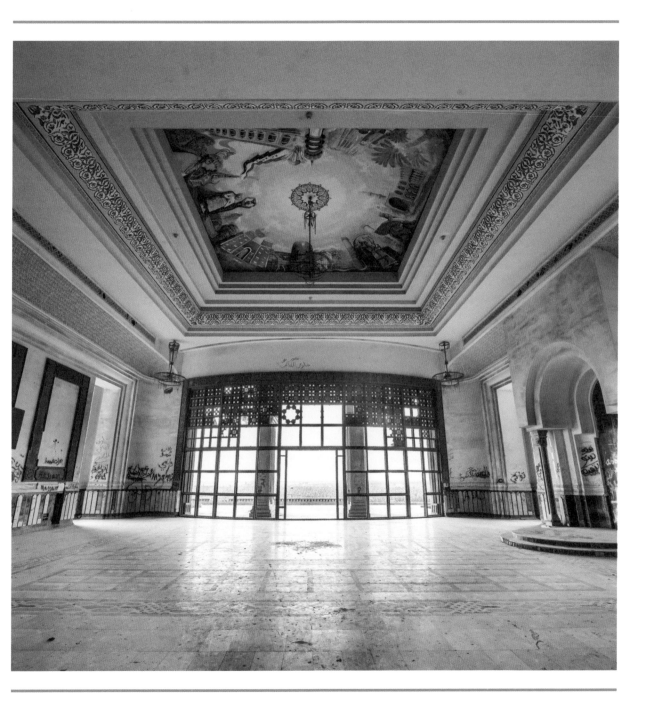

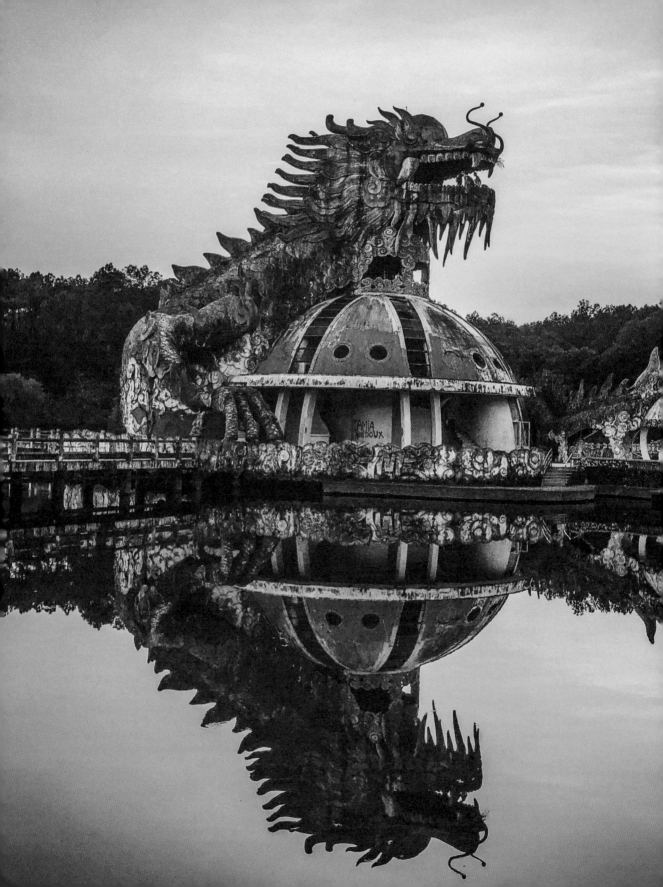

Asia

Ryugyong Hotel

39° 2' 12.048'' N, 125° 43' 52.14'' E

PYONGYANG, NORTH KOREA

North Korea's strange and superlative 'Hotel of Doom'

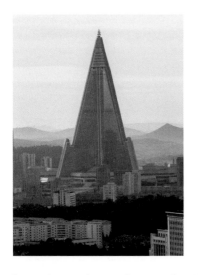

In 1986, a South Korean architectural firm completed construction of the world's tallest hotel: The Westin Stamford in Singapore. Today, it is a luxurious five-star hotel with a Michelin-starred restaurant and rooftop swimming pools, where an international clientele check in to harbour-view rooms for about $200 a night. Its grand opening, however, triggered the construction of a rival hotel 7,240km (4,500 miles) away – a hotel that, some four decades later, has no restaurants or pools and has yet to see a single guest check in. This is the Ryugyong Hotel in Pyongyang, North Korea. *Ryugyong* means 'capital of willows', though it is better known by another moniker: 'The Hotel of Doom'.

Left: The Ryugyong Hotel is the tallest structure in North Korea.

After years of near-economic parity, the 1980s saw North Korea falling far behind its southern neighbour. In response, the North's leadership ordered the construction of a hotel to soar 100m (330ft) higher than the one its rivals had built in Singapore, bringing the title of the world's tallest hotel across the 38th parallel. Shaped like a steeply sided pyramid, it would be completed by 1992, in time for the 80th birthday of North Korea's founder and dictator Kim Il Sung. It would attract business travellers to the country, serving as a monumental gateway for foreign investment.

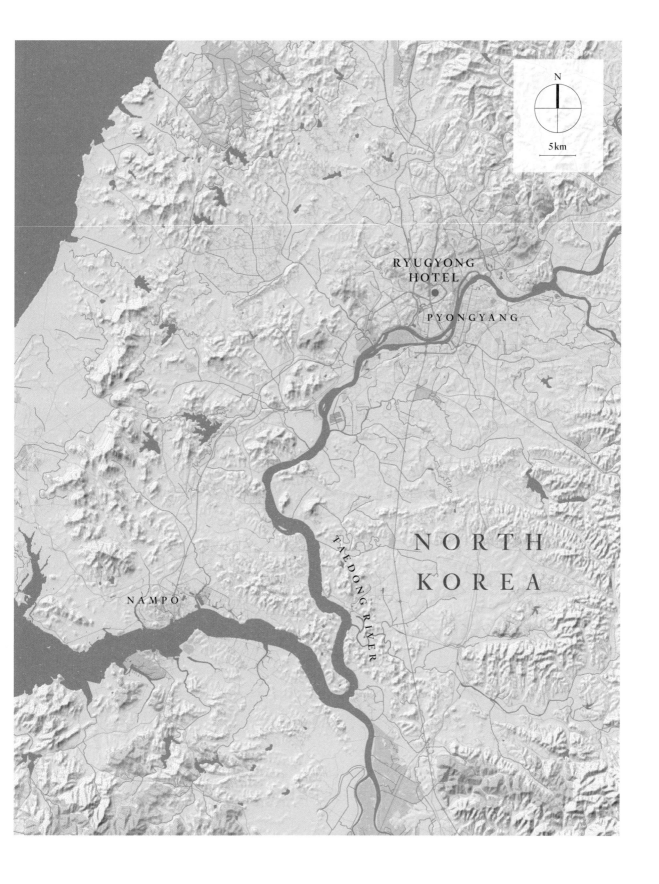

RYUGYONG
HOTEL

PYONGYANG

NORTH
KOREA

NAMPO

TAEDONG RIVER

N

5km

Depending on whom you believed, it would have as many as 3,000 or 7,000 guest rooms, with five revolving restaurants spinning at its pinnacle.

The end of the Cold War meant the end of aid from North Korea's ally, the Soviet Union. The 1990s saw the country suffer severe economic collapse, as well as flooding and drought. The resulting famine led to hundreds of thousands, if not millions, of deaths. Construction efforts on the Ryugyong Hotel seemed to come to a halt in 1992. By the time Kim Il Sung died in 1994, the building stood derelict and windowless.

For over a decade, this concrete shell was a towering monument to failed ambition, airbrushed from official depictions of Pyongyang and removed from maps – despite its unignorable presence on the capital's skyline. Rumours circulated that it was structurally unstable, that its lift shafts were wonky and that its construction had gobbled up as much as 2 per cent of North Korea's GDP. Though no foreigners had set foot inside, its brutalist-meets-Las Vegas design saw it dubbed 'the world's worst building'.

Then, in 2008, construction unexpectedly resumed under the direction of an Egyptian engineering conglomerate, with plans to open by 2012, the 100th anniversary of Kim Il Sung's birth. Another birthday passed without any such opening taking place and, ever since, news of the hotel has only intermittently trickled out to the wider world.

Its concrete facade has now been fitted with glass panels and the crane mounted on the roof has been removed. In more recent years, LED lighting has been fitted to the side of the hotel, with epic depictions of sunsets and fireworks beneath a triumphant North Korean flag. In 2013, it was announced that Kempinski, the Swiss hotel group, were in initial discussions to run the hotel, but the company withdrew amid rising tensions related to North Korea's nuclear weapons programme. In 2019, a new sign was erected outside the hotel lobby, though the most recent pictures of the interiors still show bare concrete and no plumbing, electrics or furnishings. Or, of course, guests of any kind.

North Korea recently announced it would cap foreign visitor numbers to 1,000 a day. Where this leaves the 3,000–7,000 guest rooms of the Ryugyong Hotel is anyone's guess. Today, the hotel mirrors the country in which it stands: much talked about, barely visited, little understood. It has long since been leapfrogged to the title of the world's tallest hotel by many new edifices in Dubai and Malaysia. It is, however, a holder of another world record of sorts: it is the world's tallest unoccupied building.

1. One of the few photographs of the Ryugyong Hotel's interiors, showing what is planned to be the lobby.

The hotel mirrors the country in which it stands: much talked about, barely visited, little understood

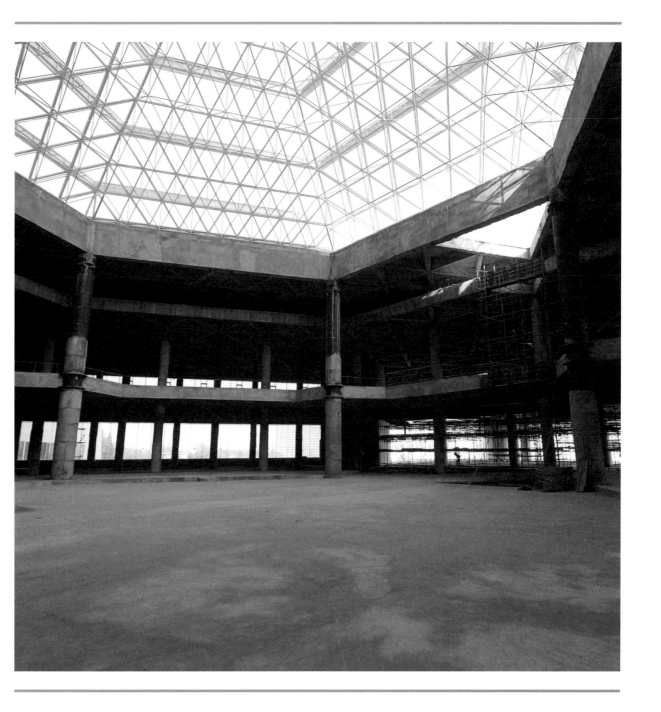

Buran at Baikonur

45° 57' 53.064'' N, 63° 18' 18.864'' E

BAIKONUR COSMODROME, KAZAKHSTAN

The Soviet rival to the Space Shuttle, left to decay in a spaceport in Kazakhstan

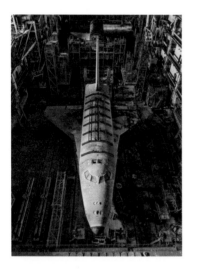

Left: **Test vehicle OK-MT, built in Moscow in 1983 to pilot safety systems and test the loading and unloading of gas tanks.**

The Soviet Union was the first nation to put a man, a woman, a satellite (and a dog) into space. By contrast, its last and most expensive gambit in the space race was doomed to fail. In 1982, the US launched its Space Shuttle into the charged atmosphere of the Reagan-era Cold War. Fearing these revolutionary new craft would be used to help deploy and intercept nuclear weapons, the Soviet Union decided to launch its own rival programme, the Buran, meaning 'blizzard' or 'snowstorm'.

Cosmetically, the Buran class bore an uncanny resemblance to its American cousin, leading many to suspect that Soviet spies had intercepted NASA blueprints. But there the similarities ended. The five operational American Space Shuttles became the emblem of space exploration in the 1980s, 1990s and 2000s, collectively clocking up 1,322 days in space. By contrast, one member of the lookalike Buran class completed one solitary mission in 1988, totalling just three hours. The programme was cancelled after the fall of the Soviet Union. Vehicles once destined for outer space were now to gather dust at the Baikonur Cosmodrome in Kazakhstan, the oldest and most storied spaceport on Earth.

KAZAKHSTAN

BURAN

BAIKONUR

KYZYLORDA

UZBEKISTAN

Only the most intrepid urban explorers have paid the survivors of the Buran class a visit, a mission that is itself almost intergalactic in its boldness and ambition. First, Baikonur lies in Kazakhstan's desert steppe – a full day's train journey from the largest city Almaty – at a point where both railway lines and roads terminate into a lunar-like wasteland. Second, it occupies a vast, heavily guarded site. Effectively a mini-republic leased to the Russian Federation, it was originally chosen by Soviet officials for its distance from settlements and prying eyes. The working spaceport contains relics from the glory days of Yuri Gagarin, the first man to fly into outer space, as well as launch pads for the current Soyuz programme. Somewhere in between lie site 112A and hangar MZK. Here, two incarnations of the Buran rest under a shroud of bird droppings, their cockpits stripped of instruments and their scaffolding in collapse. Explorers describe secretly hiking across the desert under cover of night, before shining their torches into this vast, echoing mausoleum to cosmic dreams.

The more important craft is OK-1K2 'Ptichka' – meaning 'little bird' – the second in the class to be built and intended for its first space mission in December 1991. Its neighbour is OK-MT, a test vehicle that was slated to be burned in the atmosphere as part of an experimental unmanned launch. Neither of these is the original Buran that made the only space flight. This was destroyed at Baikonur in 2002, when the roof of its hangar collapsed in an earthquake, resulting in the deaths of eight workmen. Broken instruments and torn blueprints are strewn around the complex. The buildings are occasionally patrolled by guards and, more regularly, by bats, which flit about the cathedral-like heights.

Where the American Space Shuttles occupy pride of place in national museums, these spacecraft have been left to decay in the desert. They are deeply ambiguous objects. On the one hand, they are a symbol of the past: of the Cold War, the space race and the former USSR, whose fragmentation left them marooned in Kazakhstan, far from Moscow. On the other, they whisper of an alternate future: of voyages never made, discoveries never celebrated, corners of the cosmos uncharted. In a small way, they offer a vision of a 21st-century Soviet Union.

1. In the foreground: 'Ptichka', an orbiter that was planned to dock with the space station Mir in 1991.

The working spaceport contains relics from the glory days of Yuri Gagarin, the first man to fly into outer space

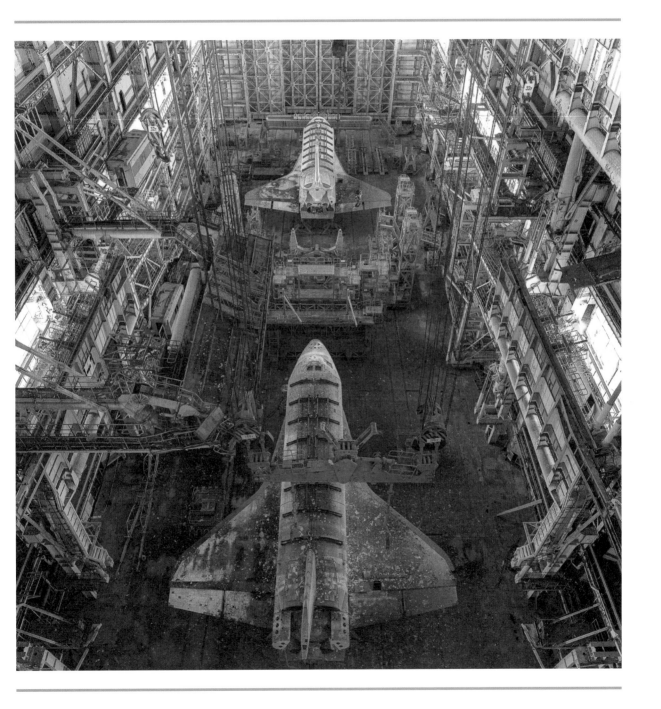

Mo'ynoq Ship Graveyard

43° 47′ 4.1532′′ N, 59° 1′ 29.784′′ E

ARAL SEA, UZBEKISTAN

Little ships wrecked in a desert when the sea disappeared

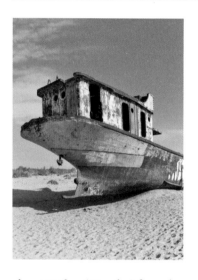

Left: A ship rests on a sandy bed in the former Aral Sea.

We are confronted almost daily with predictions of environmental collapse and an irretrievably altered world. We are asked to imagine scenarios of dying seas and furnace-hot temperatures, collapsing industries and broken food chains – a new epoch in which we become refugees in landscapes we can no longer recognize as home. Around the Aral Sea, this is not a hypothesis for a distant future, but a history of the recent past. Here, mankind drained a once-vast sea, an act of destruction wrought with the suddenness and scale of a vengeful god. In Mo'ynoq, Uzbekistan, this has left a stark symbol of environmental disaster: beached fishing boats, about 150km (93 miles) from the nearest water.

Half a century ago, the Aral Sea was the world's fourth largest lake – its name derives from Turkic languages as the 'Sea of Islands', for the islets and archipelagos that once rose from its fathoms. In the 19th century, Russian warships were hauled overland to sail its leagues. By the Soviet era, the local fishing industry reputedly employed some 40,000 people, hauling in catches for dinner tables across the USSR. Like the Dead Sea and the Caspian Sea, the Aral Sea was an endorheic lake: a body of water into which rivers fed, but from which none flowed outwards to the ocean.

UZBEKISTAN

MO'YNOQ
SHIP
GRAVEYARD

NUKUS

TURKMENISTAN

Into its northern shores flowed the Syr Darya, gorged on the meltwaters of the Tian Shan. Into the south swept the Amu Darya (known as the Oxus in antiquity), traversed by the armies of Alexander the Great and, later, Genghis Khan.

In the 1960s, the Soviet authorities resolved to divert the rivers' waters to irrigate vast swathes of the Uzbek Soviet Socialist Republic (now Uzbekistan), planning to turn the region into a cotton superpower. This proved devastating for the Aral Sea. By 1997, it had shrunk to 10 per cent of its former surface area. As the waters receded, its islands became peninsulas; the peninsulas, in turn, became absorbed into the mainland. Freshwater fish populations vanished as the waters became increasingly saline. Mo'ynoq's story is much the same as other towns along the Aral Sea. For some years, the fishermen chased the shore as it crept across the horizon but, eventually, there were no fish left worth catching. They abandoned their boats on the parched seabed, their hulls to never again know the hush of the tide.

Mo'ynoq is now a depopulated town on a dead-end road near the Kazakh border. There are echoes of its heyday as a fishing port: derelict canning factories and Soviet monuments depicting leaping fish and foaming waves. Inside its museum are more sad mementoes: taxidermized seabirds, paintings of fishing boats bobbing in blue harbours.

Today, those same fishing boats lie beached and rusting in the sagebrush just beyond the town. They are humble vessels, far removed from the Moscow committees that authored their doom. Their remains rattle and creak in the arid air, sometimes providing shelter from the sun for passing cows or camels. Where other boats across the Aral Sea have been broken down for scrap, this little armada has been left to wither as a memorial to the vanished sea.

The collapse of the Aral Sea continues to have a human impact. Pesticide runoff from upstream – along with dust storms and Soviet-era biological weapons testing – has led to high incidences of cancer, lung disease and infant mortality among local communities.

Recent decades have seen efforts to save the last surviving patch of the Aral Sea in Kazakhstan by damming but, as with many environmental issues, it is a project contingent on cross-border cooperation and a sense of collective responsibility. Lying on the Uzbek shore, Mo'ynoq doesn't stand to benefit from these plans.

1. The ship graveyard seen from a rocky bluff just to the north of Mo'ynoq.

2 & 3. Old ships in advance stages of decay.

This little armada has been left to wither as a memorial to the vanished sea

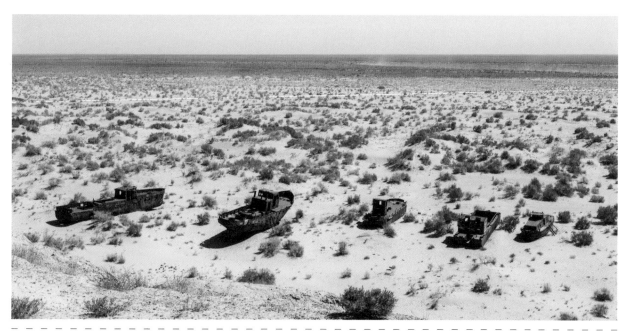

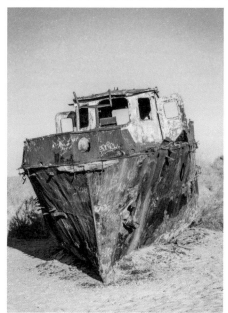

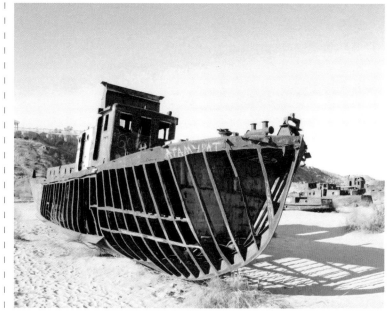

Aniva Lighthouse

46° 1' 4.872'' N, 143° 24' 55.368'' E

SAKHALIN, RUSSIA

A lighthouse stands watch at Russia's far frontier

Russia is a country the size of a continent. In the west, its borders touch the forests of Poland. In the east, on the last speck of Russian territory before you reach Japan stands the Aniva Lighthouse – on a map, the temples of Hokkaido seem within touching distance. This abandoned building is a legacy of an old rivalry between these two powers, tussling for hegemony over the Pacific.

The lighthouse lies at the tip of a dagger-like peninsula on Sakhalin, the largest island in the Russian Federation. The surrounding southern part of the island was settled by the Japanese from the 17th century onwards, with Russians establishing penal colonies in the north in the 19th century. Control seesawed back and forth: Japan ruled the island as far as the 50th parallel following the Russo-Japanese War of 1905, before seizing the opportunity to snatch all of Sakhalin during the upheaval of the Russian Civil War. The Soviet Union then regained its foothold in the north in the 1920s.

The Aniva Lighthouse was built by the Japanese in 1937 to guard over a treacherous strait, where thick mists had doomed many ships, and to help guide military supply boats shoring up the frontier with the Soviet Union. It took two years to build the concrete tower, which rose 31m (100ft) over its rocky islet.

Left: The lighthouse at the southern tip of the Tonino-Aniva Peninsula on Sakhalin.

SAKHALIN

SEA OF

OKHOTSK

YUZHNO-
SAKHALINSK

ANIVA
LIGHTHOUSE

SEA OF

JAPAN

WAKKANAI

JAPAN

A few days before the end of the Second World War, the Soviet Union invaded the southern part of Sakhalin: for some soldiers, it seems likely the glint of Aniva's beam signalled the end of combat. It remained staffed by the Soviets until 1990, when it was reportedly converted to be an automated nuclear-powered lighthouse. As the age of GPS dawned, it was wholly abandoned by 2006.

Today, it stands steadfast on its salty domain, weathering the fiercest Pacific storms and welcoming only the most determined of explorers who arrive by motorboat. It makes for a dramatic sight: less a lighthouse, more a fragment of Atlantis rising from the spray, gulls orbiting around its tower. Someone has graffitied 'Radiation' in Russian on an exterior wall but it is not clear how much of a risk this is: visitors step inside through the rusted doorway undeterred. The elements, too, have found their way inside: there are interfaces corroded by sloshing seawater, tangled wiring and obsolete switches – all of it seasoned with bird droppings.

A small sign announces to guests: 'You are currently at the very tip of the island of Sakhalin – keep the place clean and orderly!!!' Days of order and cleanliness are a distant memory: the windows are broken, the oven in the kitchen is rusted, there is a rickety bed that appears not to have been slept in for decades. Or, then again, perhaps not. Some visitors claim to have spent the night in the lighthouse, falling asleep to the sound of breaking waves below. The lamp seems to be in good condition – its beam was said to travel some 28km (17½ miles) out into the surrounding seas.

It would have been a lonely station for the Japanese, Soviet or Russian keepers who lived here for weeks on end, at the obscure edge of their homelands, where sovereignty frayed into the sea. To this day, the governments of Russia and Japan still dispute ownership of the Kuril Islands, out to the east of Sakhalin – a diplomatic wrangle much debated in the chambers of power. The Aniva Lighthouse, on the other hand, seems largely unwanted by anyone, except perhaps circling gulls.

1. All visitors to Aniva must land boats by the rocky islet on which the lighthouse stands.

Aniva Lighthouse weathers the fiercest Pacific storms and welcomes only the most determined of explorers

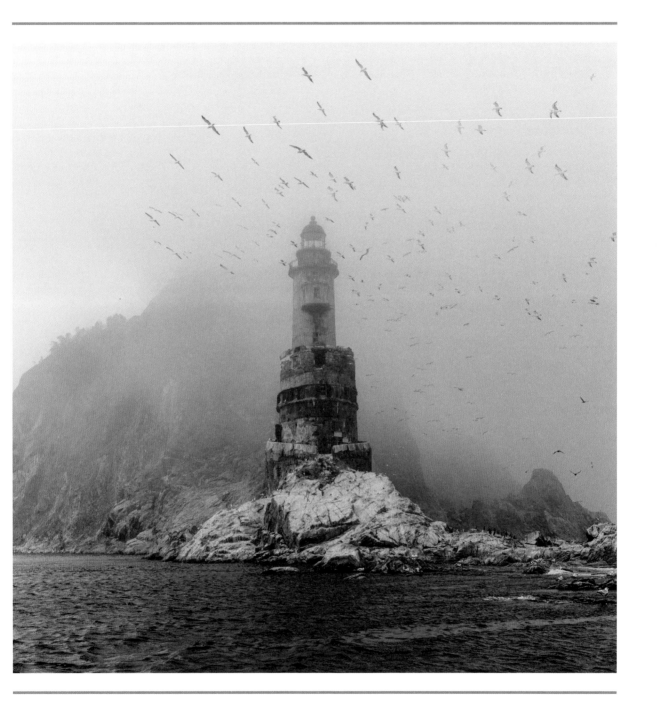

Hồ Thuỷ Tiên Waterpark

16° 24' 28.728'' N, 107° 34' 42.852'' E

HUE, VIETNAM

A waterpark where crocodiles lived on after humans left

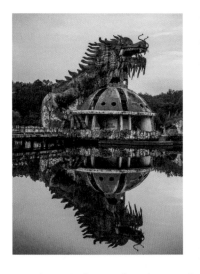

Folklore tells that Vietnamese people are descended from a dragon, and that the nation is shaped like a dragon in motion. Statues of dragons flank the gateways in the Imperial City of Hue, from which Vietnamese emperors ruled. On the outskirts of Hue is another dragon, less revered than its imperial siblings – its scales swathed in graffiti, its upper lip moustachioed with foliage – rearing up to breathe fire over an algae-strewn lake. This dragon forms the centrepiece of the Hồ Thuỷ Tiên Waterpark, an abandoned theme park that has become a mythical beast among visitors to Vietnam.

Left: **The Hồ Thuy Tiên Dragon, within which real crocodiles once lived.**

The Hồ Thuỷ Tiên Waterpark was first opened by the Hue Tourism Company in 2004 at a cost of some 70 billion Vietnamese dong, about £2 million. It was only half-built when it opened, but nonetheless boasted an aquarium, restaurants, stages for musical performances, water slides and swan pedalos that swam under the benign gaze of a glittering golden dragon. Beyond these facts, there is little information about the park, although it seems that Hồ Thuỷ Tiên sank rather than swam. It closed in 2006, and was to be part of an ecotourism development in 2013 – plans that came to nothing.

E A S T

V I E T N A M

S E A

HỒ THUỶ TIÊN
WATERPARK

DA NANG

L A O S

V I E T N A M

Since being closed, Hồ Thuỷ Tiên's post-apocalyptic allure has seen it become arguably more popular than it was when open. To enter, explorers must go through a faded yellow gate proclaiming 'Trung Tâm Vui Chơi Giải Trẻ' ('Youth Entertainment Centre') and a 'security guard' may appear to explain the site is closed due to health and safety concerns, or else to ask for a small fee.

From here, a path winds through the woods to the dragon itself, where you can follow a staircase that climbs three storeys up to its mouth for views over a dingy lake. The dragon squats atop a dome structure that houses an aquarium strewn with smashed glass. Legend goes that here three crocodiles lived on long after the park was shut. Surviving for years on the generosity of backpackers (who, stories go, fed them live chickens), they were eventually sent to retire in another wildlife park – though unsubstantiated rumours of feral crocodiles still swirl around the site. In their absence, a docile herd of cows can be seen wandering about the ruins.

On the lake's western shore there are other relics: tube slides that swoop through jungle, and children's pools with little fibreglass elephants and fairy toadstools arranged around fetid water. There is an open-air stage where audiences once perched on yellow and blue seats, a graffiti-swathed simulator labelled 'Thrillrider', and a little blue car for children to climb on – adorned, of course, with a Vietnamese dragon.

Perhaps because of the tales of crocodiles and the dragon, many visitors refer to Hồ Thuỷ Tiên as a real-life *Jurassic Park*. A better comparison would be Miyazaki's classic animation *Spirited Away*, in which a young girl enters an abandoned theme park that takes on a life of its own after dark. Theme parks promise a chance to cross the threshold to another realm. Hồ Thuỷ Tiên is still true to its promise, though this realm is now one of decay, dishevelment and dragons who have lost their golden lustre.

1. Abandoned waterslides drop into fetid water.

2. The open-air theatre where performances were once staged.

3 & 4. More waterslides snake through resurgent forest.

Its post-apocalyptic allure has seen it become arguably more popular than when it was open

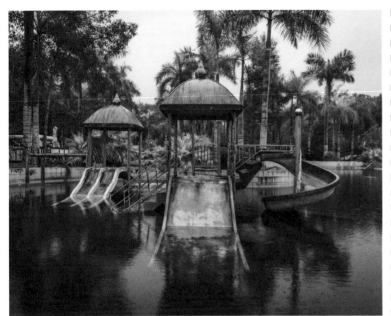

Fukushima Red Zone

37° 24' 5.904'' N, 140° 56' 56.796'' E

FUKUSHIMA, JAPAN

A corner of uninhabited Japan

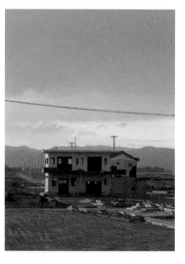

Left: A house in the town of Naime, a little further inland from Okuma.

Many abandoned places offer a kind of time travel, transporting us to the moment they were forsaken. In Pompeii, we might travel two millennia to the day the rocks rained down from Vesuvius. In Pripyat (see page 54), we might cross four decades until the morning that smoke rose over the Chernobyl reactors. To set foot in Okuma, Fukushima, is to traverse back a short time to 2011, on a Friday afternoon, when a wave thundered onto the shore and claimed almost 20,000 lives across Japan. In time-travel terms, the journey is short but its significance is far-reaching. Urbexers are normally comfortable vaulting barriers, evading guards, even risking dangerous radiation, but in Okuma there is an additional element of trespass: intruding into a scene of recent tragedy, and a region still in deep shock.

Until 2011, Okuma was a town of some 11,000 on Japan's Pacific coast. Between the little town and the sea lay the Fukushima Daiichi Nuclear Power Plant. On 11 March, an earthquake triggered the immediate shutdown of the reactors; 50 minutes later, the following tsunami flooded the diesel generators needed to circulate cooling water, leading to a series of nuclear meltdowns and hydrogen explosions. Okuma was abandoned, and a 20-km (12½-mile) exclusion zone imposed around the site.

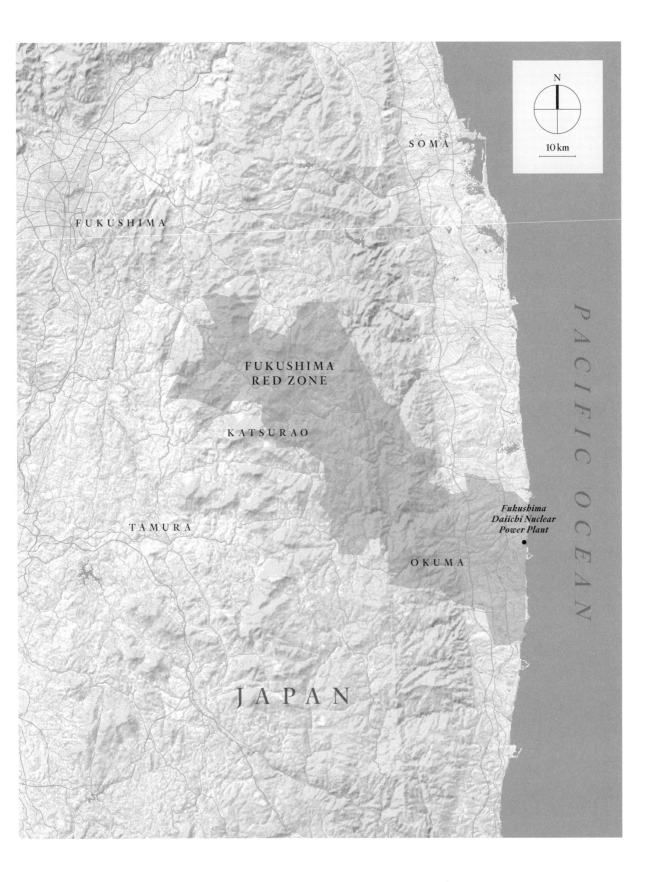

SOMA

FUKUSHIMA

FUKUSHIMA
RED ZONE

KATSURAO

*Fukushima
Daiichi Nuclear
Power Plant*

TAMURA

OKUMA

JAPAN

PACIFIC OCEAN

N

10 km

As the path of the fallout became clear, the exclusion zone was adjusted to a corridor extending to the northwest of the power station, at the heart of which lay Okuma. Since then, much of the town has been obstructed by roadblocks, patrolled by police, and chronicled by only a few intrepid urbexers.

Their accounts describe a place still setting out on its journey of abandonment: the doors are locked, the vending machines are stocked with soft drinks and – strangely – the traffic lights still work, changing from red and green over streets lined with weeds. There are other small signs that something is awry. The potted plants have died, tiles have slipped from rooftops, headstones have toppled over in the cemetery – perhaps earthquake damage or else a legacy of the years in which no repairs have been made.

Nearby, the library is neatly stocked with unread volumes, and writing is still chalked on the blackboard in the schools. Supermarkets are far more chaotic. Ravaged by animals or human scavengers, their floors are lined with rotted products and garlanded by cobwebs. In Okuma, it is still 2011: shops sell CDs and discounted PlayStation 2s, Nelson Mandela is still alive, and Osama Bin Laden has not been found.

As with Chernobyl, predictions of future deaths from the Fukushima Nuclear Incident vary widely, ranging from small numbers to many hundreds. As with Chernobyl, Okuma might be seen as a grim premonition of a future in which humanity has lost control of the powerful technology it created. Where the rest of Japan's Pacific Coast has seen rapid redevelopment after the tsunami, Okuma has been sealed off as an archive of that day in March. There is, however, good news: a new Okuma town hall has been established to the southwest, and in 2019 some 40 per cent of the exclusion zone was deemed safe for habitation – albeit with only 50 people choosing to return.

Out of respect, urbexers seem to have largely stayed out of homes belonging to people whose lives have continued elsewhere. Here, there must be mementoes of that Friday morning in March – plates unwashed in the sink, laundry in the drier – markers of a time when the cherry blossoms were starting to bloom across Japan, before the earth shook and a wave hit the shore.

1. An Okuma supermarket, ravaged by animals, humans or perhaps earthquakes – photographed five years after the incident.

Okuma has been sealed off as an archive of that day in March

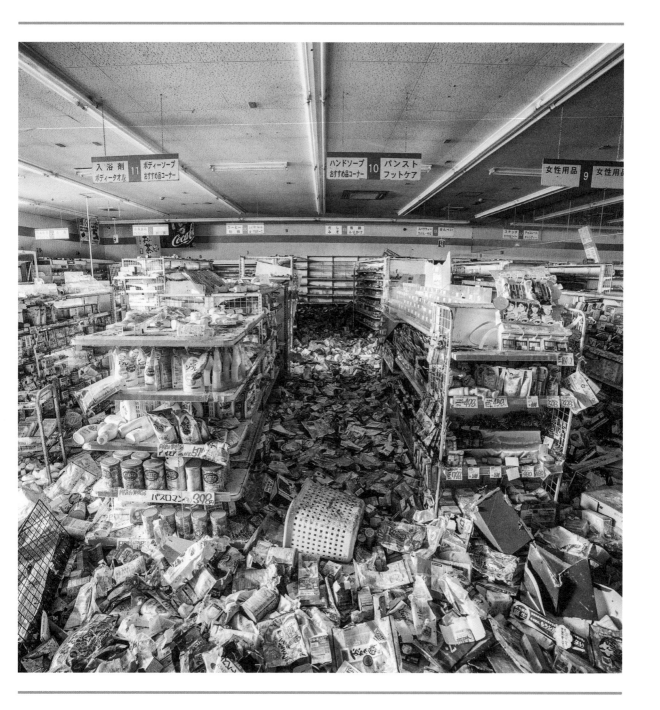

Hashima

32° 37' 40.224'' N, 129° 44' 18.708'' E

EAST CHINA SEA, JAPAN

A coal-mining island adrift in the East China Sea

Hashima is known locally as Gunkanjima, meaning 'battleship island'. Seen from above, it is easy to understand how it might easily be mistaken for a warship, with its long, thin profile tapering to a point like a bow. Its puffing chimneys might once have brought to mind a passing steamer. There are steep sea walls that could be a hull, and tower blocks that suggest a bridge where sailors stood watch. Hashima is, nonetheless, an island, albeit one unlike most others: just about every centimetre of its 6.5 hectares (16 acres) has been tarmacked, concreted and built upon. However, for the past half century, it has been abandoned – a ghost ship of stone, wrecked in the East China Sea.

Left: The landmass of Hashima resembles a ship at sea.

Hashima lies 15km (9 miles) away from the Japanese city of Nagasaki. Coal was first discovered here in 1810, and from the 1890s to the 1970s, the island served as a coal mine owned by the Mitsubishi Group, tripling in size as land was reclaimed from the surrounding waters. Mine shafts were drilled beneath the island, some sinking as deep as 1km (½ mile). The mine eventually metamorphosed into a little community out among the waves. It was home to a kindergarten, a school, a swimming pool, a cinema and a games arcade, as well as rooftop gardens tended by miners savouring the sunlight.

3 km

NAGASAKI

JAPAN

HASHIMA

EAST

CHINA

SEA

Hashima claimed a peak population of around 5,000, making it one of the most densely inhabited landmasses on Earth. Susceptible to being battered by typhoons, it became a testing ground for robust modern architecture. It was notably home to Japan's first reinforced concrete tower block.

During the Second World War, prisoners of war and forced labourers from Korea and China were put to work in the mines of Hashima. An estimated 1,300 perished amid lethal working conditions and malnutrition. In modern times, South Korea has objected to Hashima's listing as a UNESCO World Heritage Site, citing Japan's failure to acknowledge wartime brutality on the island. Hashima was abruptly abandoned in 1974 as petroleum came to displace coal in Japan, and it has been left to the elements ever since. Only in 2009 did the island open to guided tours, following a proscribed route along the southern shore, which has been deemed safe.

The skeletal monoliths of tower blocks and streets strewn with rubble present an extraordinary sight. In recent years, surveyors have found that the steel components of reinforced concrete have been corroded by the sea air, and have warned that some structures could collapse imminently. Urban explorers claim to have found their own ways to access these dangerous off-limits parts of the island, leaping the fences from the tourist pathway, pursued by guards with megaphones. These fugitive accounts paint a more intimate portrait of the last days of Hashima: little keyboards in the kindergarten, sandals for children whose feet have long since outgrown them, apartments where telephones are off the hook and storms blowing straight from the sea onto the television sets. Other photos show rusted chairs in the barbers, and fetid water in communal baths, where miners scrubbed soot from their bodies.

To some, Hashima is an ominous presence, a Petri dish of decay out at sea, haunted by stories of Second World War cruelty. Perhaps because of this, the island was chosen as the villain's lair in the James Bond film *Skyfall*, though the producers opted to reconstruct it in Pinewood Studios, owing to the dangers of filming on the real-life island. For those who wish to explore it safely, some of Hashima can be seen via Google Street View. In among the pixels, you can see creepers climbing the stairwells and grasses sprouting at the ruined Shinto shrine that crowns the island's highest point. New life is springing up from the dark earth into which miners descended, rising to meet the sun.

1. Fallen masonry and collapsing tower blocks are a common sight on Hashima.

2. A ruined bathhouse, looking out to the island's highest point.

3. Decaying timbers in a tower block courtyard.

4. A broken telephone and TV left in an abandoned apartment.

For the past half century Hashima has been a ghost ship of stone, wrecked in the East China Sea

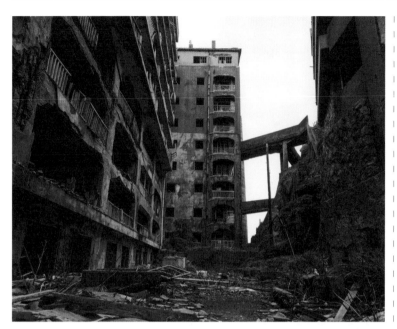

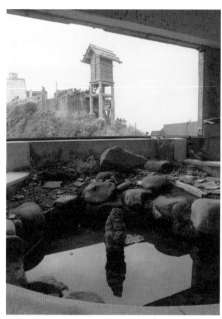

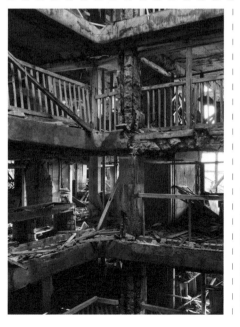

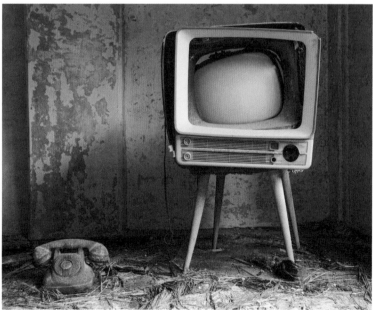

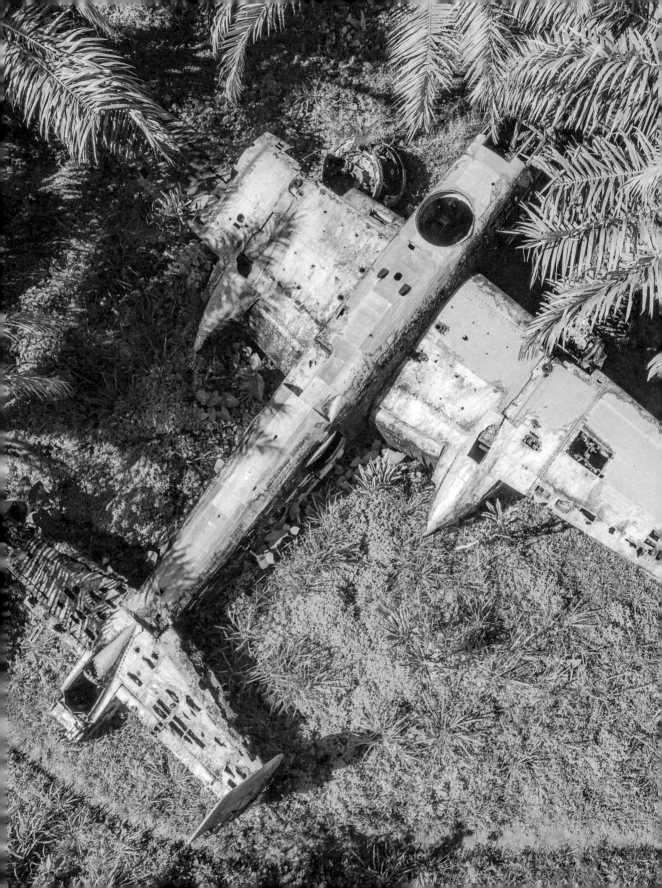

Oceania

Wittenoom

22° 14' 23'' S, 118° 20' 05'' E

WESTERN AUSTRALIA

An ordinary outback town beset by tragedy

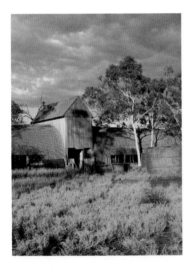

In 2006, the Government of Western Australia announced that Wittenoom would officially no longer be a town. Its electricity supply was to be cut off and its last residents moved on, its name removed from maps and the lettering scrubbed from road signs. Instead, anyone driving through the burnt red landscape of the Hamersley Range would see another sign: 'Danger – Asbestos in this Area – Do Not Stop'. Many towns in the Australian interior have prospered out of mineral exports. Wittenoom is not one of them. Here, disturbing ancient strata of outback rock proved a curse – and a source of ongoing tragedy.

Left: The old Catholic convent in Wittenoom, where Mario Hartmann is reported to have formerly lived.

Asbestos was first mined in the area around Wittenoom in the 1930s. In 1948, an informal miners' camp grew into a town. Claiming a peak population of 20,000, Wittenoom had its own post office, hotel and school. Pictures of the town's early years show smiling children playing in the street, and men chatting in the sunshine outside the pub. Those photographs also show asbestos-shovelling competitions, and sack races across asbestos tailings. In two decades, Wittenoom produced 161,000 tonnes (177 US tons) of blue asbestos, commonly used for insulation for steam engines and piping. It is now widely believed to be among the deadliest kinds of asbestos.

WITTENOOM

AUSTRALIA

INDIAN
OCEAN

PERTH

N

100 km

In 1948, English-born doctor Eric Saint moved to Western Australia to work with the Royal Flying Doctor Service, an airborne medical organization that serves remote outback settlements far away from hospitals. In Wittenoom, he noted the absence of dust extractors in the mine and alerted the mining company to the health risks. His warnings went ignored. As years went by, other doctors noticed cases of asbestosis and lung cancer among locals. The mine became unprofitable and, in 1966, it shut – 20 years after the first warnings, just as the world was waking up to the lethal risks of asbestos.

In the years since, 2,000 residents are estimated to have died as a result of inhaling asbestos fibres – new conditions among former child residents are still being reported – and the mine's former owners have been subject to court cases. Wittenoom is often cited as the country's deadliest industrial disaster and forms part of the largest contaminated area in the southern hemisphere, known as 'Australia's Chernobyl'.

But there is a difference. While the Chernobyl Exclusion Zone is officially open to some kinds of tourism, visiting Wittenoom is emphatically discouraged: strains of asbestos still blow along the streets, the smallest exposure to which can have health consequences. Film crews have ventured into the town clad in PPE. Their footage shows the fuel pumps of the gas station, the rusting kitchen inside Doc Holiday's Cafe (which still bears its signage) and a derelict phone box. Many of Wittenoom's bungalows have been demolished to deter looters. In modern times, influencers have used Wittenoom as a backdrop for social media posts, inviting the ire of many Australians for whom this ghost town is still populated with painful memories.

In truth, though, Wittenoom is not quite a ghost town. Efforts to clear the town of residents have been only partially successful: of the six people here in 2015, one remains at the time of writing. Austrian immigrant Mario Hartmann came to Wittenoom in the 1990s. He survives in a bungalow with the help of a solar power system and a vegetable patch, shooting passing kangaroos to feed his dog. He claims thus far to be free of disease. For him, it seems, breathing the lethal air of Wittenoom is the price of living in a town that has slipped off the map.

Everyone else passing through Wittenoom is advised to stay inside their car at all times with the windows up. Or, better still, stay away entirely.

1. An aerial view of Wittenoom showing where houses have been demolished, though the street plan remains.

Wittenoom forms part of the largest contaminated area in the southern hemisphere

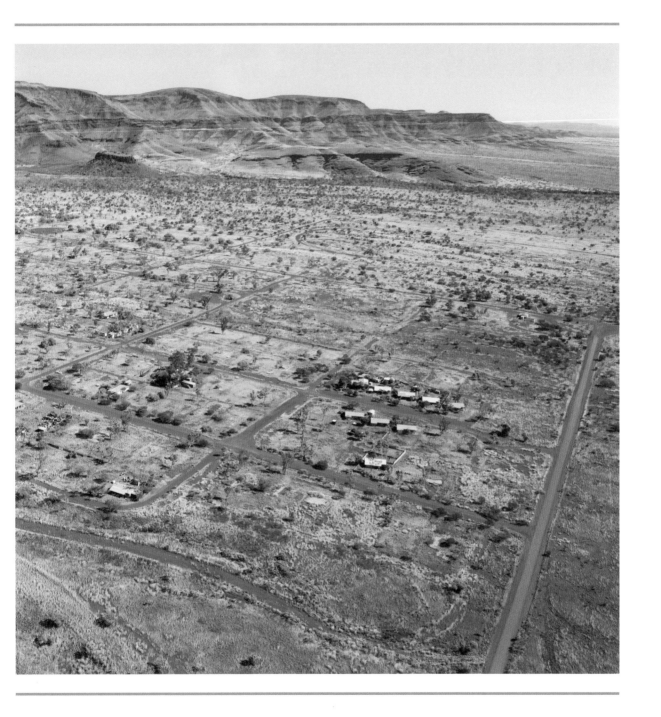

Wrecks of Homebush Bay

33° 49' 57.144'' S, 151° 4' 36.3'' E

SYDNEY, AUSTRALIA

Seafaring ships where nature has staged a mutiny

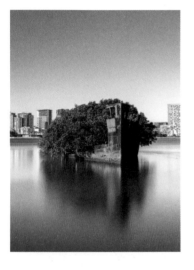

In Sydney Harbour, you can find boats of all species: cruise ships creeping beside Circular Quay, speedboats sweeping beneath the Opera House, flotillas of yachts bobbing among the inlets. Close to the westernmost point of the harbour is Homebush Bay, on whose waters floats one of the strangest vessels anywhere in the world: the SS *Ayrfield*, also known as the Floating Forest.

First established by Irish surgeon D'Arcy Wentworth in the 19th century, Homebush Bay was once a site of heavy industry, noisy with a state brickworks, an abattoir and an armaments depot. By the 1960s, industrial decline had set in and it served as a dumping ground for toxic waste and a wrecking yard for ships, the SS *Ayrfield* among them.

A steel-hulled collier (a coal-carrying ship), the SS *Ayrfield* was built in 1911 as the SS *Corrimal* on the Firth of Forth in Scotland. Within its first year, the ship had sailed past the battlements of Edinburgh Castle and the rise of Arthur's Seat to its new home in Sydney Harbour. The ship spent the Second World War shuttling US troops about the Pacific Islands, and by the 1950s it was transporting coal from Newcastle, New South Wales, to Sydney's Blackwattle Bay, puffing beneath the span of the Harbour Bridge –

Left: The SS *Ayrfield,* one of the wrecks in Homebush Bay, with the suburb of Rhodes just beyond.

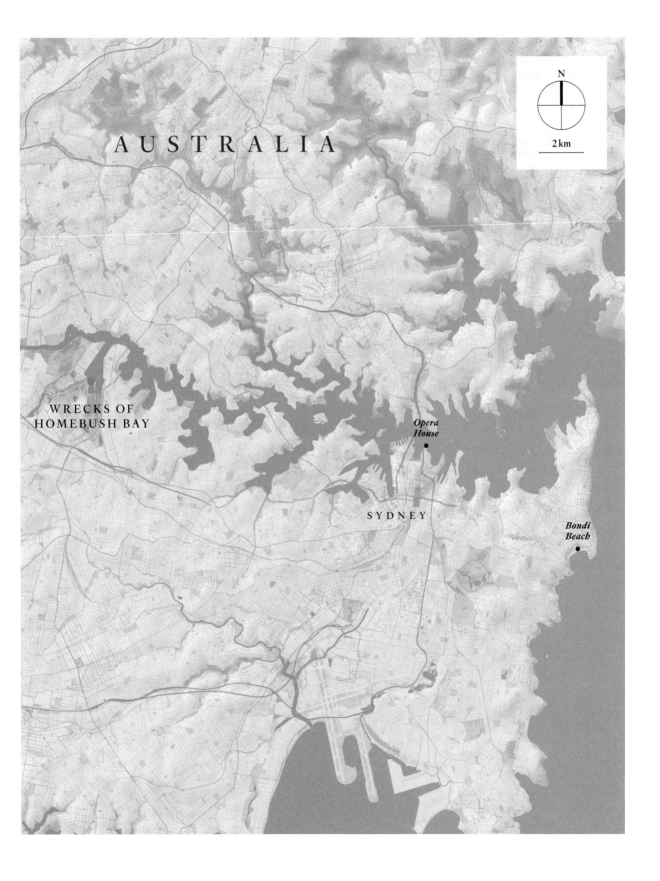

AUSTRALIA

N

2 km

WRECKS OF
HOMEBUSH BAY

*Opera
House*
●

SYDNEY

*Bondi
Beach*
●

then just two decades old. Eventually, the *Ayrfield* was sold for scrap. It made its final homecoming to Homebush Bay in the 1970s.

As the ship awaited its fate, the value of scrap metal crashed and wrecking yards went out of business. The *Ayrfield* was destined to be slowly dismembered not by saws and wrenches, but by the gentler hand of Mother Nature. The abandoned ship now is rusted and covered in barnacles, its masts and chimney gone. What is most remarkable is its cargo – not coal but verdant mangroves, a miniature forest that surges out of the hull. It is thought that these mangroves owe their existence to visiting birds who came to perch here, covering the decks in droppings and depositing seeds until there was enough accumulated soil for trees to take root and flourish.

There are other ships in Homebush Bay that have experienced the same fate as the SS *Ayrfield*, sold for scrap and now semi-sunken in their watery graves. Built in Tyneside, England, its neighbour is the SS *Mortlake Bank*, now a perch for silver gulls and pied cormorants. Closer to the bank is the appropriately named SS *Heroic* – a tugboat also built in Tyneside that served as a rescue ship during both world wars. It most famously rescued the *Allara* – a sugar-carrying freighter torpedoed by a Japanese submarine in 1942 – and had the distinction of towing RMS *Queen Mary* into Sydney Harbour. The *Queen Mary* today attracts countless tourists at its permanent mooring in Long Beach, California, and is home to a hotel and restaurants. The *Heroic*, like the *Ayrfield*, is a home to mangroves and visiting seabirds.

Mangroves are cited as one of humanity's greatest weapons against climate change: they store vast amounts of carbon, serve as a bulwark against coastal flooding and provide a rich ecosystem in which birdlife and marine life can flourish. Mangroves have granted a second wind to SS *Ayrfield*: it is more photographed and known in its afterlife than it was in active service. We know how swiftly and capably nature can reclaim abandoned spaces on land. In Homebush Bay, it has proved so on water, too.

1. The 1941-built Navy ship HMAS *Karangi*, with the SS *Heroic* on its starboard side.

The ships in Homebush Bay are now home to mangroves and seabirds

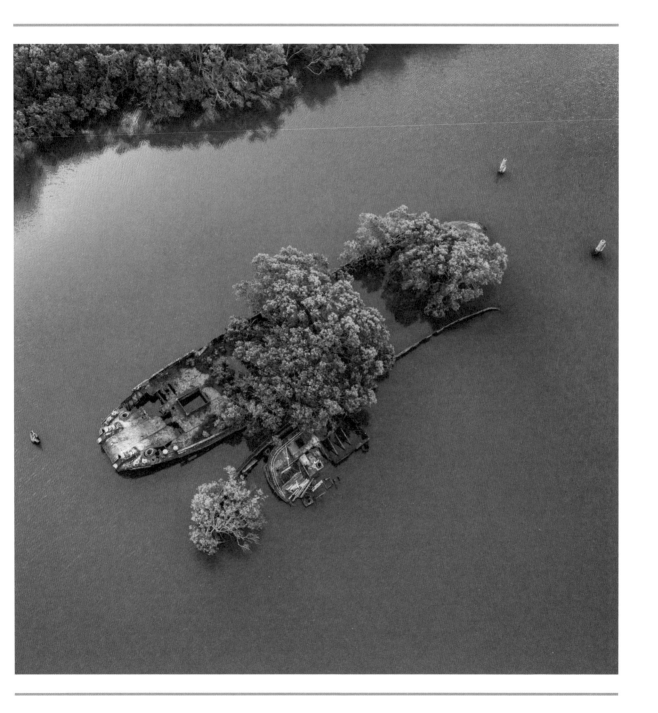

Port Arthur

43° 8' 51.432'' S, 147° 51' 0.972'' E

TASMANIA, AUSTRALIA

A penal colony at the end of the world

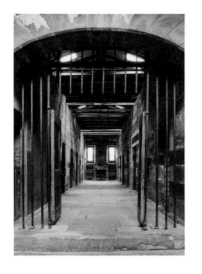

In 19th-century Britain, even petty criminals were sent to Australia: for the price of a stolen wallet or a rustled sheep, they were dispatched by convict ship to the far side of the world. Those who dared reoffend in the colony might in turn find themselves dispatched to the far side of Australia, to the penal settlement at Port Arthur, Tasmania. It is a place whose name travelled with tales of suffering and isolation. For Australians of British heritage, it is one of the oldest marks of their ancestry in the hemisphere. For this reason – and others – it continues to have a profound meaning for the nation.

Left: Inside the Separate Prison at Port Arthur.

Port Arthur began as a small timber station in the 1830s, and soon evolved into a penal settlement. Set at the tip of the rugged Tasman Peninsula, its geography conspired to keep prisoners separate from the rest of the world. It was surrounded on three sides by supposedly shark-infested waters, which stretched south, uninterrupted, to Antarctica. The only escape route to civilization was to the north, via the isthmus of Eaglehawk Neck, where a narrow strip was watched over by prison guards.

The penal settlement was a hive of industry, a centre of shipbuilding and logging. The mid-19th century saw the start of construction of the so-called Separate Prison.

TASMANIA

PORT
ARTHUR

TASMAN

SEA

This was part of an 'enlightened' Victorian approach of correcting criminals through psychological rather than corporal punishment. Prisoners were hooded, known by numbers not names and kept in darkness on a diet of bread and water. Rather than root out criminality, it is believed to have precipitated many prisoners' mental collapse.

One or two convicts managed to escape: George 'Billy' Hunt dressed up as a kangaroo to hop across the isthmus but hungry guards shot at him, hoping to bag a kangaroo dinner. Hunt then shed his disguise and handed himself in. Many others never made it out alive. On the opposite side of Carnarvon Bay lies the Isle of the Dead, where as many as 1,000 prisoners are buried in mostly unmarked graves. The prison was wholly abandoned in the 1870s.

Port Arthur has since been ravaged by a century of bushfires, and the most significant buildings were never rebuilt after the flames died down. The Penitentiary is now roofless, with some of its bricks pillaged for other building projects. The Law Courts and Hospital are empty husks, while the old church is still crowned by pointed towers, though a grassy lawn now grows in its nave. The Separate Prison is in better shape. Restored in recent times, you can pace echoing stone corridors and sit in the chapel where prisoners once listened to sermons about Christian charity, while hidden from fellow inmates by wooden screens.

For over a century, Australians and foreigners have come in droves to explore the ruins of Port Arthur, in part because it lies at the genesis of the modern nation. By far the saddest ruin of all is the shell of the Broad Arrow Café. In April 1996, Australia suffered its worst massacre in modern times when a solitary gunman descended on the café at lunchtime, killing 35 people – tourists, staff, locals and children among them – and injuring many more. This tragic 20th-century story overlays the already troubled 19th-century ruins. It means that all-comers to this beautiful peninsula must inevitably meditate on crime and punishment, sorrow and loss, and thoughts of loved ones departed to somewhere far away.

1. The Penitentiary, which originally served as a flour mill and granary before being converted to a prison.

2. Windows at the Penitentiary.

3. There are only a few marked graves on the Isle of the Dead, which was reserved for military and free men.

The tragic 20th-century story overlays the already troubled 19th-century ruins

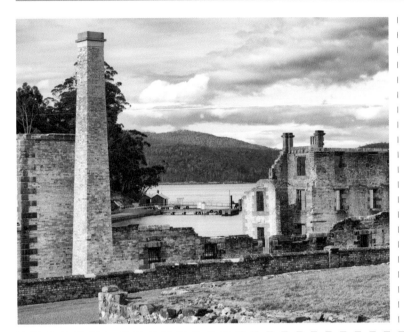

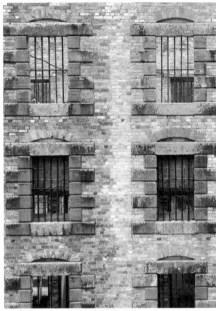

MS *World Discoverer*

9° 1' 22.764'' S, 160° 7' 22.872'' E

SOLOMON ISLANDS

A cruise ship at its journey's end in the Pacific

For 25 years, the MS *World Discoverer* was true to its name. Come the southern hemisphere summer, the ship would steer among the ice floes of Antarctica, passing gale-blown Union Flags in the Falkland Islands, puttering beneath the glaciers and fjords of Patagonia. The ship then migrated northward with the summer, navigating the treacherous channels of the Northwest Passage, the archipelagos of the Bering Strait and the forested Alaskan shore.

Launched in Germany in 1974, MS *World Discoverer* was one of the first of a new class of expedition cruise ship, designed to carry wealthy tourists across the world's wildest oceans. It had cabins for some 137 passengers and a crew of 75, and a sun deck and small swimming pool. Days on board saw holidaymakers taking excursions on Zodiacs – inflatable dinghies that took them up close to Antarctic seabird colonies, whale pods, and even Pacific beaches. Evenings were spent in the on-board theatre, listening to experts lecture on wildlife, history and geography. Surviving photos show passengers cooing at icebergs from the forward deck, dressed for dinner in suit and tie, and the ship moored in tropical sunshine in the Marquesas Islands, one of the most remote island chains in the world.

Left: The aft section of the MS *World Discoverer*.

N

10 km

NGGELA ISLANDS

MS *WORLD DISCOVERER*

IRON

BOTTOM

SOUND

SOLOMON

ISLANDS

At around 4pm on Sunday, 30 April 2000, MS *World Discoverer* was passing through the Sandfly Passage of the Solomon Islands when it hit an uncharted reef. Captain Oliver Kruess issued a distress call and all 99 passengers on board were swiftly evacuated onto another ship. Believing that the hull was pierced and the ship would sink, Kruess decided to beach MS *World Discoverer* in Roderick Bay on the Nggela Islands; he and his crew were later commended for their actions. For a while, efforts focused on salvaging the ship, but civil unrest at the time across the Solomon Islands made this impossible. As years passed, the ship slipped into a slow decay under the effects of the lapping tide and the fierce sun, and its interiors were looted for anything of value. Eventually, salvage was no longer deemed cost-effective.

Its owners, Society Expeditions, conceded defeat by launching a brand-new ship of the same name in 2002, but two years later that new ship was seized by creditors as the company filed for bankruptcy. It means the wreck of the original MS *World Discoverer* has had no owner for approaching two decades. It is, at the time of writing, in legal limbo, listing at a 46-degree angle in a blue bay. Even for urban explorers, the MS *World Discoverer* has seemingly proved out of reach: there are no pictures of its decks, grandly named 'Explorer,' 'Adventurer' and 'Marco Polo.' Set in a little-visited nook of a little-visited country, it is mostly sighted from passing cruise ships or from curious browsers on Google Earth.

The past two decades have seen ferns sprouting in the bridge, and greenery is starting to surge out of the cabins. At some point, the lifeboat on its port side seems to have gone missing and the deck is splintering. The most recent photos of MS *World Discoverer* show the lettering of its name on the bow still legible amid peeling paint. But, as with all shipwrecks, it is gradually being prized apart atom by atom, its remains dispersed by the currents on which they were once borne.

1. The wrecked ship seen from the northeast.

2. The funnel still bears the logo of Society Expeditions.

Even for urban explorers the MS *World Discoverer* has seemingly proved out of reach

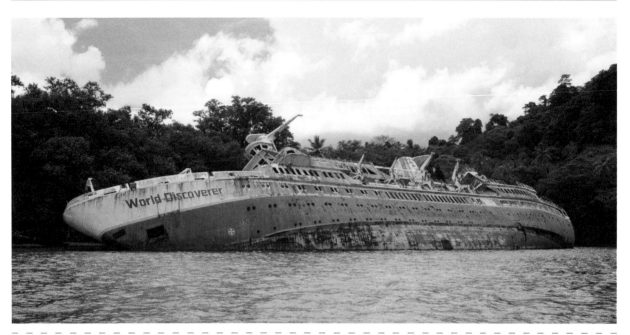

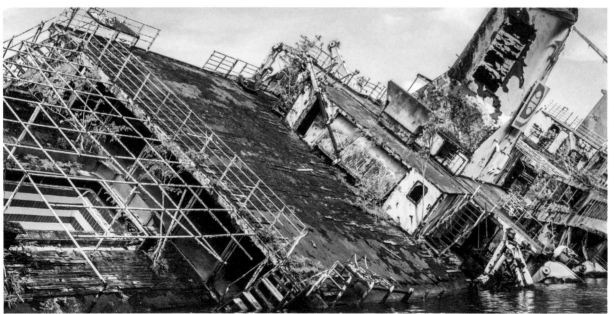

Second World War Remains of Papua New Guinea

9° 41' 3.408'' N, 150° 2' 25.224'' E

PAPUA NEW GUINEA

Historic warplanes grounded among remote Pacific Islands

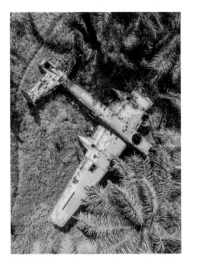

Admiral Yamamoto was commander-in-chief of the Japanese Combined Fleet during the Second World War. The mastermind of the Pearl Harbor attacks, he was a prized target for the Allies. In April 1943, Yamamoto planned a morale-boosting visit to his forces in the Pacific. Setting out to the Solomon Islands in his Mitsubishi 'Betty' bomber, he fell into a trap: American intelligence had decoded his flight plans, and USAAF fighter planes intercepted his convoy over Bougainville, now an autonomous region of Papua New Guinea.

His bomber was shot down and the admiral was found dead under a tree, allegedly still grasping his sword. In another part of the world, it seems likely the wrecked plane may have become a tourist attraction or even put on show in a museum. Here, the wreckage of this seismic historical event has been abandoned in the jungles of Bougainville Island, 6km (3¾ miles) from the nearest track. Visitors describe hacking their way through the foliage to see the Betty bomber emerge from the forest, its wings snapped off and the tail gunner's position watching over a boggy clearing. It is but one of countless aircraft abandoned to the forests, swamps and reefs in one of the least visited parts of the Pacific.

Left: The B-25H Mitchell bomber at Talasea, New Britain, missing its left wing.

N

50 km

B-25H
MITCHELL

KIMBE
BAY
WRECK

NEW BRITAIN

BOUGAINVILLE

ADMIRAL
YAMAMOTO'S
BETTY

B-17-F
FLYING
FORTRESS
BLACK
JACK

SOLOMON

SEA

The New Guinea campaign had begun with the Japanese capture of Rabaul on the island of New Britain in 1942, then part of an Australian-administered territory. The Japanese planned to use what is now Papua New Guinea as a bridgehead for a possible invasion of Australia itself. By 1943, the tide had turned, after fierce fighting in the interior had repelled the Japanese.

The Allies moved to neutralize Rabaul, capturing Talasea Airstrip as they advanced north in 1944. This emergency airfield has long since been lost to a palm oil plantation, though two aircraft linger on to this day, marooned among the lofty palms. Among them is the USAAF B-25H Mitchell, which was searching for Japanese ships off New Britain when it was hit by small arms fire and forced to make a landing at Talasea. One of the wings has been chopped off and plants now sprout in its engine. A Royal New Zealand Air Force PV-1 Ventura suffered a similar fate – its fuselage is now a tunnel of greenery. The airstrip was too short for both aircraft to take off, and so they were left to rust long after atomic bombs were dropped and peace treaties signed.

One of the most legendary wrecks in Papua New Guinea is the USAAF B-17-F Flying Fortress 'Black Jack'. It was flying over the Owen Stanley Range in a storm when both engines failed, and – having run out of fuel – the plane was forced to ditch in a reef near Cape Vogel. The crew managed to escape and swim to shore before Black Jack slipped to the seabed 45m (150ft) below, to be discovered by divers only in 1986. Its rotors and gun turrets are still partly intact – intrepid divers can peek into the cockpit and imagine the last frantic moments as the water rushed closer.

These are but a fraction of Second World War remains littered across Papua New Guinea; the neighbouring Solomon Islands has a similar hoard of aircraft, tanks and ships in states of decay. Machines continue to be discovered, while others, doubtless, remain out there yet to be found. Their ownership is a legal grey area. With unexploded ordnance remaining, some locals have argued that the old Allies should return to clear up their mess, while 'grave robbers' have attempted to ship out valuable finds. For now, these metal ghosts linger on, a reminder of the years when these quiet islands became a battleground contested by superpowers.

1. The Lockheed Ventura lost in foliage at Talasea.

2. A Japanese Donryu bomber at Madang, by the Bismarck Sea.

3. The B-17-F Flying Fortress 'Black Jack' – a holy grail for divers.

4. A Japanese Mitsubishi A6M 'Zero' at Kimbe Bay.

Machines continue to be discovered, while others remain out there yet to be found

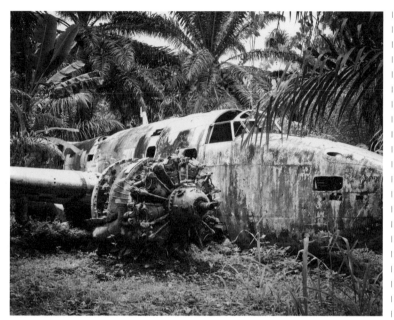

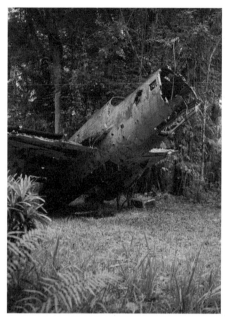

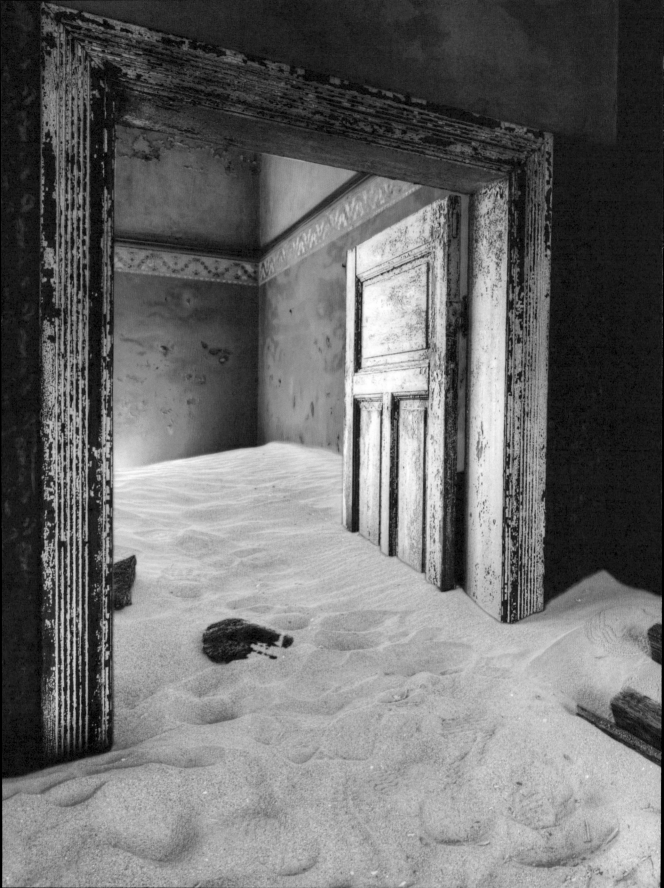

Africa

Shipwrecks of the Skeleton Coast

23° 59' 44.484'' S, 14.27' 27'' E

SKELETON COAST, NAMIBIA

A treacherous, untamed coastline strewn with doomed ships

Left: The wreck of the trawler *Zeila* lies just a few metres from the shoreline.

Look at a satellite map of the African coast, and midway between the rich greens of Angola and the leafy mountains of the Cape is the burnt expanse of Namibia's Skeleton Coast. It is a swathe of desert running to the Atlantic, a coastline largely devoid of settlements, roads, people. The indigenous San people knew it as 'The Land God Made in Anger'. Portuguese sailors named it 'The Gates of Hell'.

To passing sailors it could be lethal: its thick morning fog disoriented navigators, while powerful currents and hidden sandbanks made it easy for ships to run aground, but impossible for even small boats to cast off again. The name Skeleton Coast originally came from the bleached bones of whales and seals that once lined its beaches. More recently, it has come to be associated with the skeletal shipwrecks – big and small, old and new – whose hulls rust along its shore. Today, large numbers lie there undisturbed, far away from scavengers and scrap merchants, just as their sailors were far from help when they first ran aground.

The most famous of the shipwrecks is the MV *Dunedin Star*. Built in Birkenhead, England, this cargo ship had an illustrious career in the Second World War, surviving multiple Italian aerial attacks as part of a convoy relieving the siege of Malta.

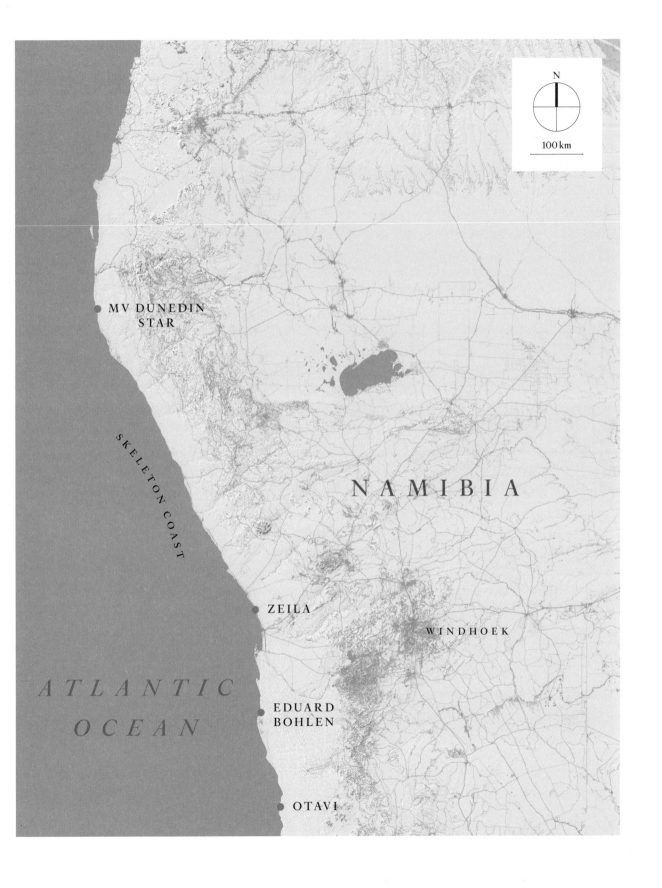

N

100 km

MV DUNEDIN
STAR

SKELETON COAST

NAMIBIA

ATLANTIC
OCEAN

ZEILA

WINDHOEK

EDUARD
BOHLEN

OTAVI

The Skeleton Coast was to be its undoing. Carrying munitions to Egypt in 1942, it hit a reef close to the present-day border with Angola. Rapidly taking on water, 63 on board were evacuated to the beach, as rescue ships rallied from afar. In the ensuing drama, one rescue ship itself ran aground, and a plane that had hoped to land nearby crash-landed in a salt flat. Air-dropped supplies ensured all souls survived in the wilderness until help arrived, though two seaborne rescuers perished. Fragments of the MV *Dunedin Star* are still visible on the beach today, including the bow.

More substantial is the wreck of the German cargo ship *Eduard Bohlen*, which ran aground in thick fog en route to Cape Town in 1909. A century of shifting sands means the boat now lies around 400m (437 yards) inland – its hull warped and broken but still recognizable, its taffrails and bollards still intact, its rudder jammed into the ground. Drifts of sand have submerged the deck – from some angles, the *Eduard Bohlen* looks to be pitching in a stormy sea of sand – under waves that break with the passing decades.

There are many others: the *Otavi*, a steamer wrecked in 1945, now a shelter for a colony of fur seals; a submerged 16th-century Portuguese ship, loaded with gold and ivory; and, more recently, in 2008, the trawler *Zeila*. Sold for scrap, it was en route to Mumbai when it broke loose from its towing and ran aground near Henties Bay. Cormorants now perch on its mast, as waves thunder over the empty deck.

Mighty though these boats might seem, they are but pinprick presences on the immense, primeval swathe of the Skeleton Coast. Some are accessible by road; others lie far beyond the reach of 4×4s and can only be spotted from sightseeing planes. From these cool heights, they might be the only visible imprint of humankind in the burning land below – less like ships on the shore, more like emissaries from another planet.

1. Remnants of the MV *Dunedin Star* at the extreme north of the Skeleton Coast.

2. The *Shawnee* – an American ship – wrecked in 1976.

3. The guano-carrying steamer *Otavi* in Spencer Bay.

4. The stern of the *Eduard Bohlen* rusting in the rolling dunes of the Namib Desert.

Powerful currents and hidden sandbanks made it easy for ships to run aground, but impossible to cast off again

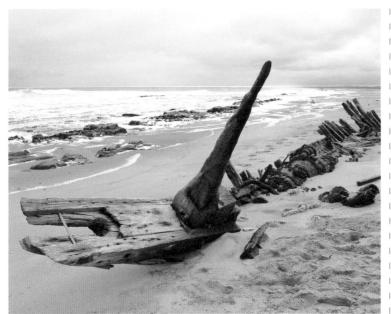

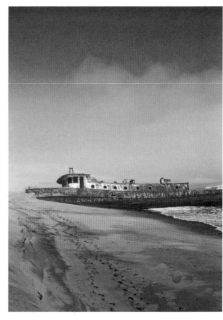

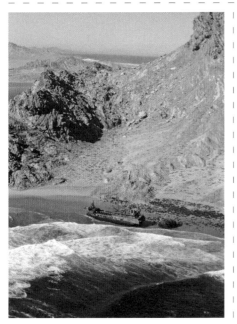

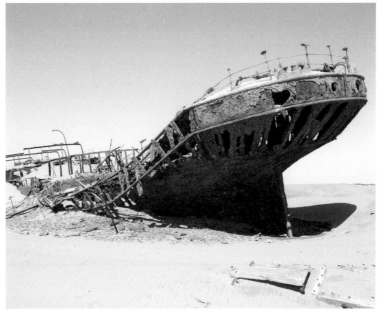

Kolmanskop

26° 42' 13.68'' S, 15° 13' 54.372'' E

NAMIB DESERT, NAMIBIA

A diamond-mining town lost in the sands of time

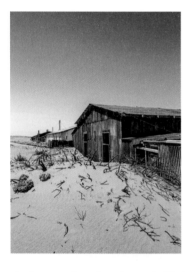

It was said that there were so many diamonds in the deserts around Kolmanskop that by night you could see them glinting in the moonlight. For some time, at least, it seems no one noticed. At the turn of the last century, Kolmanskop was a lonely stretch of railway line in German South West Africa (today, Namibia). Its name translates from Afrikaans as Coleman's Hill. It got its name after an ox-driver called Coleman abandoned his cart on a hillock in a sandstorm. That this event was grounds for the naming of a town might give an idea of how obscure the area was. In 1908, a railway worker by the name of Zacharias Lewala was shifting drifts of sand from the iron tracks when, legend tells, he spotted something shiny in his shovel. His boss sent it for tests. Diamonds had been discovered.

The German colonial authorities declared the region a mining *Sperrgebiet*, meaning 'restricted area', which is still enforced to this day: a zone stretching 26,000sq km (10,040sq miles) from the Atlantic tides to the red sands of the interior. German miners sifted through the terrain on all fours, loading jam jars with diamonds. Out of this accumulated wealth by the first diamond miners grew the prosperous town of Kolmanskop.

Left: A row of buildings under siege from sand in Kolmanskop.

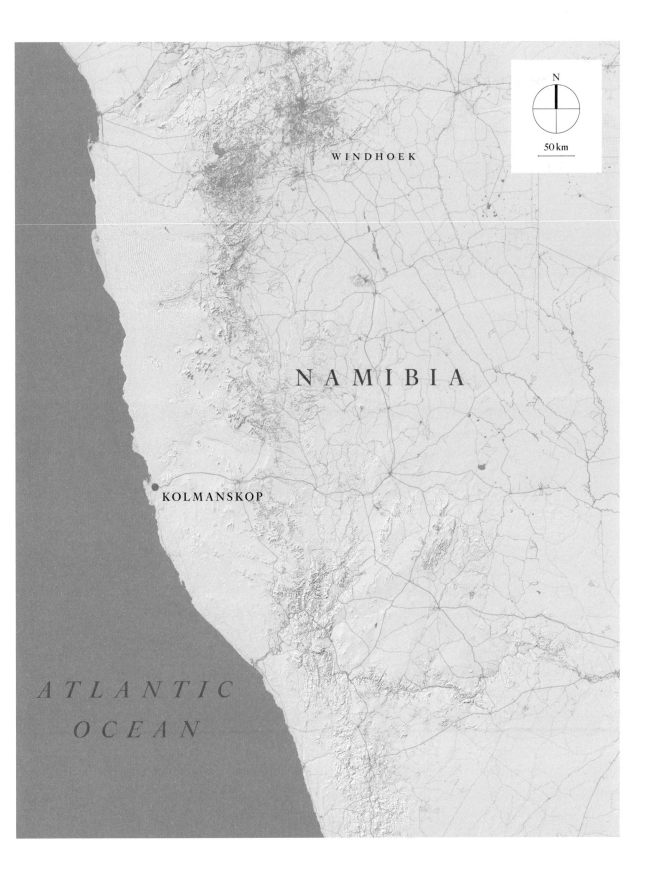

N

50 km

WINDHOEK

NAMIBIA

KOLMANSKOP

ATLANTIC

OCEAN

Kolmanskop evoked Prussian and Bavarian hometowns, thousands of miles and one hemisphere away. It is said the first things built here were the pub and the skittle alley, followed by rows of houses with gable roofs, and grand mansions that had balconies, sun rooms and *Jugendstil* (Art Nouveau) flourishes. In time, a large concert hall welcomed opera companies and orchestras from Europe, while the local doctor is said to have operated the first X-ray machine in the southern hemisphere. Like today's oil-rich Arabian megacities, Kolmanskop was wealthy enough to magic greenery out of the parched desert: water was imported by train and put to use growing eucalyptus, lush lawns and roses. At its peak, the town had 1,300 residents and supplied about 12 per cent of the world's diamonds.

Mining operations hit pause during the First World War, and Kolmanskop was dealt a heavy blow in 1928 when larger diamond deposits were found far to the south. The town clung on for a few decades as a supply base, until the last three families left in 1956.

Kolmanskop ever since has been a visual metaphor for the sands of time. As diamond miners and their families moved out, drifts of windblown sand moved in. Particles slipped in year by year, through broken windows and gaps, onto floors. Where they might once have been swept away by a brush, they now lay undisturbed. Decade by decade, sand heaped as high as the light switches, carrying wooden doors off their hinges. There are few signs of possessions left behind – perhaps they are stories buried under the drifts. A few areas of Kolmanskop remain in good condition: the shopkeeper's house is now a museum, with ledgers telling of the residents' lavish taste for caviar, Camembert and chocolate. Curiously, the skittle alley has been preserved, along with the hall that once reverberated to the strains of lieder and oompah bands.

Unlike some mining towns, Kolmanskop looks to have been a place built with a future in mind. Its houses rest on sturdy foundations – they whisper of people who wanted to put down roots in this thin soil. Diamonds are the world's hardest naturally occurring material, a symbol of eternity and indestructibility, first created in the Earth's mantle between one billion and three billion years ago. The diamond-mining town of Kolmanskop, by contrast, managed little more than 40 years before its slow destruction began, and its sharp outlines became blunted and coarsened by the desert wind.

1. Sand drifts carry doors off their hinges across the old settlement.

Kolmanskop has been a visual metaphor for the sands of time

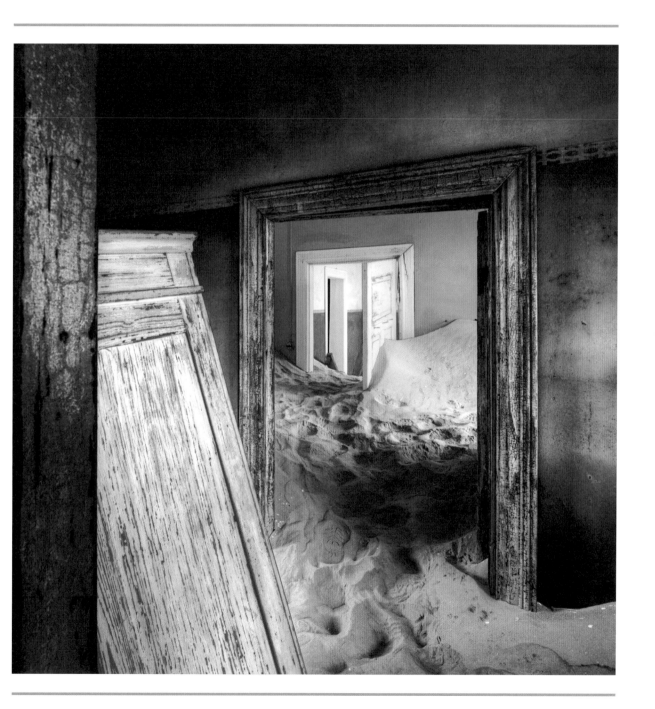

Mobutu's Gbadolite

4° 17' 25.26'' N, 21° 1' 12.144'' E

NORD-UBANGI PROVINCE, DEMOCRATIC REPUBLIC OF THE CONGO

The crumbling glory of Zaire's great dictator

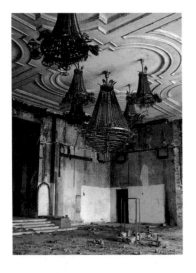

Of the 'Big Man' dictators of 20th-century Africa, Mobutu Sese Seko of Zaire was about the biggest: a tyrannical president who plundered an immense personal fortune from one of the world's poorest countries. The definitive example of Mobutu's corruption was his regular trips to Paris. He would go shopping with Louis Vuitton bags stashed with banknotes, then charter Concorde to fly home to his palace in Gbadolite, the cargo hold loaded with pink champagne.

Gbadolite's runway was extended so it could accommodate the supersonic airliner. Today, that very same airport where Mobutu dismounted to board his Mercedes is partly overgrown with grasses and visited only by a few small UN aircraft. Its grand arrivals hall is mostly empty, its VIP pavilion and control tower derelict. Beyond it lie the ruined palaces of Gbadolite, where Mobutu used to sip his pink champagne and eat caviar only three decades before. The airport, the town and the palaces have become a parable of one man's greed, and the transience of power.

Mobutu came to power as President of Zaire (today, the Democratic Republic of the Congo) in 1965, after deposing the democratically elected leader, Patrice Lumumba. Mobutu allied with the West during the Cold War: they accepted his powerful personality

Left: Chandeliers still hang from the ceiling of the Bamboo Palace of Gbadolite.

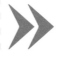

CENTRAL
AFRICAN
REPUBLIC

N

50 km

BANGUI

MOBUTU'S
GBADOLITE

DEMOCRATIC
REPUBLIC
OF THE
CONGO

cult and brutally repressive regime as a necessary bulwark against Communism. His ancestral home was Gbadolite, then reportedly a village of mud huts in a remote nook of the country, on the border with the Central African Republic. It was to this unlikely spot that Mobutu directed his estimated personal wealth of $5 billion, creating what was called 'The Versailles of the Jungle'.

Accounts of Gbadolite in Mobutu's heyday describe a world apart from the rest of the country: it had its own hydroelectric plant, a dedicated Coca-Cola bottling facility, a Chinese pagoda complex in the shape of Beijing's Forbidden City and the largest nuclear bunker in Africa. Pride of place went to a five-star hotel – the Motel Nzekele – where Pope John Paul II, François Mitterrand and the King of Belgium allegedly stayed. On a hill outside the town was Mobutu's own residence, a 15,000-sq m (161,000-sq ft) palace complex, where peacocks roamed and fountains gurgled, and the dictator and his family lived in luxury amid Carrara marble surfaces and twinkling chandeliers.

In 1997, rebellion swept through Zaire: Mobutu was ousted and fled to Morocco, where he died soon after. The rebel forces swiftly overran Gbadolite and looted what wealth the dictator had been unable to take with him. Gbadolite today is less than a shadow of its former self. The hydroelectricity plant is intermittently functioning, meaning the town must rely on imported fuel for its generators. The Coca-Cola facility is gone, and the hotel sees few guests, but a portrait of Mobutu still hangs at its entrance.

Mobutu's own palace, meanwhile, is today little more than concrete and weeds. The foundations on which his remote-controlled bed was once mounted is now a puddle. Conversely, the swimming pool around which ambassadors were entertained is dry. Of four stone lions that once stood here, only two remain – the last statues to bear witness to those giddy days of opulence.

Mobutu's years of misrule have continuing consequences for both the Democratic Republic of the Congo and the African continent, decades after his death. Residents of Gbadolite say their town unfairly bears the stigma of profiting from Mobutu's kleptocracy – they claim that little wealth was shared during his reign. Today, it appears there is little left worth stealing. Just as swiftly as Mobutu's Versailles was conjured out of the jungle, the jungle is reclaiming the ruins of Versailles.

1. The Motel Nzekele, where royalty and popes once were reported to have stayed – now fallen on hard times but still in business.

2. One of two stone lions that remain guarding Mobutu's old jungle palace.

3. A corridor inside the palace complex leads to a trickling fountain.

4. Ornamental pools in the ruined residence.

The town and the palaces have become a parable of one man's greed

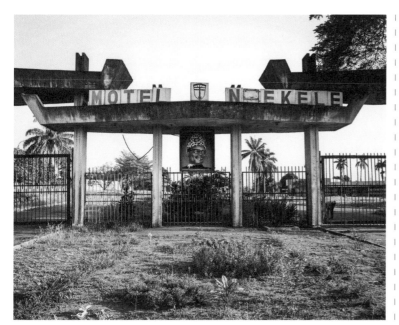

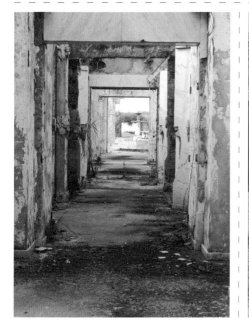
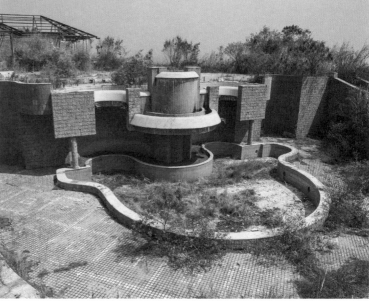

Mos Espa

33° 59' 39.84'' N, 7° 50' 34.26'' E

NEFTA, TUNISIA

An old Star Wars set on the cusp of the Sahara

A long time ago in a desert far away, George Lucas began work on the first *Star Wars* movie. He chose southern Tunisia for the opening scenes of *Star Wars: Episode IV – A New Hope*. Freak rainstorms interrupted production and shifting sand dunes played havoc with R2D2's remote controls. Nonetheless, the Sahara cast a spell on Lucas, who adapted local architecture and costumes for the film, and borrowed the name of a nearby town – Tataouine – for Luke Skywalker's home planet. In the decades that followed, Tunisia became the closest pilgrims could come to a faraway galaxy without leaving planet Earth. They checked in at the Hotel Sidi Driss in Matmata, whose interiors starred as the Lars Homestead, where Luke lived with his aunt and uncle. They explored the canyon at Sidi Bouhlel, where Luke meets Obi-Wan Kenobi for the first time. As Tunisia's package tourism industry boomed along its coastline, so its inland *Star Wars* trail made the jump to lightspeed.

Two decades later, Lucas returned to Tunisia to film *Star Wars: Episode I – The Phantom Menace*. In 1997, the town of Mos Espa was constructed in deserts beyond the town of Nefta, serving as the location for Anakin Skywalker's pod race scenes, and reappeared in *Episode II – Attack of the Clones*.

Left: Entering the fibreglass and timber structures of Mos Espa.

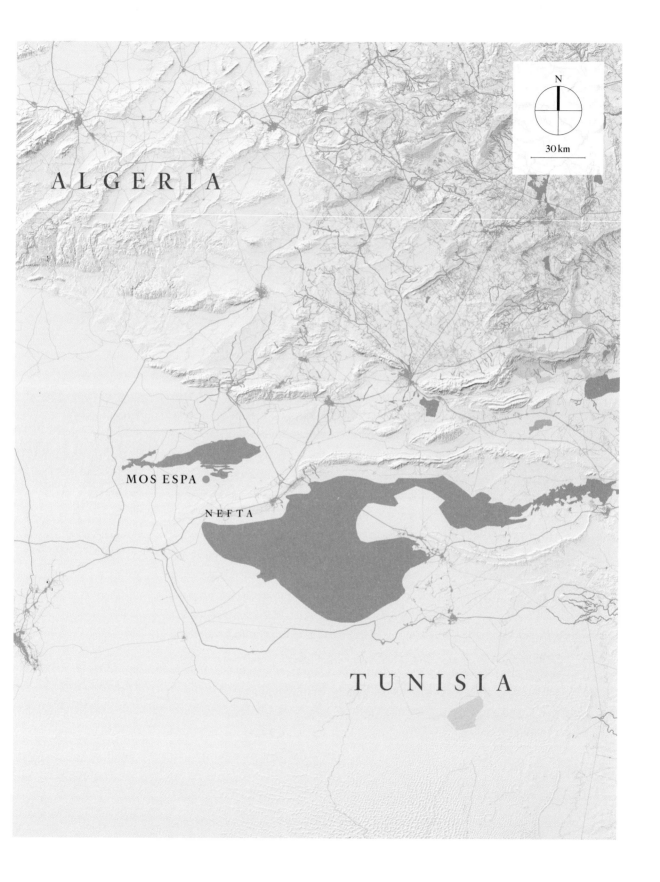

Since the cameras departed, Tunisia has been through turbulent times: 2010 heralded the Tunisian Revolution that began the Arab Spring and, amid widespread protests, the tourism industry, on which many locals relied, slumped. This slump turned into a collapse in 2015, following two terrorist attacks on the North African country: on the Bardo National Museum in Tunis and outside the coastal resort of Sousse. Many countries advised their citizens to stay away. The most recent *Star Wars* films used locations in Abu Dhabi and Jordan for their desert planets, and the coronavirus pandemic has dealt a third blow to an already struggling tourism industry.

The abandoned set of Mos Espa, then, is a reminder of happier years, when hordes of tourists, droids and camera operators passed through the Saharan wastes like the caravans of old. It lies at the end of a sand-strewn road, close to the seasonal salt lake of Chott El Gharsa. The set today is in poor condition, consisting of fibreglass facades and wooden scaffolding, some parts fraying in the wind. Windblown sands have buried some of the doorways. *Star Wars* fans might still identify Watto's junkshop, where the enslaved Anakin Skywalker works, and the marketplace, where (in the absence of droids and scrap metal from spacecraft) enterprising Tunisian traders sell trinkets and camel rides to tourists. Dotted about the site are moisture vaporators left over from the *Star Wars* set, their antennae pointing up to the cloudless skies.

Whether or not tourists return in numbers any time soon, the future of Mos Espa faces another threat to its existence: shifting sand dunes. In 2014, *Star Wars* fans raised $75,000 for the Tunisian government to save the site from oncoming dunes, though local guides say that some other parts of the set already lie buried under the Sahara. As the dunes continue to dip and roll – like slow-motion waves out at sea – those lost parts of Mos Espa might re-emerge in the future. One wonders how they might appear to a passer-by in decades or centuries to come: ruins built by filmmakers from a place far away, a long time ago.

1. *Star Wars* moisture vaporators in the central marketplace.

Star Wars **fans might still identify Watto's junkshop where the enslaved Anakin Skywalker works**

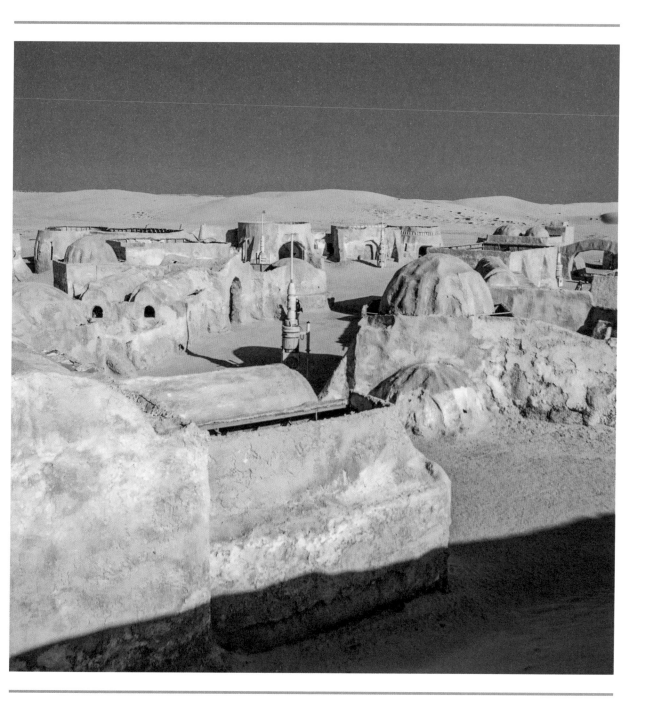

São Martinho dos Tigres

15° 46' 58.656'' S, 11° 50' 49.848'' E

TIGRES ISLAND, ANGOLA

A fishing village cast adrift from the African mainland

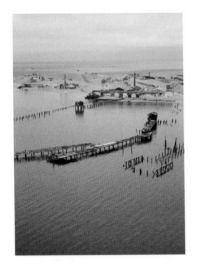

Left: The docks that lead to the fishmeal factories of São Martinho dos Tigres.

Few people make the journey to São Martinho dos Tigres, or St Martin of the Tigers. It is an epic expedition. From the remote Angolan town of Tombua, you must first drive your 4×4 along a narrow strip between the desert and the sea: 100km (62 miles) with no people, places or roads, just sand, spray and the threat of the incoming tide. Those who do traverse this treacherous shore will then see something like a mirage: an island on which there stands an abandoned village. You'll need to have brought a boat to get to São Martinho dos Tigres, which is a surreal, almost allegorical presence in this empty, sun-bleached world.

Tigres Island cannot be found on old sea charts. It has only existed since 1962, when waves broke through an isthmus connecting the island to the mainland. Before that it was the Tigres Peninsula, and the first European to set eyes upon it was the Portuguese explorer Diogo Cão in 1485. It took another four centuries before his countrymen established a permanent foothold on this parched tongue of desert, reportedly so-called because the fearsome winds brought to mind a tiger's roar.

The village of São Martinho dos Tigres was founded in 1865. The land was thin, but the sea was abundant, and fishermen came from the faraway Algarve, Portugal, to settle.

By the mid-20th century, it had a population of around 1,500, with processing factories for fishmeal, a school and a hospital. Homes were arranged around a broad central street that doubled up as a runway so a plane could bring the post. The greatest building was the Catholic church, its weathervane shaped like the kind of ship in which Diogo Cão had sailed past the peninsula centuries before. Fresh water arrived by boat, until a pipeline was laid in the 1950s.

On 14 March 1962, disaster struck. A raging storm drove waves up to 10m (33ft) high onto the isthmus. Locals took shelter in their homes as the storm cracked the fresh water pipeline. The newly formed Tigres Island was cast adrift from the mainland, its safe harbour gone. For some years, residents carried on – until the tides of history also turned. The Angolan War of Independence led to Portugal withdrawing from its former colony in 1974, and so São Martinho was abandoned.

Visitors to São Martinho dos Tigres can still catch faint echoes of the colonists amid the roaring desert winds. Houses, lifted on stilts so they could rise above drifting sand, are painted the pastel yellow hue that recalls the streets of Lisbon and Porto. There are offices that belonged to fishing companies, one emblazoned with the Portuguese coat of arms, framed by anchors. But much has been looted and lost: the fish-processing factories are derelict and roofless, sands are submerging old gravestones and goalposts are still waiting for someone to kick a winning goal.

Most melancholy is the church, robbed of its pews, its pulpit now broken. If anyone wonders who would care to reside in São Martinho now, an engraving over the doorway might offer a kind of answer: *Hic Domus Dei* ('This is the home of God').

Despite mutters of interest from Angolan politicians, it seems there are no imminent plans to bring new residents along the treacherous shore and across the churning sea to São Martinho dos Tigres. The strait between the island and the mainland is about 10km (6 miles) and it is said to be growing with every year. So, too, grows the gulf in time since the last residents departed.

1. The main street at São Martinho, which doubled up as a runway for supply planes.

2. Rusting oil drums outside one of the factories.

3. An abandoned home.

Tigres Island was cast adrift from the mainland, its safe harbour gone

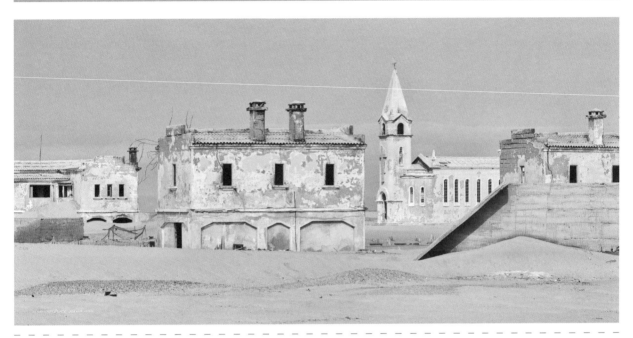

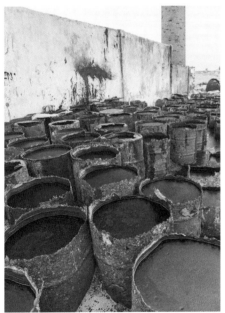

Index

Picture Credits

akg-images viennaslide/Harald A. Jahn 25
Alamy Stock Photo agefotostock 66, Alex Konon 54, Angela Jordan 137ar, Chris Willson 197ar, Christoph Gerigk/Biosphoto 197br, Cristiano Montagnani 91ar, Dave G Houser 190, 191a, David Kirkland/Axiom 197al, David Wall 91bl, Denis Feldmann 33al, Diane Bartlett 178, Ellena Kiki 137al, Geof Kirby 203br, Hemis/de Winter - Van Rossem 112, Image Source 38, ImageBroker 91al, James Davis Photography 78, 104, Jason Richardson 10, Juniors Bildarchiv GmbH 42, Life on white 146, 164, Liquid Light 212, Marcin Rozpedowsk 65bl, Martin Bertrand 18, 21 all, Media Drum World 175al, bl & br, 197bl, Meritxell 22, Michael Marquand 108, Miroslav Valasek 13, MJ Photography 219a, Nathaniel Noir 129br, Poelzer Wolfgang 176, 194, Reuters 69, Robert Estall Photo Agency 203bl, robertharding 100, 145, Ronny Bolliger 167ar, SIPA Asia/Zuma Wire 148, Westend61 219bl & br, Wirestock, Inc. 30, Wolfgang Diederich 119ar, Xinhua 96
André Joosse, www.urbex.nl 41b
David De Rueda 155
Dreamstime.com Andreas Zeitler 159a, Artenex 58, 61ar, Barylo Serhii 57b, Bennymarty 189b, Boggy 124, 141, Demerzel21 84, Dinozzaver 159bl, Elena Sineglazova 159br, Fotokon 61b, Gary Webber 203ar, Hon Chung Ham 182, Igor Sobolev 215, Jamen Percy 185, Jesse Kraft 115, Leventina 129bl, Lukas Bischoff 8, Natalia Golovina 200, Natalya Sidorova 126, Pomazlinas 129a, Prillfoto 111, Rita Phessas 61al, Robert Downer 189al, Ronny Bolliger 167al, bl & br, Samystclair 88, Sirio Carnevalino 33ar & bl, Thomas Jurkowski 137bl, Wirestock 29
eyevine © Sean Smith/Guardian 211ar & br
Flickr tjabeljan (CC by 2.0) 119 bl
Getty Images Antoine Gyori/AGP/Corbis 142, Arterra/Universal Images Group 45, Birol Bebek/AFP 134, Brendan Smialowski/AFP 92, Chris McGrath 133, Christopher Furlong 168, Christopher Pillitz 107ar, DigitalGlobe 95, Donato Fasano 224, Joel Auerbach 120, 123a, bl & br, John Wessels/AFP 211al, Keow Wee Loong/Barcroft Media 171, Marcelo Rabelo/Barcroft Media 74, 77, Martin Sachse/ullstein bild 37, Muhammet Fatih Ogras/Anadolu Agency 137br, Stocktrek Images/Richard Roscoe 107bl, The Asahi Shimbun 172, 175ar, Westend61 216
iStock alsem 156, Claudiad 103, Delpixart 119al, Demerzel21 87, Derek Galon 107br, Dirk94025 91br, Esin Deniz 130, ewg3D 65br, Federico Fermeglia 17ar, Gianni Marchetti 203al, JackF 2, jahmaica 70, Justinreznick 1, Mienny 204, Nadya85 53, Philipp Goers 4, Stefan90 34, takepicsforfun 116, thomaslusth 119br, THP Creative 186, Travel Photography 33br, tupungato 26, Wolfgang Steiner 198, 207
Matt Lambros 80, 83
Michael Scott 62, 65 al & ar
Museo Virasto/Finnish Heritage Agency Photo: Helena Ranta/Archaeological Image Collection (CC by 4.0) 46, 49a & b
Panos Pictures Andrew Johnstone 107al, JB Russell 208, 211bl
Shutterstock Amazing Aerial Premium 160, Andrew Hutchings 181, Andy Parsons/Time Out 14, 17al, bl & br, Brian Logan Photography 99, Graham Harries 57a, Jon Fitton 41a, Kommersant Photo Agency 152, Lukas Bischoff Photography 50, RedHeadAnnika 138, Tetyana Dotsenko 191b, THP Creative 189ar, Tomasz Wozniak 73
Simon Cockerell/Koryo Tours 151
Wikimedia Commons: Yaroslav Shuraev (CC by-SA 4.0) 163

Maps derived from open source three-second-arc height data and OpenStreetMap contributors.

For H and F – for not abandoning me!

Author's acknowledgements
Thank you to Joe and Sybella for such an enjoyable book to write in the depths of lockdown. And to editorial colleagues past and present for shepherding words and travels over the years – most of all Peter Grunert, Amanda Canning, Orla Thomas and Christa Larwood.

About the author
Oliver Smith has spent years travelling the faraway corners of the world. A four-time Travel Writer of the Year award winner, his work has appeared in *The Sunday Times*, the *Financial Times, Outside Magazine* and many more.

First published in Great Britain in 2022 by Mitchell Beazley, an imprint of Octopus Publishing Group Ltd Carmelite House, 50 Victoria Embankment, London EC4Y 0DZ www.octopusbooks.co.uk

An Hachette UK Company www.hachette.co.uk

Text copyright © Oliver Smith 2022

Distributed in the US by Hachette Book Group 1290 Avenue of the Americas, 4th and 5th Floors, New York, NY 10104

Distributed in Canada by Canadian Manda Group, 664 Annette St., Toronto, Ontario, Canada M6S 2C8

All rights reserved. No part of this work may be reproduced or utilized in any form or by any means, electronic or mechanical, including photocopying, recording or by any information storage and retrieval system, without the prior written permission of the publisher.

Oliver Smith asserts his moral right to be identified as the author of this work.

ISBN 978 1 78472 692 8

A CIP catalogue record for this book is available from the British Library.

Printed and bound in Malaysia
10 9 8 7 6 5 4 3 2 1

Editorial Director: Joe Cottington
Senior Managing Editor: Sybella Stephens
Copy Editor: Helen Ridge
Creative Director: Jonathan Christie
Cartographer: Jason Clark
Picture Research Manager:
 Giulia Hetherington
Picture Library Manager: Jennifer Veall
Senior Production Manager:
 Katherine Hockley

Publisher's note
All information in this book was correct at the time of going to print.